THE ART OF REBELLION III

The book about street art

publikat

I'd like to thank everyone
who helped me in realising this book,
especially Krixl and Jan – for the patience.
Also every artist shown in the book for
joining in & making it something special.
All my friends, especially Clemens & Mambo
for giving me the right advice in difficult questions.
And, of course my Mom, Dad,
my sister Yvonne, Gabi & Mogly dog.
One love & peace.
– Christian

Imprint:
The Art Of Rebellion III
Copyright © C100 & Publikat

First published 2010:
Publikat Verlags- und Handels GmbH & Co. KG
Hauptstraße 204
D-63814 Mainaschaff
T +49 (0) 6021 / 90040-0
F +49 (0) 6021 / 90040-20
info@publikat.de

First print run 11/2010
Second print run 08/2011

Concept, Art Direction and Design:
Christian Hundertmark (C100)
C100 Purple Haze
ch@c100purplehaze.com
www.c100purplehaze.com
Text copyright © 2010 C100 Purple Haze
Images copyright © 2010 C100 Purple Haze
All photos by the artist except where noted.
Design and layout copyright © 2006 C100 Purple Haze

ISBN: 978-3-939566-29-8

Printed and bound in China.

This book is dedicated to the memory of Hanne Bee, an amazing artist and lovely person.

Intro

When I decided to draw my very first graffiti sketch in 1989 – it said "Batman" with the famous Batman logo in the background – I didn't know what enormous importance this had for my further career. This certain sketch was the main ignition for the whole development of my personality to what I am now. If it had not been there, maybe this book in your hands wouldn't even exist. Actually it meant, that I spent the next ten years with painting graffiti and furthermore with making friendships with many great artists and built up an international network with them.

At the end of the 90's, after finishing my graphic design studies, I was less active in painting graffiti until I found an article in a magazine about a new art form nowadays labelled as street or urban art – I was infected immediately. I felt the same enthusiasm and excitement like when I was a graffiti-writing teenager due to all these new techniques and inspirations from other artists. This time, there weren't any books about street art, at least only a few good websites who kept this small scene together – big up to www.ekosystem.org. I just decided to publish my own book and with the publishing house "Publikat", I found a good partner on my way – back in the days, we were graffiti partners so the assurance was guaranteed. So we did "The Art of Rebellion I – World of Street Art" in 2003 and got huge acceptance by the international street art scene. Also the book sales approved, that the taken financial risks and countless hours of work were the right decision for us.

Three years later we released "The Art of Rebellion II", what showcased the status quo of street art back then in 2006. My friend Dave the Chimp said, that this was a "proper art book". For me, his comment was both; a very nice compliment but also my main goal – showing this art form in the design it deserved! Since then, four years passed by and if someone had asked me whether I ever planned a third part of "The Art of Rebellion", I would have negated this. In my opinion, everything I wanted to say/show was already within the two previous books. But sometimes things changed like I changed my opinion and now it's finished – welcome to "The Art of Rebellion III – the book about street art"! What once seemed to be a small art movement and in a way also "rebellious", has become a highly respected art form, accepted and pushed by galleries, museums and the media – all over the world. Nowadays you can find a big variety of books about street art on shelves in stores – unfortunately sometimes it's cognizable that they were made with a lack of love on the concept, design and details and it seems they were just done for the profit. Street art has already become an industry with some artists promoting themselves like rock stars and collectors pay big money for the art – I will leave it to everyone to judge, if he likes this development or not. Anyway, there is so much amazing new art put up on the streets and exhibited in galleries everyday – all over the world – that I feel a huge necessity which has to be documented in a book. Enjoy!
– Christian Hundertmark (C100)

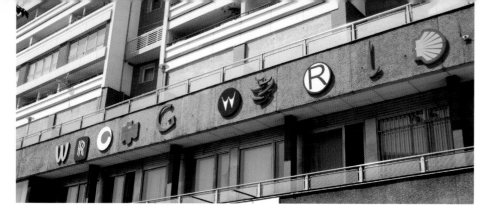

"Wrong World" – Artist: The Wa – Berlin (Germany), 2007

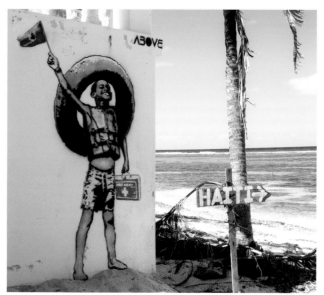

"Haiti" – Artist: Above – USA, 2010

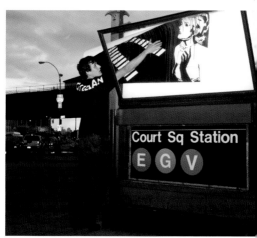

Artist: Jordan Seiler – New York (USA), 2009

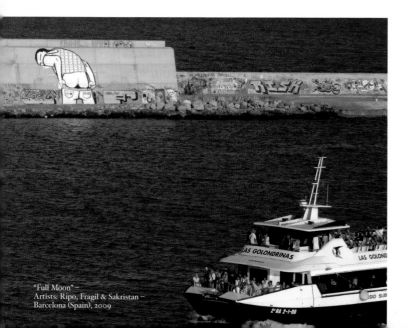

"Full Moon" –
Artists: Ripo, Fragil & Sakristan –
Barcelona (Spain), 2009

"Decadent Redneck Series" –
Artists: Brad Downey & Erik Tidemann –
Trondheim (Norway), 2009
Info: Two camouflage half deer men soldiers disguised as a giant shrub
go on a military operation to deliver a glowing fur orb to the darkness
of the Norwegian wood.

"Les Voleurs Smog" – Artist: G* – Paris (France), 2009

"Listen To My Street" – Artist: SupaKitch –
Installation – New York (USA), 2009

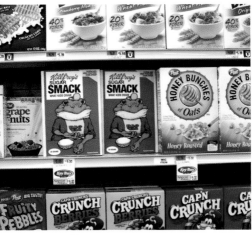

"Sugar Smack Shelf" –
Artist: Ron English – USA, 2009

Artist: Ana Ellmerer – Bunsen burner –
Lamezia Terme (Italy), 2009

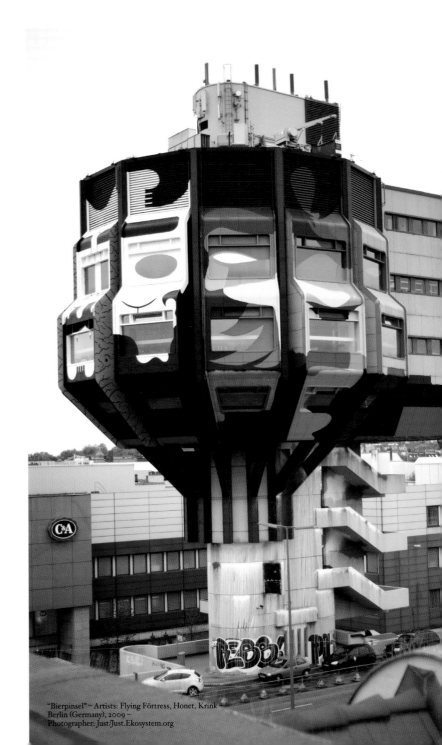

"Bierpinsel" – Artists: Flying Förtress, Honet, Krink –
Berlin (Germany), 2009 –
Photographer: Just/Just.Ekosystem.org

The artists Suzi4 (Berlin), Geo & Jpeg (Melbourne) climbing a rooftop –
Berlin (Germany), 2009 – Photographer: Just/Just.Ekosystem.org

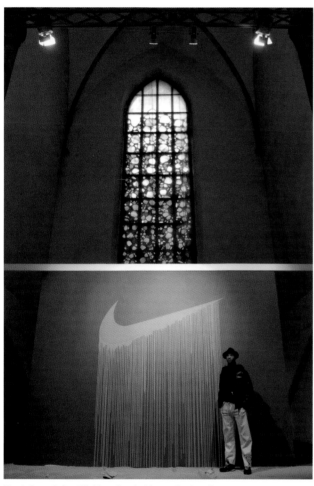

Zevs in front of a liquidified Swoosh at the Museum Osnabrueck.
Courtesy of Rik Reinking Collection – Osnabrueck (Germany), 2008 –
Photographer: Just/Just.Ekosystem.org

Brad Downey setting up his installation "Traffic Jam for Berlin" at the Museum Osnabrueck.
Courtesy of Rik Reinking Collection – Osnabrueck (Germany), 2008 –
Photographer: Just/Just.Ekosystem.org

Artists: Mentalgassi – Flip image –
Berlin (Germany), 2010 –
Photographer: Just/Just.Ekosystem.org

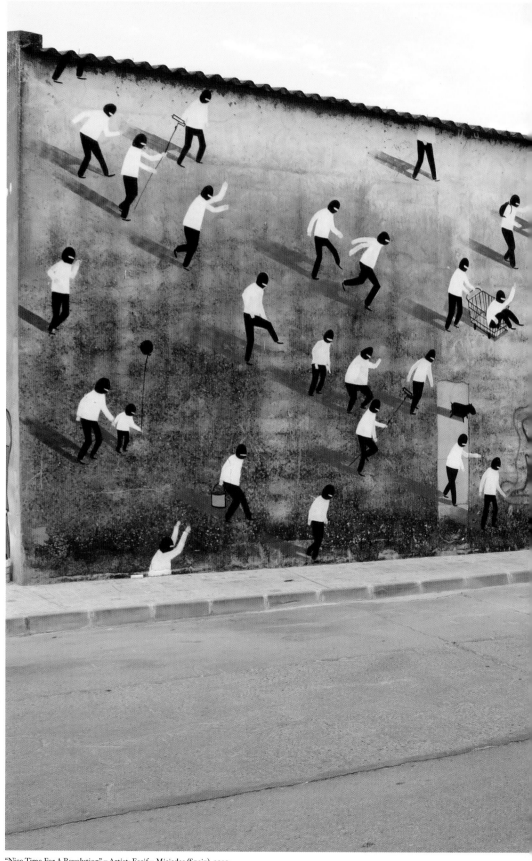

"Nice Time For A Revolution" – Artist: Escif – Miajadas (Spain), 2010
Escif: "I made this wall in a little sunny village called Miajadas inside a great street art event where some great artist where invited also. The wall represent, in an ironic way, the arrival of the dark poor artists to the little town ... Nice time for a revolution?"

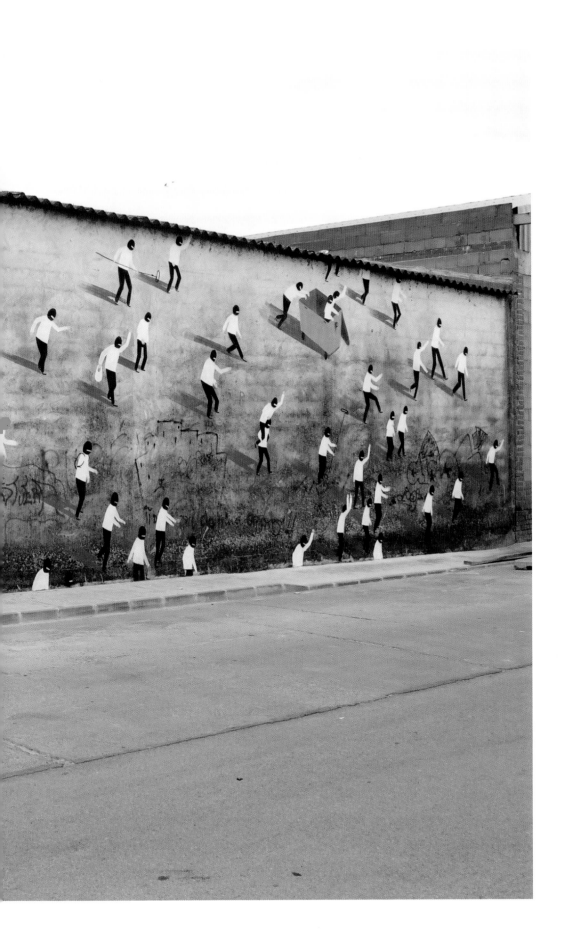

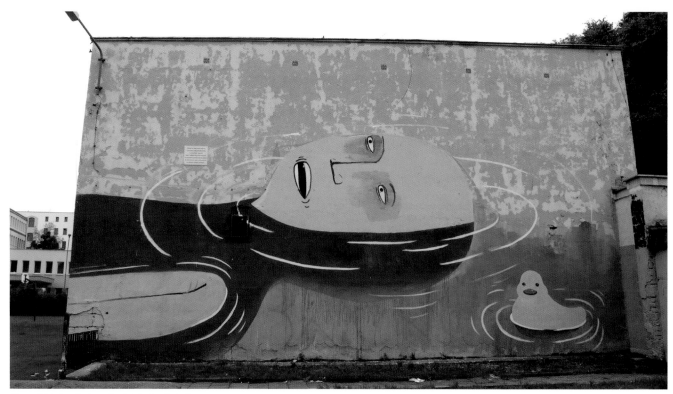

"Poetical Suicide 01" – Artist: Escif – Wroclaw (Poland), 2010
Escif: "I love life, but I don't agree with the way in which the world is
coming. This wall is the first of a series of poetical suicides. A kind of
symbolic protests like trying to get drowed in a bathtub."

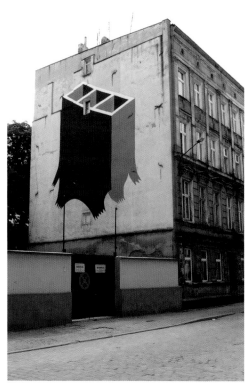

"Concrete Jungle" – Artist: Escif – Wroclaw (Poland), 2010
Escif: "Contemporary forests made with buildings ...
About the wild city."

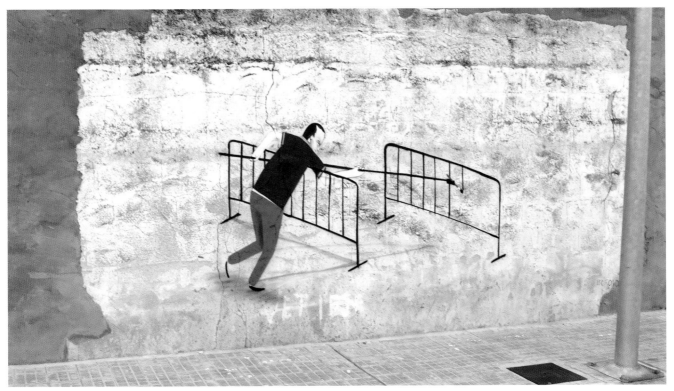

"Someone's Painted A Fence Behind The Fence" – Artist: Escif – Miajadas (Spain), 2010
Escif: "When somebody puts their tag on a wall or paints a mural, they are momentarily appropriating that wall and sidestepping the restrictions prohibiting this. Symbolically, graffiti builds small autonomous zones in which the graffiti writer acts to his or her own standards for a moment, proving that a city can be built from the bottom up, showing that another world is possible. Just for a moment, as if by magic, anything goes. Someone has painted a wall behind the wall."

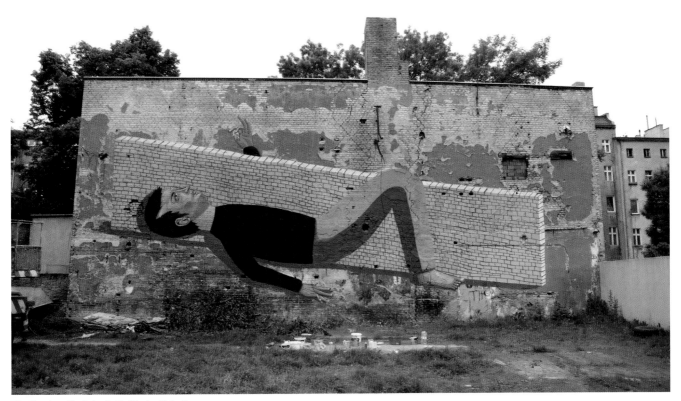

"Breaking the wall" – Artist: Escif – Wroclaw (Poland), 2010
Escif: "I think Poland as a country is really marked because of the second world war. We can feel it in its walls, in its buildings, in its quartiers and also in its citizens. A country divided by the past and the future, a country divided by a symbolic wall."

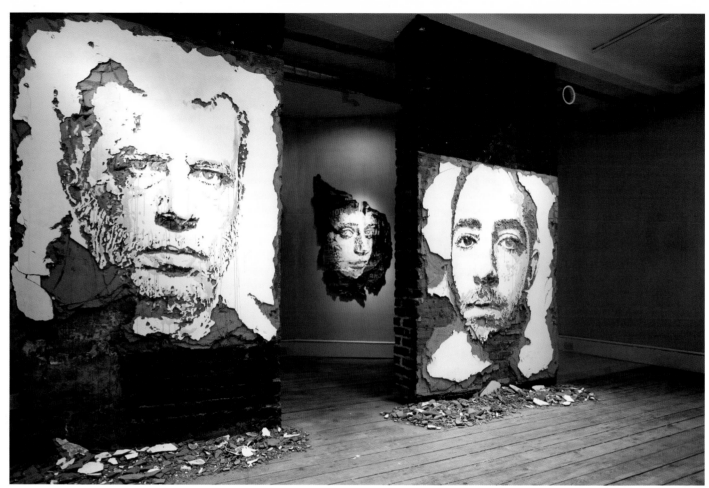

Artist: Vhils – Solo show "Scratching the Surface" at Lazarides Gallery,
London (United Kingdom), 2009 – Photographer: Ian Cox

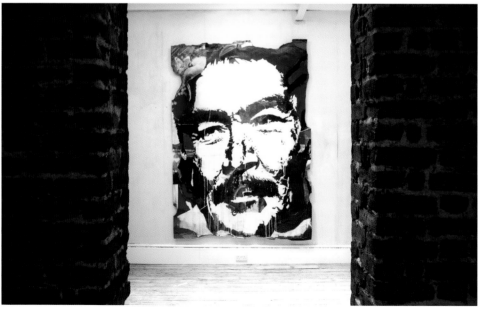

Artist: Vhils – Group show "Grow up" at Lazarides Gallery,
London (United Kingdom), 2009 – Photographer: Ian Cox

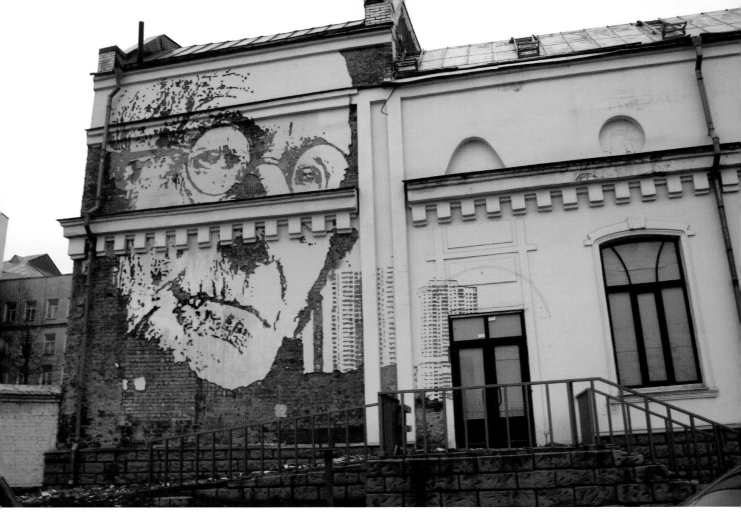

Artist: Vhils – "Scratching The Surface" project, Moscow (Russia), 2009
Vhils: "The idea is to take the act of vandalism – the act of destroying in order
to create – to the extreme, as modus operandi. To use processes which, on the
surface, are not valued in a more conservative work environment – tools such
as etching acid and household bleach, spray paint and Quink – to take these
undervalued materials and create some sort of confrontation through stencil,
graffiti and visual arts techniques. All this confrontation between different
layers, different media, generates new things. It's like sampling in music; our
generation is quintessentially cut & paste, DIY."

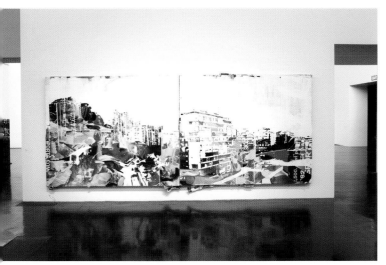

Artist: Vhils – Wallsall Museum, Outsiders show, Wallsall (United Kingdom), 2008 –
Photographer: Ian Cox

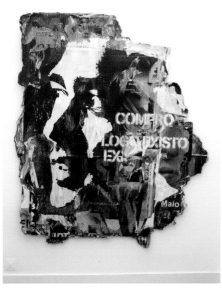

Artist: Vhils – Compro logo existo Series, Vera Cortes Agency,
Lisbon (Portugal), 2006 – Photographer: Matilde Meireles

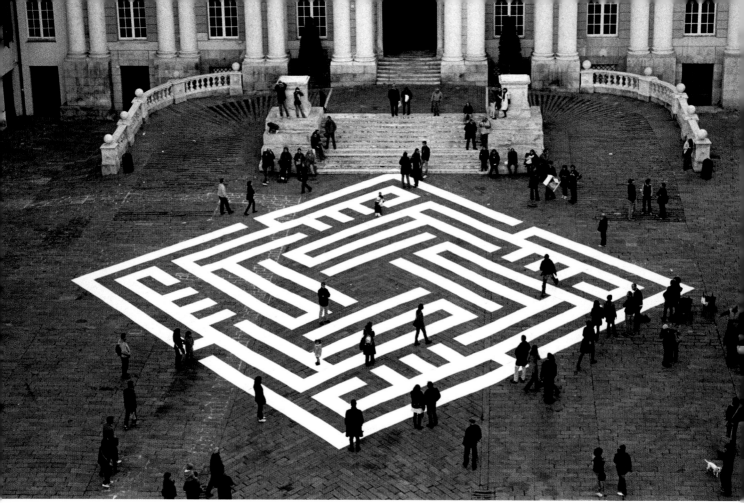

Artist: L'Atlas – 400 cartons fix double face tape – Genova (Italy), 2008

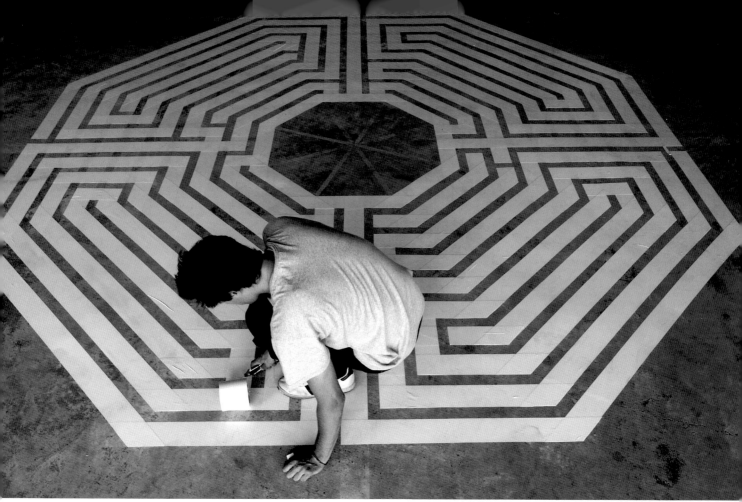

Artist: L'Atlas − Gaffer tape on concrete − Winzavod, Moscou (Russia), 2010 −
Photographer: Manon Lutanie

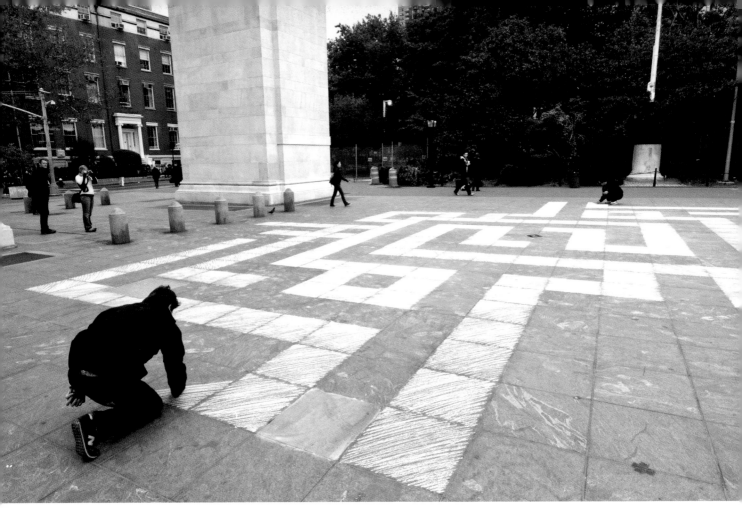

Artist: L'Atlas – Chalk on concrete – New York (USA), 2010
Photographer: Tanc

Photographer: Manon Lutanie

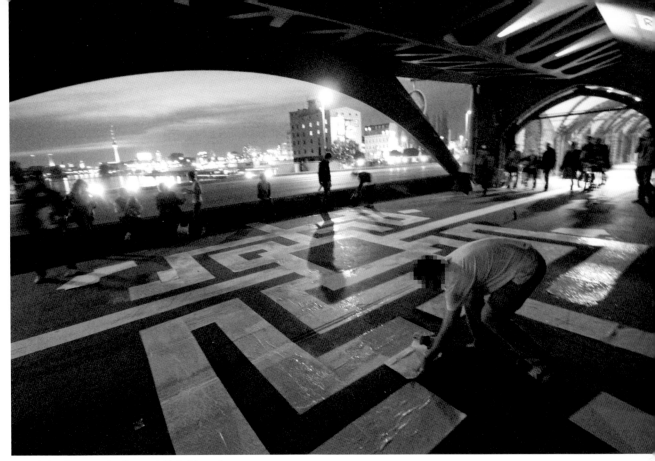

Artist: L'Atlas – Papers pasted on the ground – Berlin (Germany), 2010
Photographer: Just/Just.Ekosystem.org

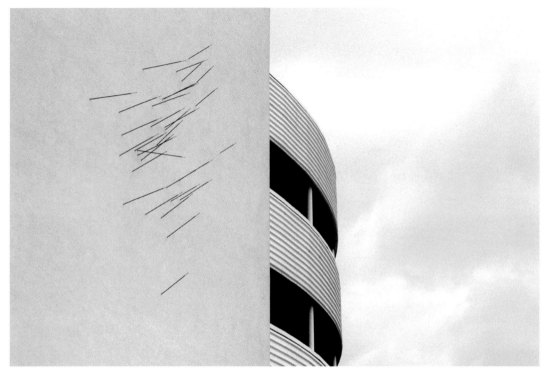

"Tickle Centrum Chodov" – Artist: Zast – Prague (Czech Republic), 2008
Zasd: "For Arrow Pieces I use a magical bow that was given to me by a very
old archer who had a gleam in his eyes when he decribed to me how to shoot.
I tinker wooden arrows (12mm diameter and 1000mm length) with a nail-tip.
The Arrows have no feathers at the tail and that's why I can't control where
they gonna hit the wall exactly. The arrows easily break through the layers of
plaster and heat insulation."

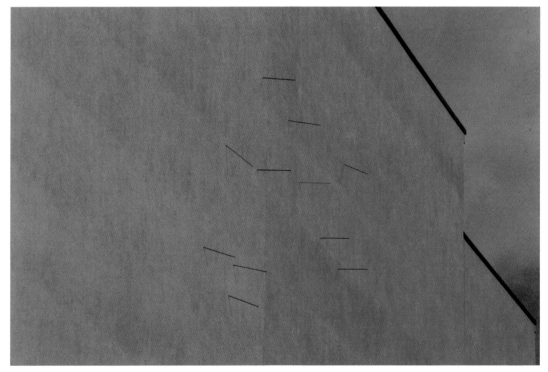

"Acupuncture Attempts" – Artist: Zast – Berlin (Germany), 2009

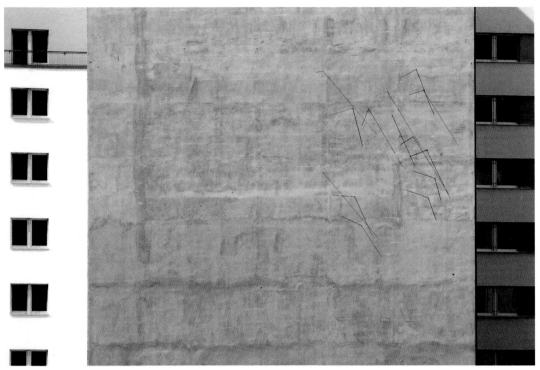

"Workmother" – Artist: Zast – Berlin (Germany), 2009

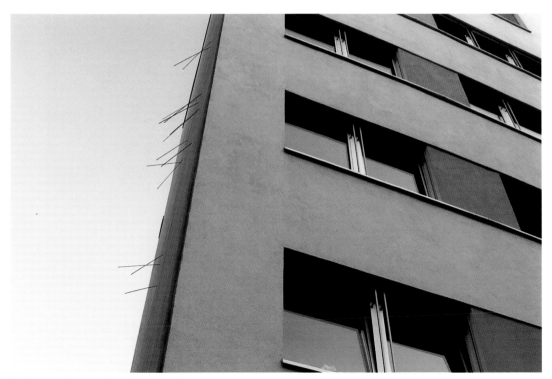

"Sculpturemother" – Artist: Zast – Berlin (Germany), 2009 –
Photographers (All Photos): ZASD and Jürgen Grosse, courtesy of urban-art.info gallery, Berlin

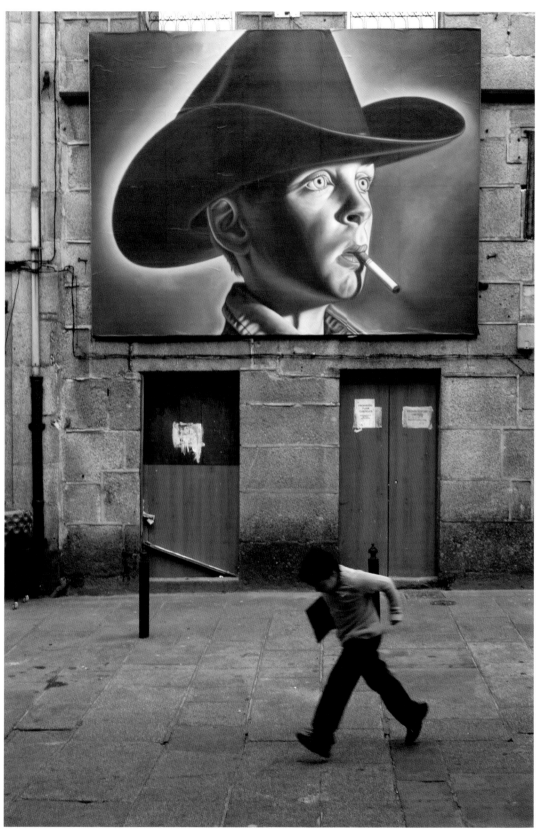

"Marlboro Boy" – Artist: Ron English –
Galicia (Spain), 2007

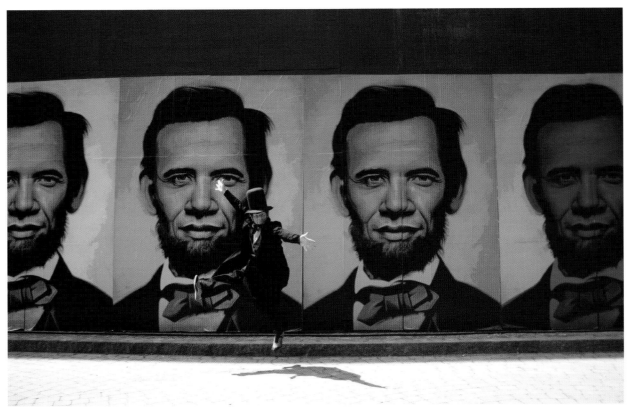

"Abraham Obama Rainbow Mural" – Artist: Ron English –
Boston (USA), 2008

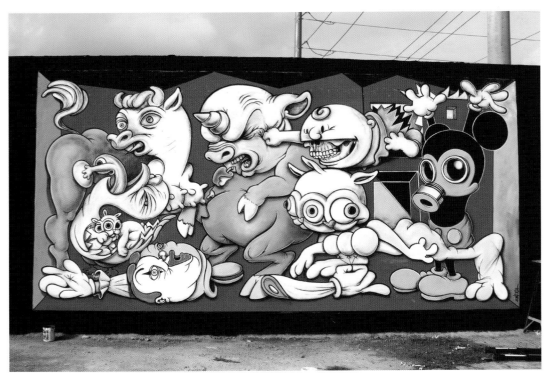

Artist: Ron English – Wall at Art Basel –
Billboard – Denver (USA), 2008

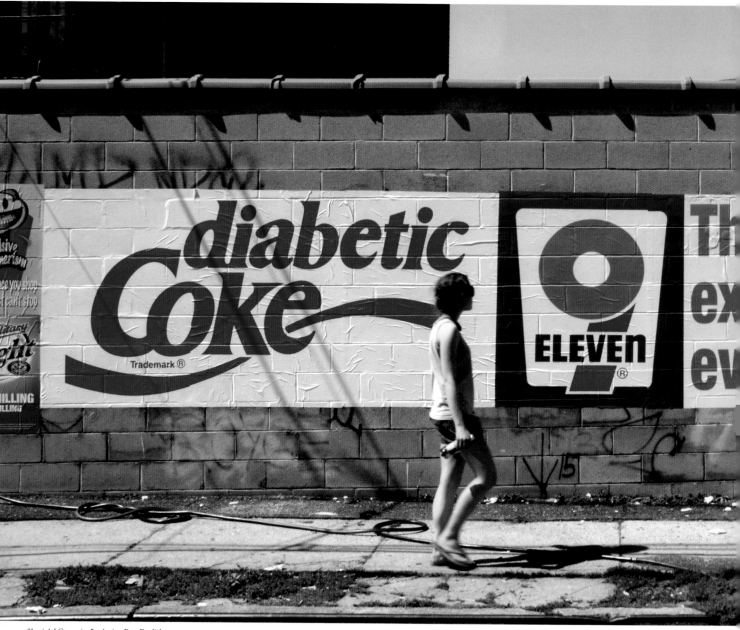

"Anti-Ad Campaign" – Artist: Ron English –
New York (USA), 2010

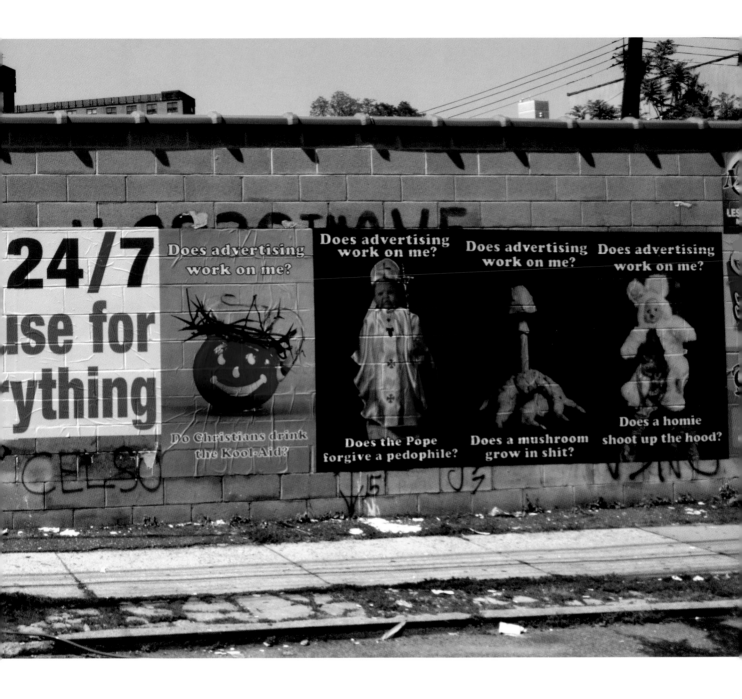

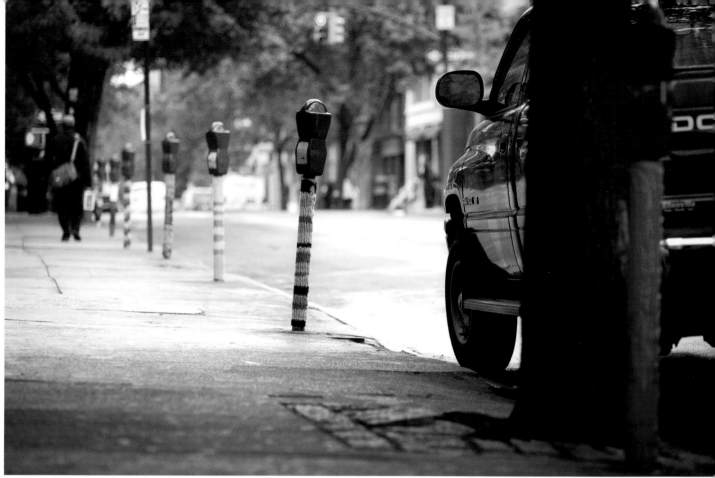

Artist: Magda Sayeg – Knit with acrylic and woolen yarns –
New York (USA), 2009
Info: The project was commissioned by the Montague
Street Business Improvement District. Directed by Magda,
over 40 volunteers contributed to the knitting and
installation of 69 parking meter cozies.
Photographer: Jonathan Hokklo

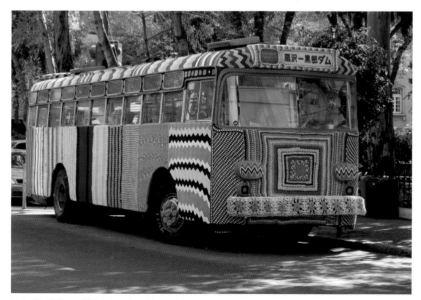

Artist: Magda Sayeg – Knit and crochet with assorted yarns –
Mexico City (Mexico), 2008 – Photographer: Cesar Ortega –
Magda: "The project was sponsored by Absolut Vodka and TCLY.com.
The bus was hollowed out and is still used as a public art workshop
space. A different street artist reinvents the bus every year."

Artist: Magda Sayeg – Knit with acrylic yarn –
New York (USA), 2007 – Photographer: Dan Fergust
Magda: "This piece was in an alley in the busy shopping
district in Manhattan. I liked the idea of something
bright and hidden, in passing."

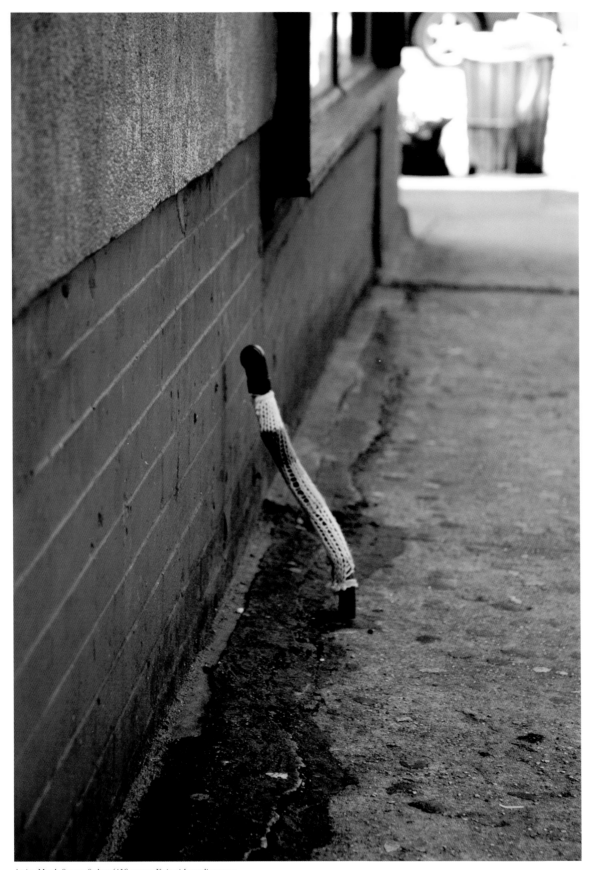

Artist: Magda Sayeg – Sydney (AU), 2010 – Knit with acrylic yarn –
Photographer: Dan Fergust
Magda: "When I passed through Sydney I did a lot of uncommissioned
pieces. A police man stopped me so I told him I was setting up a
scavenger hunt for a church youth group. He let me continue."

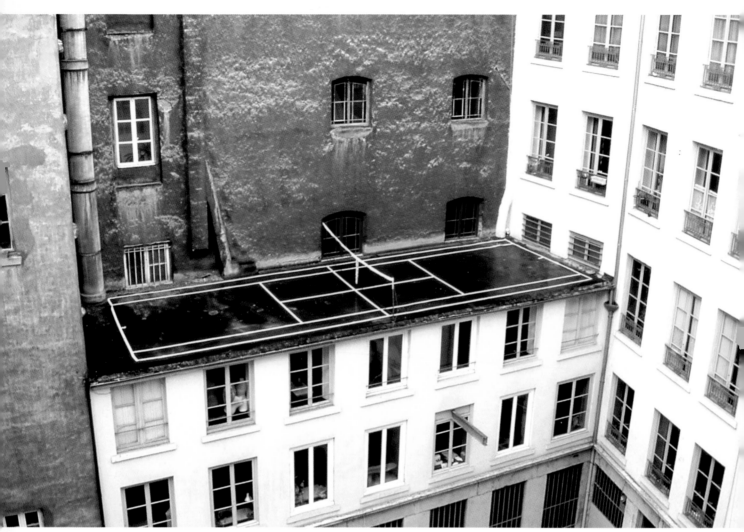

"Tennis" – Artist: Arno Piroud – Tape – Lyon (France), 2004
Arno: "Realised for a show in my flat during a day. Visitors (and also
the people who live there) could see this strange tennis court by my
window. I made this intervention in 15 minutes with a commando
of four people."

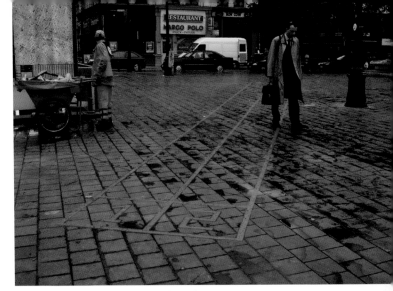

"Duel" – Artist: Arno Piroud – Tape – Brussels (Belgium), 2006
Arno: "Realised for a show in the city. There was 10 interventions in different places. It was like a special tour of the city from the first intervention to the last one. The idea was to impulse a new rythm, a new way of using the streets (graphically and physically)."

"Les Feux De L'amour (Fire Of Love)" – Artist: Arno Piroud –
Taped stencil from 2001 – Various places
Arno: "I leave a message in the streets, on the road ... Declaration of love to
the City or what? You've got to find what I want to transmit. The most important
thing in this work is that I put some fiction in the real world, and stories begin."

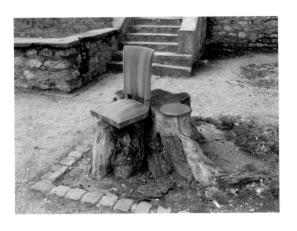

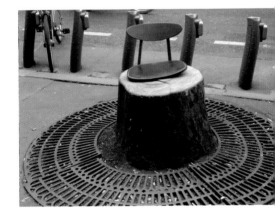

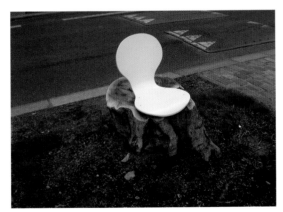

"Assises Éphémères (Ephemeral Seats)" – Artist: Arno Piroud –
Cutted truncks and old seats found in the streets –
Various places, but starting in Paris (France), 2007
Arno: "This is opportunist design! These pieces explain my work very
well: A sculptural gesture with the hard question of the pedestal an useable
object: Design or sculpture? An art piece for everyone, not in galleries or
art centers ... a sign in the street, different from the everyday life."

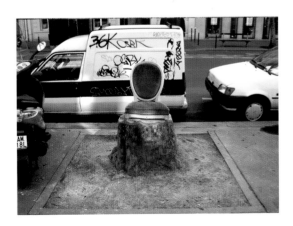

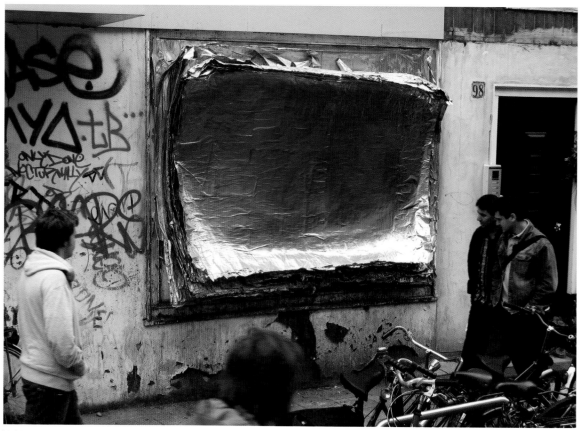

"Gold" – Artist: Influenza – Commercial flyposters »touched«
with gold from the can – Amsterdam (The Netherlands), 2008

"Golden Gate II" – Artist: Influenza – Security fence turned as a »gift«
to the neighbourhood – Rotterdam (The Netherlands), 2009

"Golden Gate I" – Artist: Influenza – Forgotten fence
turned gold – Rotterdam (The Netherlands), 2009

"Plastic Bags As Jolly Roger" – Artist: Influenza – Plastic bags, found in the streets and »relocated« on various spots with a view – Rotterdam (The Netherlands), 2009 / 2010

Artist: Urban Camouflage – Cleaning clothes –
Stockholm (Sweden), 2008

Artist: Urban Camouflage – Bottles – Karlsruhe (Germany), 2008

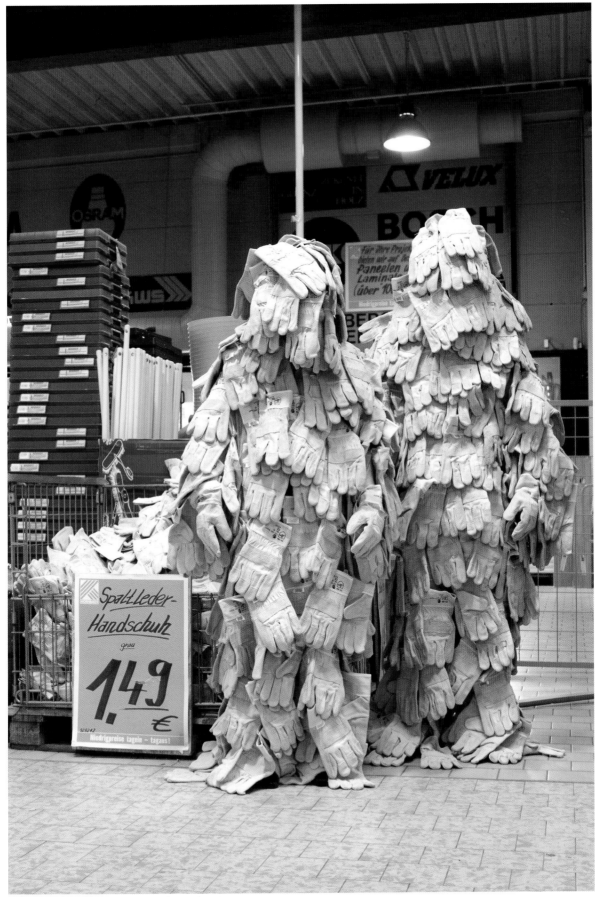

Artist: Urban Camouflage – Gloves – Karlsruhe (Germany), 2008

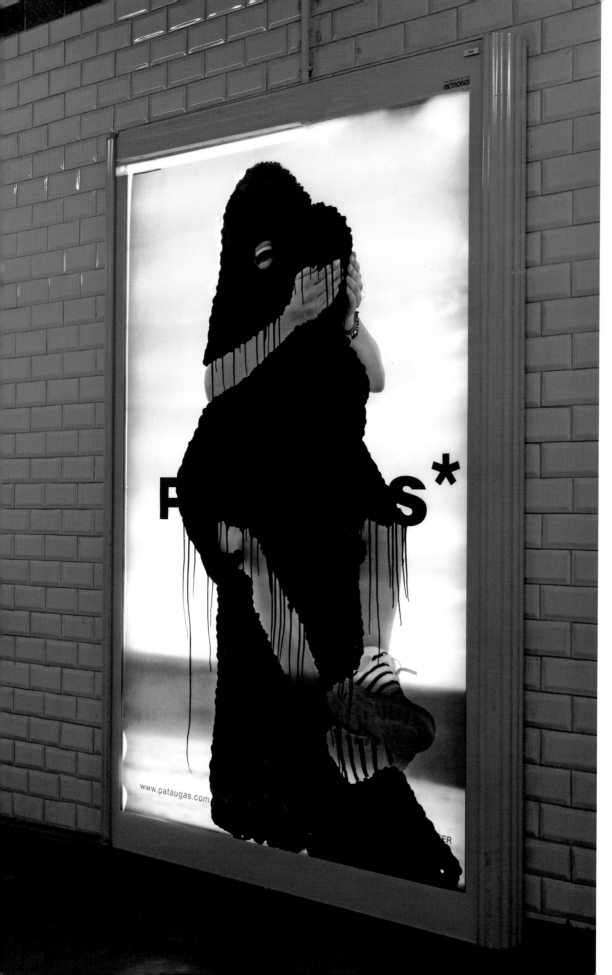

Artist: Princess Hijab –
Metro Paris (France), 2010 –
Photographer: A. Breant

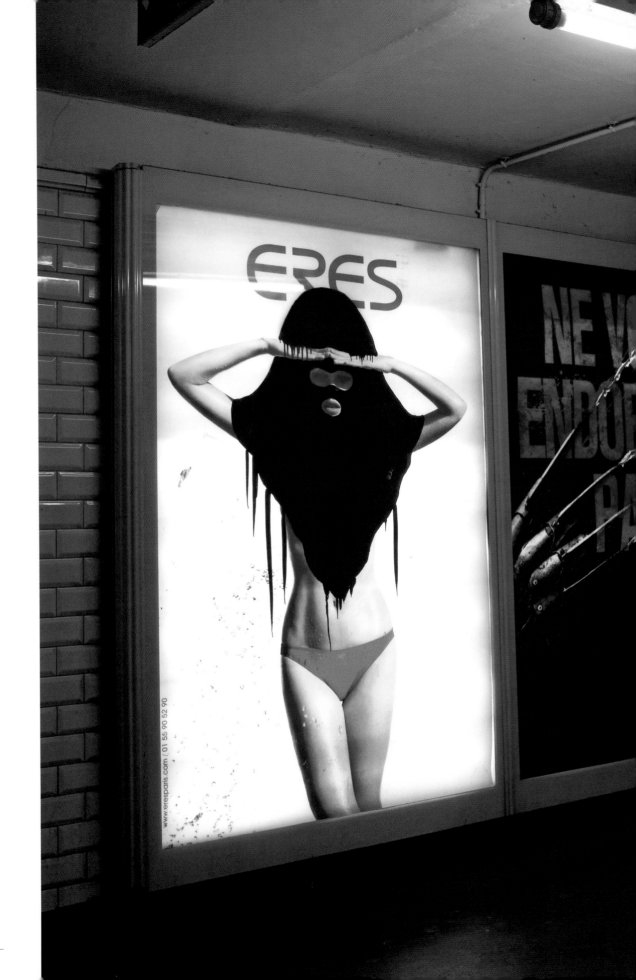

Artist: Princess Hijab –
Metro Paris (France), 2010 –
Photographer: A. Breant

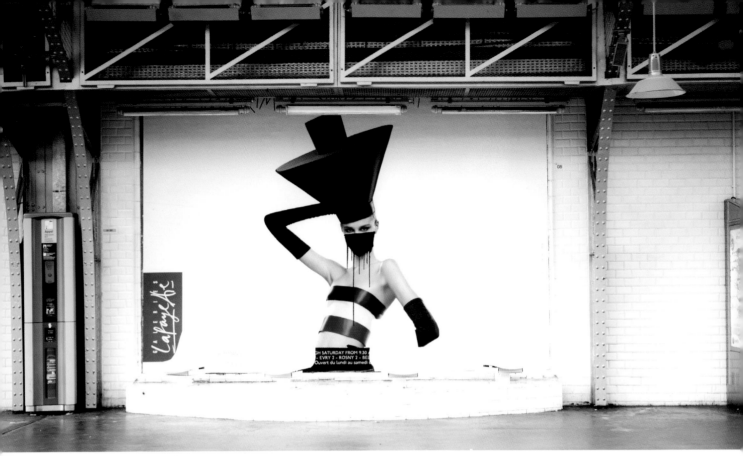

Artist: Princess Hijab – Metro Paris (France), 2009 –
Photographer: A. Breant

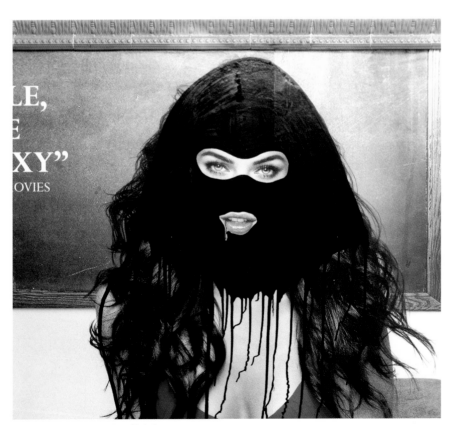

Artist: Princess Hijab – Metro Paris (France), 2009 –
Photographer: C. Meireis

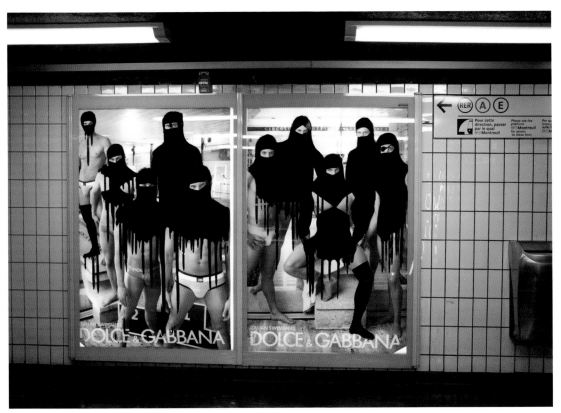

Artist: Princess Hijab – Metro Paris (France), 2009 –
Photographer: A. Breant

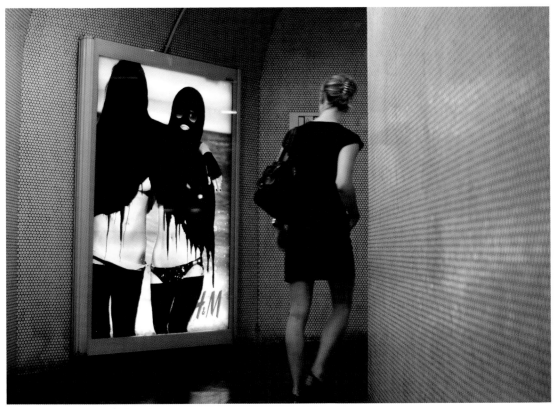

Artist: Princess Hijab – Metro Paris (France), 2010 –
Photographer: J. Caudan

"Freedoom" – Artist: East Eric – Acrylic paint +
fire extinguisher – Lyon (France), 2007

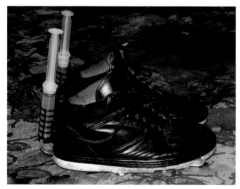

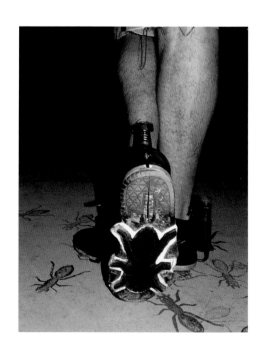

Inject print shoes (Independent printing system, reloadable) –
Artist: East Eric – 1999 to 2010, project in curse –
Photographer: Xandra

"Guantanamo (Remake)" – Artist: East Eric – Acrylic paint +
fire extinguisher – Barcelona (Spain), 2007

"Hell Is Pink" – Artist: East Eric – Acrylic paint + tuned fire extinguisher –
Cernay (France), 2008 – Photographer: Benoit Facchi

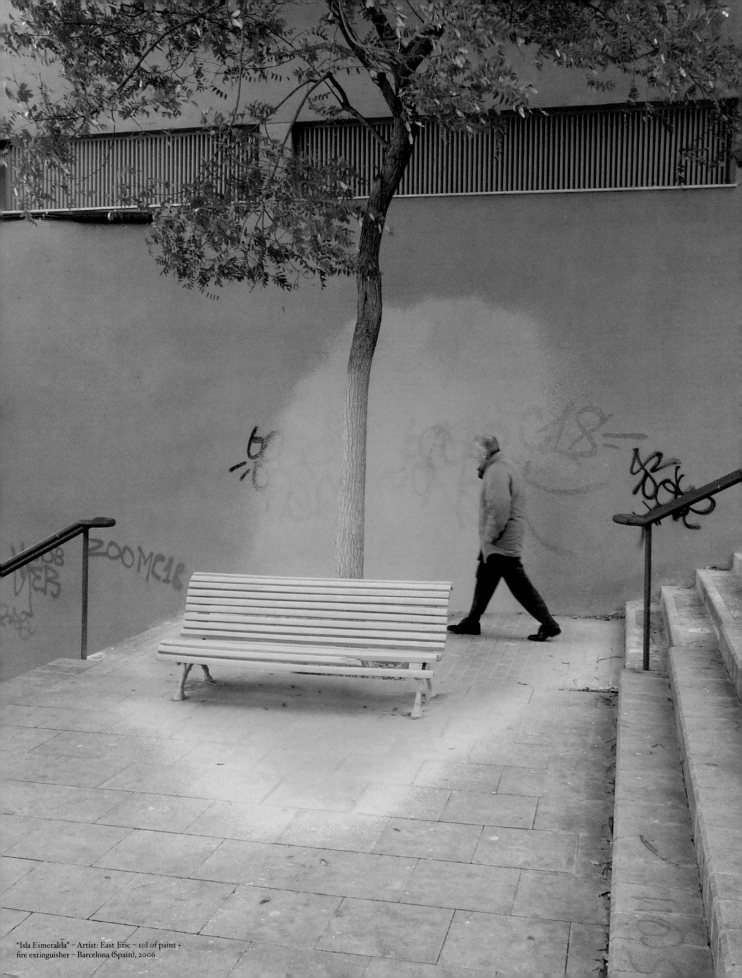

"Isla Esmeralda" – Artist: East Eric – 10l of paint +
fire extinguisher – Barcelona (Spain), 2006

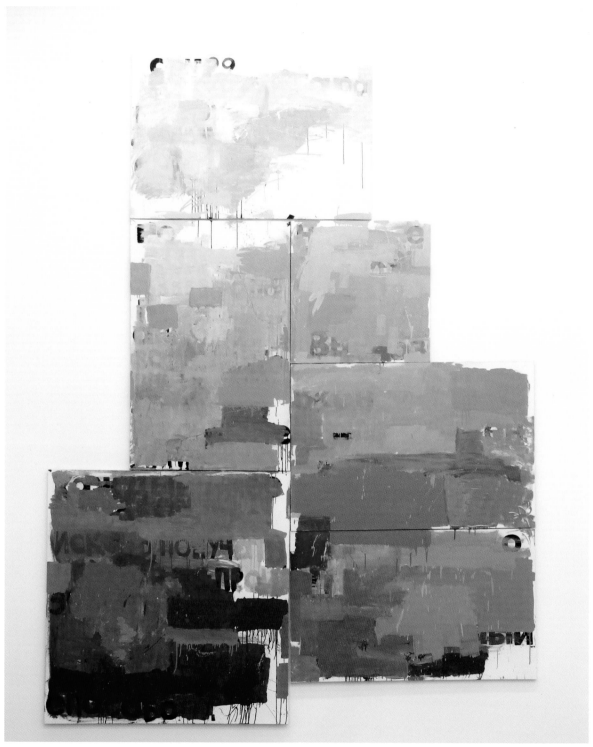

"Article #29" – Artist: Misha Most – Acrylic and enamel household paint,
350cm x 450 cm – Regina gallery, Moscow Winzavod Artcenter (Russia), 2009
Misha: "It is an article on freedom of speech, the spread and opinion and information
(it consists of several undertopics) which is often forgotten in our country unless it is
needed in the interests of the government. It is one of many articles of the constitution
which is roughly opressed by the government itself. It was for a collective exhibition in
Regina gallery in Moscow Winzavod Artcenter, the exhibition was named the "Conquered
City". The works depicted the oppressed citizen and things around him. So I wrote the
whole article 29 in black letters acrylic and then buffed it with a household paint, trying
to make something beautiful out of that mess at the same time."

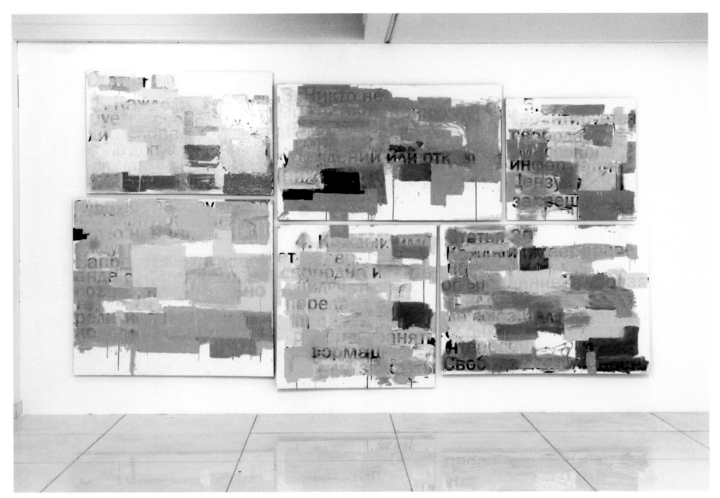

"Article 29, 30" – Artist: Misha Most – Acrylic and enamel
household paint, 300cm x 450cm – Samara city (Russia), 2009

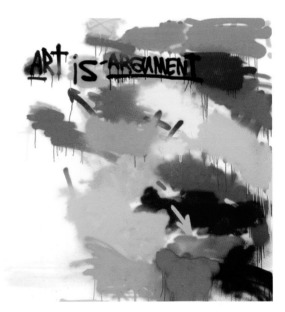

"Art Is ..." – Artist: Misha Most –
Spray paint, 150cm x 150 cm – Moscow (Russia), 2008
Misha: "From the series "Dialogues" (present at few
exhibitions), a series of works depicting struggle, problems,
arguments and the search of an answer, or truth, which
I tried to visualize. This work was just a depiction of
arguments around art and out of which comes a piece of
art. These works also reminisce my graffiti background as
I usually face misunderstandings from the authorities, which
in the same way overpaint my works. I had several projects
around that topic of overpainted paintings, but I also like
the visual aspect of it, a bit expressionistic."

Artist: Delta – Installation at NIMK , Amsterdam (The Netherlands), 2009

Artist: Delta – Papercollage at Boarding, Eindhoven (The Netherlands), 2008

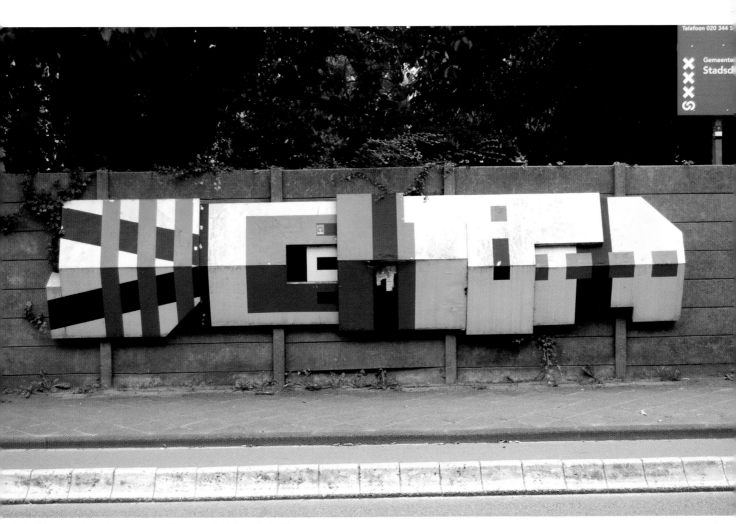

Artist: Delta – Street installation, wood and acrylics – Amsterdam (The Netherlands), 2007

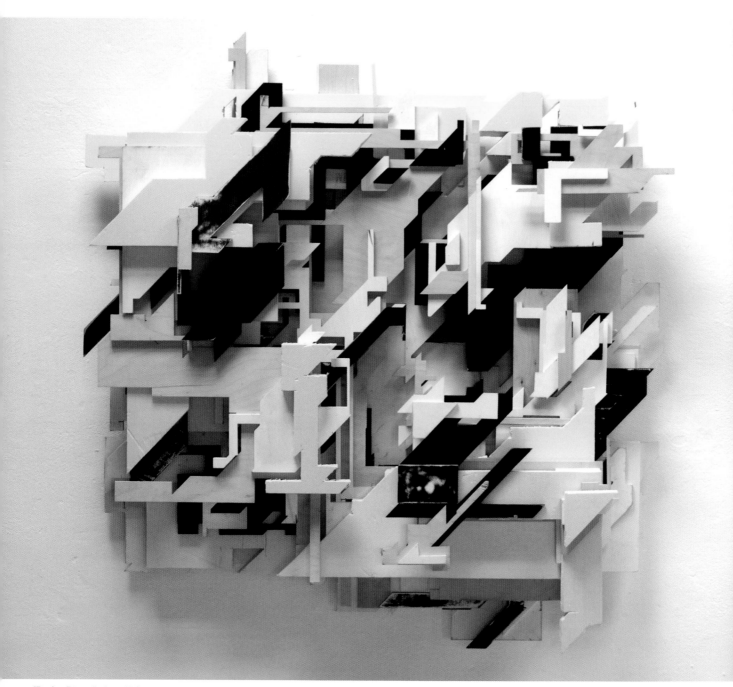

"Random Distress" – Artist: Delta – 130 x 130 x 40 cm,
styrofoam, wood, acrylics – Amsterdam (The Netherlands), 2010

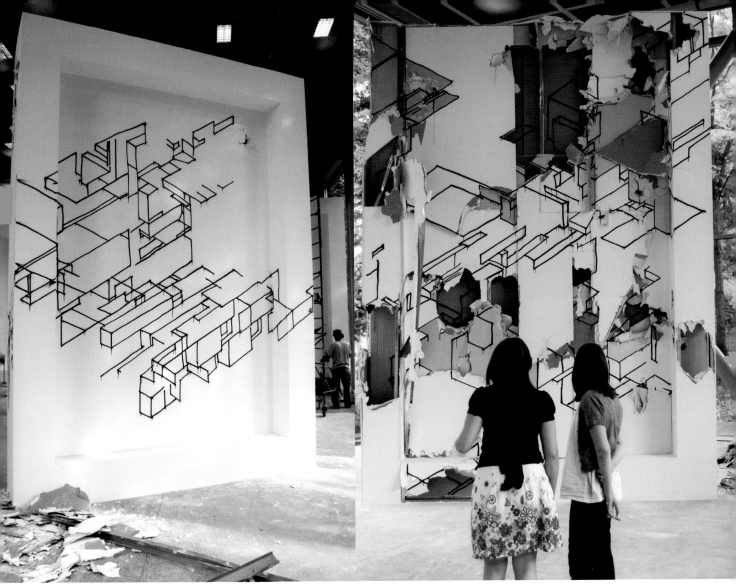

Artist: Delta – Installation at Fondation Cartier, Paris (France), 2009

Artist: Delta – Amsterdam (The Netherlands), 2009

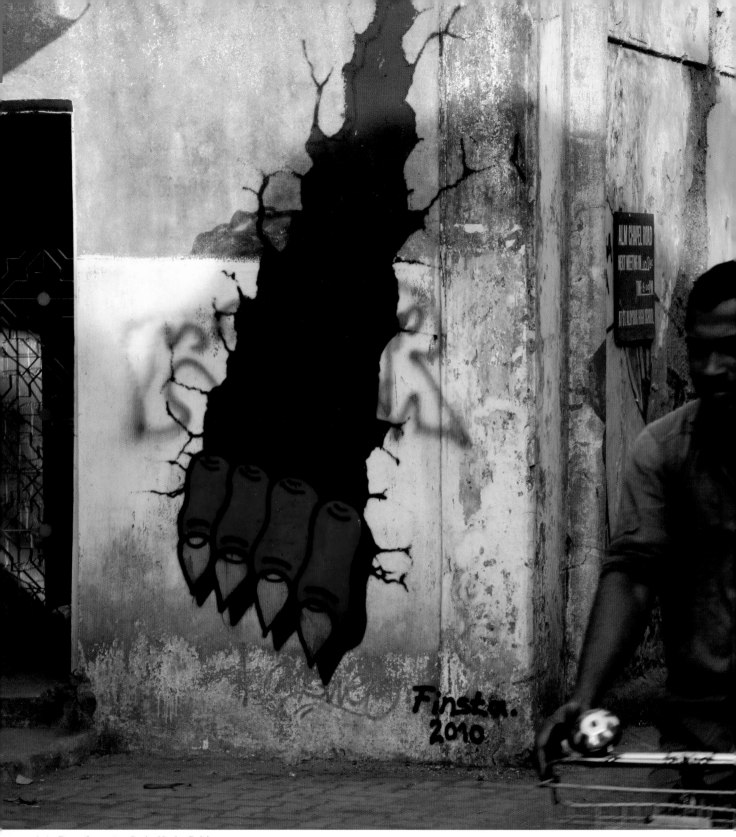

Artist: Finsta − Spray paint − Bandra, Mumbay (India), 2010

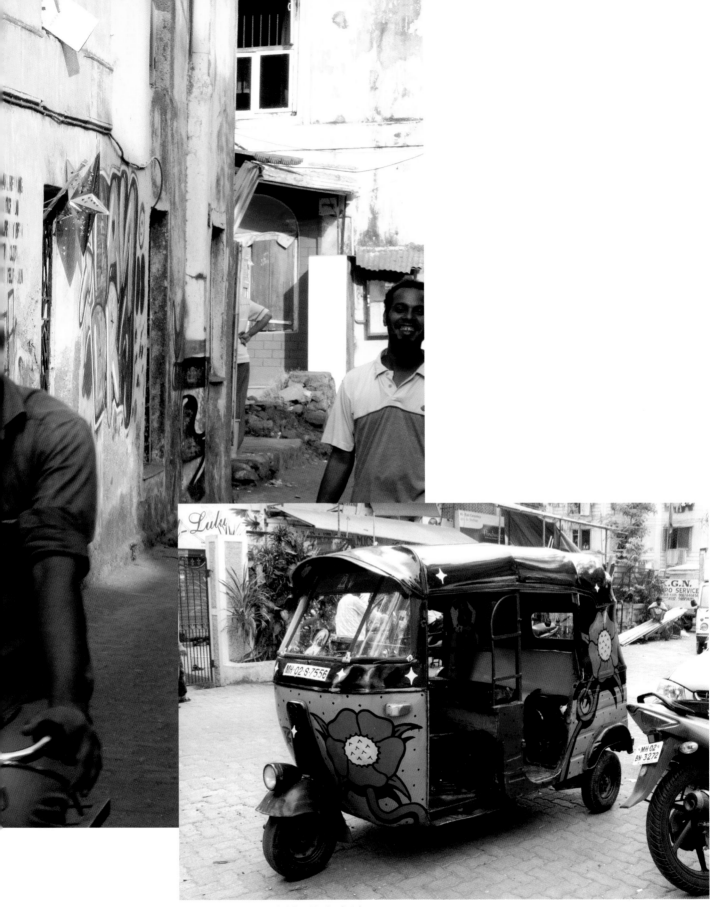

Artist: Finsta – Painted school riksha – Mumbay (India), 2010

Artist: Finsta – "Glossy Stuff" Exhibition at Gallery Steinsland Berliner – Stockholm (Sweden), 2010

Artist: Finsta – T-shirt print for Hurtyoubad – Sweden, 2010

Finsta working at home – Sweden, 2009 –
Photographer: Andreas Banton

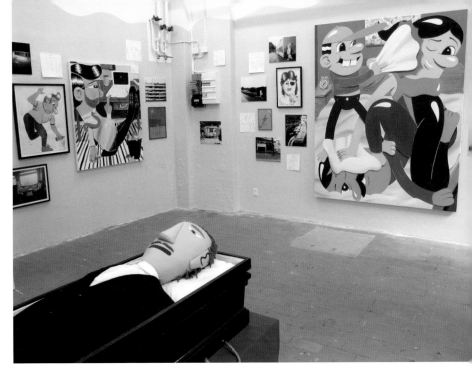

Artist: Husk Mit Navn – Copenhagen (Denmark), 2010

Artist: Husk Mit Navn – Copenhagen (Denmark), 2010

Artist: Husk Mit Navn – Copenhagen (Denmark), 2010

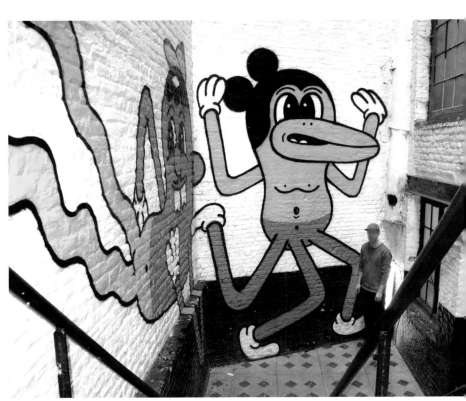

Artist: Husk Mit Navn – Copenhagen (Denmark), 2010

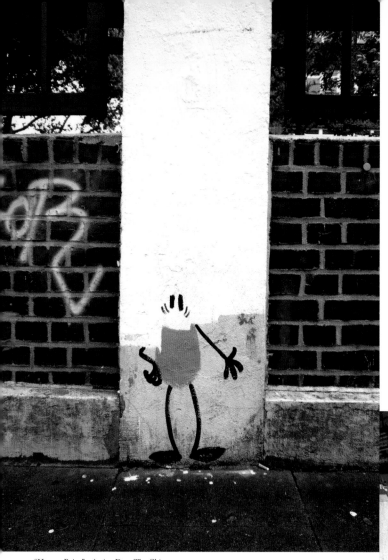

"Human Beins" – Artist: Dave The Chimp –
Hamburg (Germany), 2009
Dave: "On moving to Berlin from London, I was faced with
a different street art environment to the one I was used to
working in. Add to this my inability to speak German well
enough to talk my way out of trouble with cops, and a new
way of working had to be developed. The Human Bein's were
born out of this challenge – characters that were small enough
to move in and out of the huge letter pieces dominating
the Berlin streets, and easy enough to be painted quickly to
prevent being caught in the act. They also became friends,
reminding me of the comfort of eating a plate of baked beans
on toast in the Astro Star cafe on Bethnal Green Road, and act
as a balance to the growing number of street artists making in-
creasingly giant pieces. The selection shown here were painted
in Hamburg, summer 2009."

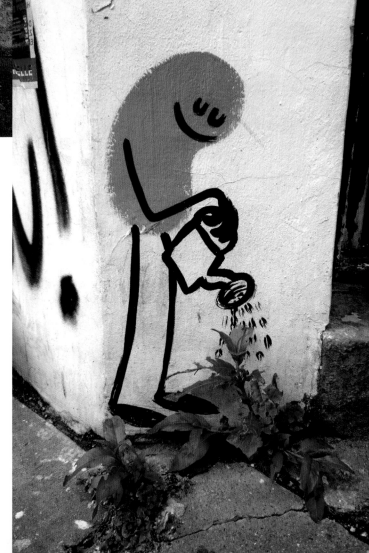

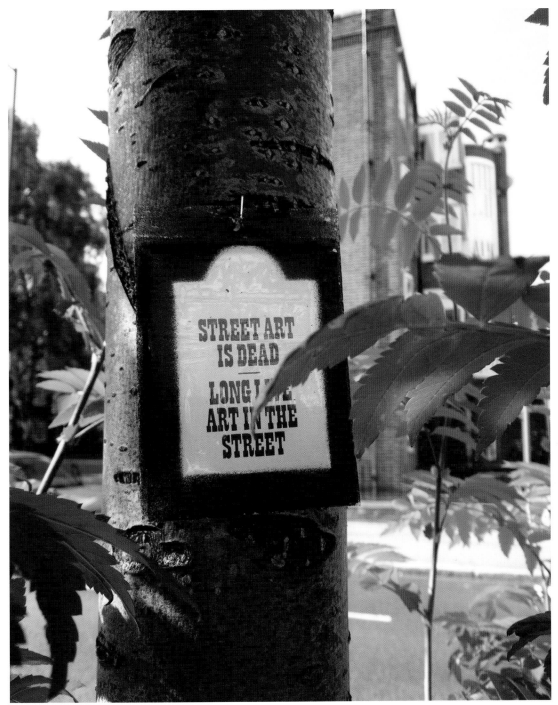

"Street Art Is Dead, Long Live Art In The Streets" –
Artist: Dave The Chimp – London (United Kingdom), 2008
Dave: "A comment on how I felt there was little "art" involved in the «street art»
scene. On finding 75 zip-lock plastic bags in a cupboard at my day job, I decided
to make small packs of fanzines and lino prints to be left in the street as a way
of distributing art to the people, rather than advertising myself. Three different
zines were made - "Learn To Draw, Forget It All", a collection of abstract doodles,
"Rejoice! You 're Not Dead Yet", random newspaper cuttings and drawings, and
"After Party With J&C", photos, drawings and text from a night spent with two
crazy women. I also made four different two-colour lino prints, each in an edition
of 25, signed and numbered. Each plastic bag contained two zines and one lino
print, and was stenciled with a tomb stone bearing the words "Street Art Is Dead,
Long Live Art In The Streets". Distributed in the streets of East London, summer
2008."

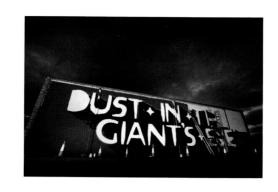

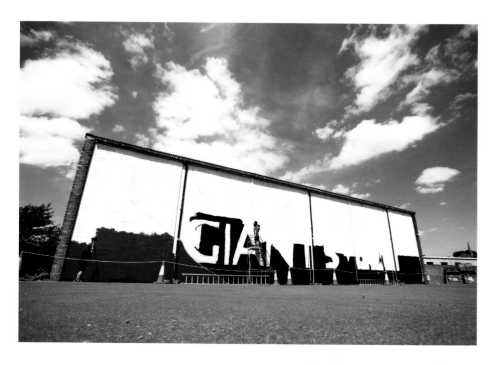

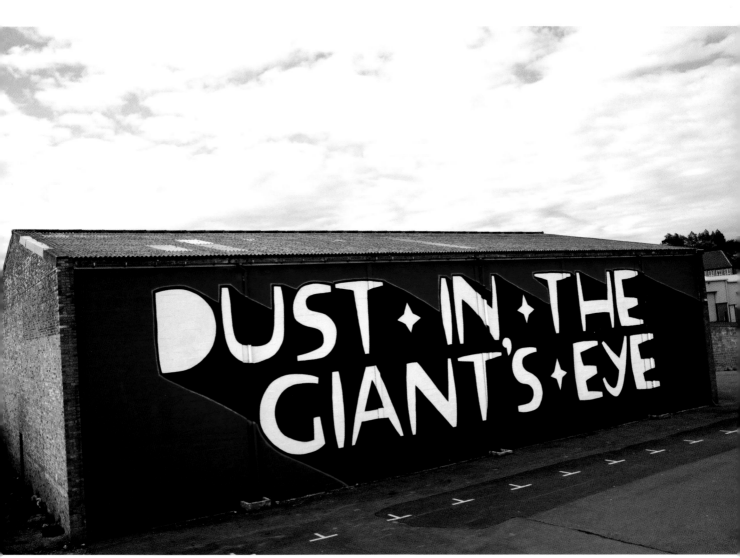

"Dust In The Giant's Eye" – Artist: Kid Acne – Spray paint, masonry paint and household gloss on concrete – Newcastle (United Kingdom), 2010

Kid Acne: "I started painting slogans a few years ago after I realized I was filling the back of my sketchbooks with more notes and phrases than I was drawing pictures in the front of them. Initially, these were meant as a reminder for lyrics and song titles or what have you, but as the list grew, I felt the need to paint them in the street.

At first, I added my characters to either side of the text, bookending the piece in the classic graffiti composition, but the faces seemed to distract from the sentiment, rather than compliment it – so I dropped the characters and set about painting a series of large scale blockbusters using household gloss, masonry paint and spray paint.

The first text-only piece I did read "You'll Miss Me When I'm Gone", which I painted on the roof of my old art college before it was controversially knocked down. The majority of the slogans are painted in black and white with a solid colour background and 2nd outline around the letters. I was going to switch up the colour scheme some more, but a friend kindly pointed out "black and white has been historically proven to have impact" so I stuck with it and think it works best."

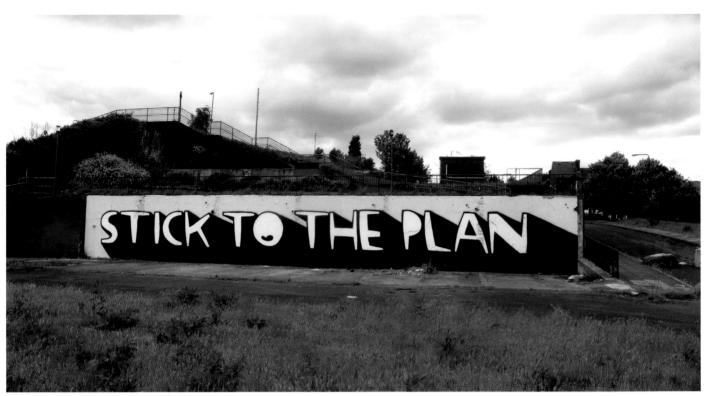

"Stick To The Plan" – Artist: Kid Acne – Spray paint, masonry paint and household gloss on concrete – Sheffield (United Kingdom), 2010

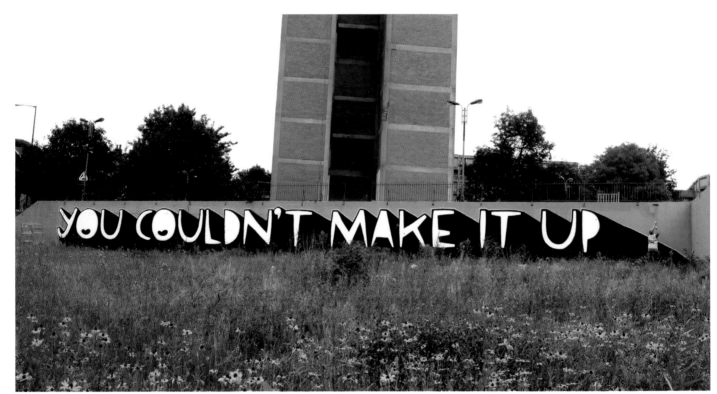

"You Couldn't Make It Up" – Artist: Kid Acne – Spray paint, masonry paint and household gloss on concrete – Sheffield (United Kingdom), 2009

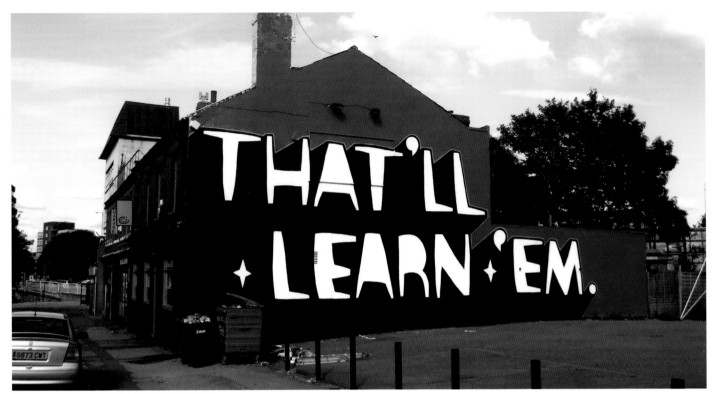

"That'll Learn Them" – Artist: Kid Acne – Spray paint, masonry paint and
household gloss on concrete – Sheffield (United Kingdom), 2009

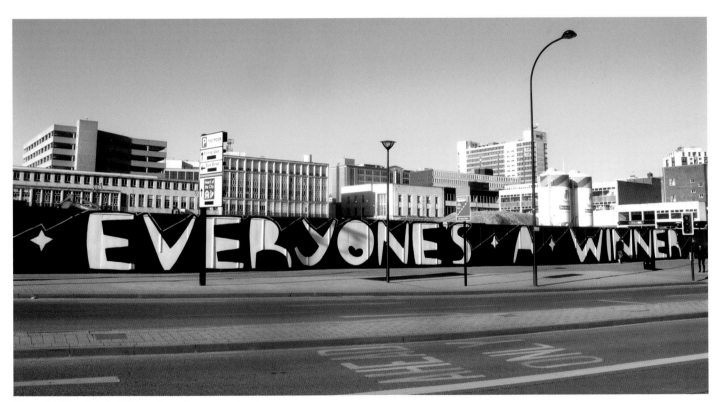

"Everyone's A Winner" – Artist: Kid Acne – Spray paint, masonry paint and
household gloss on wood – Sheffield (United Kingdom), 2009

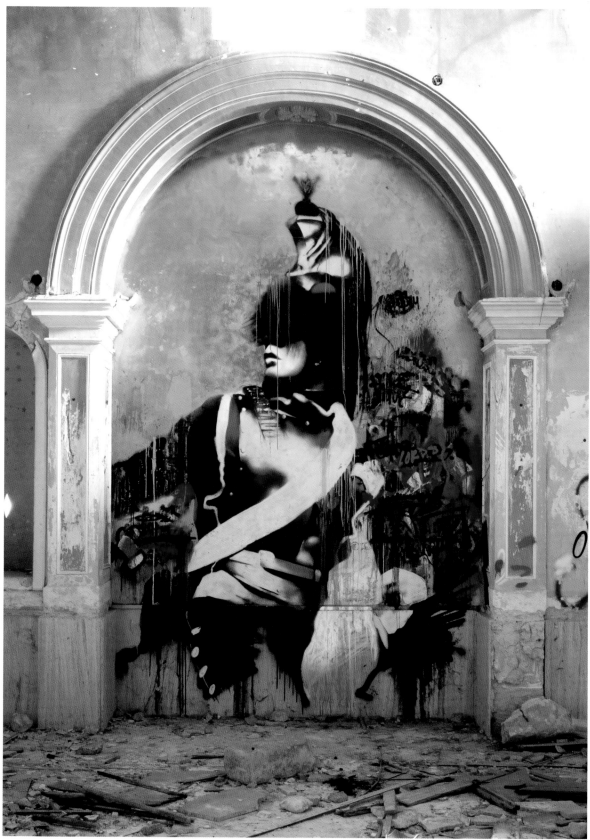

Artist: Conor Harrington − Spray paint, acrylic paint −
Grottagle (Italy), 2008 −
Photographer: Ciro Quarantat

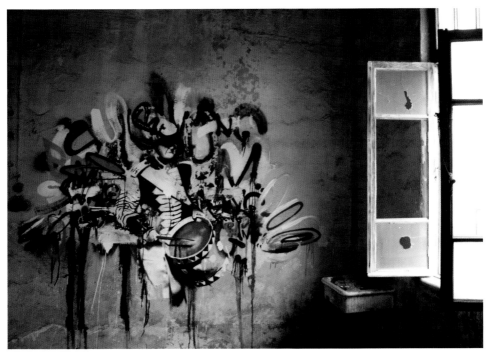

Artist: Conor Harrington – Spray paint, acrylic paint –
Tel Aviv (Israel), 2010 –
Photographer: Andy Telling

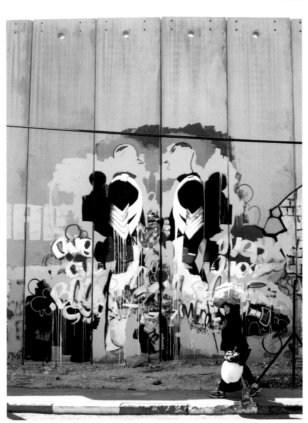

Artist: Conor Harrington – Spray paint, acrylic paint –
Bethlehem (Palestine), 2010 –
Photographer: Andy Telling

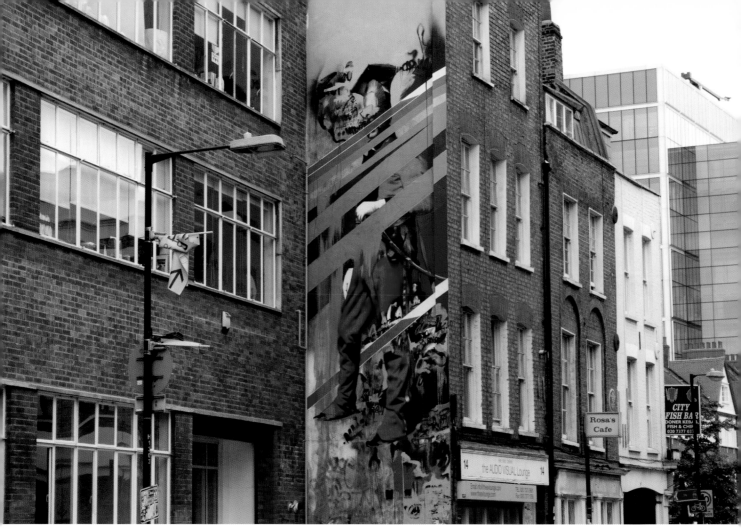

Artist: Conor Harrington – Spray paint, acrylic paint –
London (United Kingdom), 2010

Artist: Conor Harrington – Spray paint, acrylic paint –
Grottagle (Italy), 2008

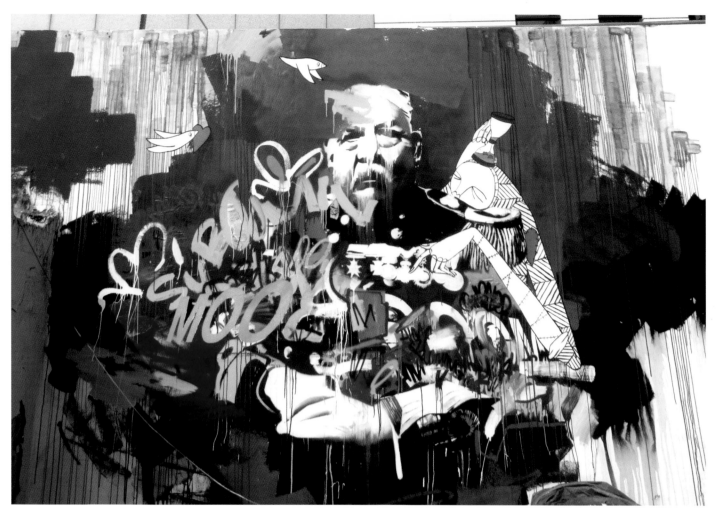

Artist: Conor Harrington – Spray paint, acrylic paint –
Tel Aviv (Israel), 2010 –
Photographer: Andy Telling

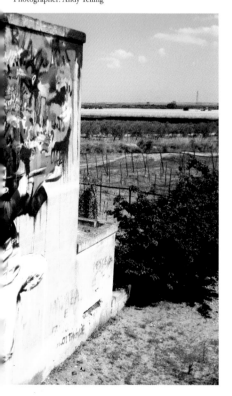

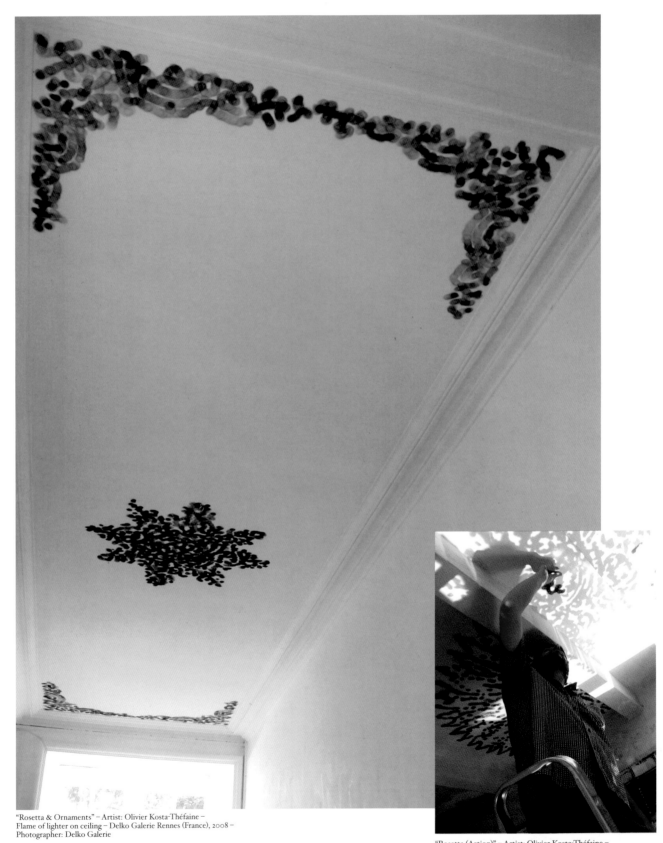

"Rosetta & Ornaments" – Artist: Olivier Kosta-Théfaine –
Flame of lighter on ceiling – Delko Galerie Rennes (France), 2008 –
Photographer: Delko Galerie

"Rosetta (Action)" – Artist: Olivier Kosta-Théfaine –
Flame of lighter on ceiling – Trafacka, Praha (Czech Republic), 2008 –
Photographer: Dimitry Oskes

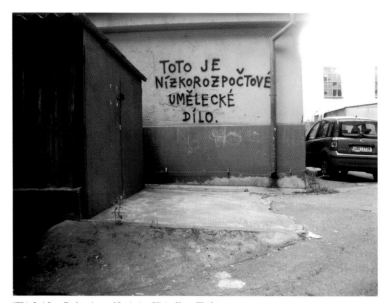

"This Is A Low Budget Artwork" – Artist: Olivier Kosta-Théfaine –
Spray paint on wall – Praha (Czech Republic), 2008

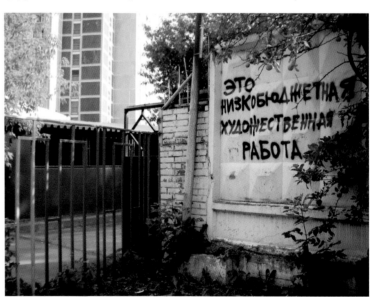

"This Is A Low Budget Artwork" – Artist: Olivier Kosta-Théfaine –
Spray paint on wall – Moscow (Russia), 2007

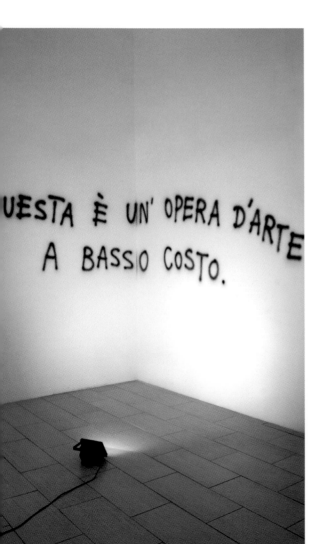

"This Is A Low Budget Artwork" – Artist: Olivier Kosta-Théfaine –
Spraypaint on wall – Torino (Italy), 2009 – Photographer: Cripta747

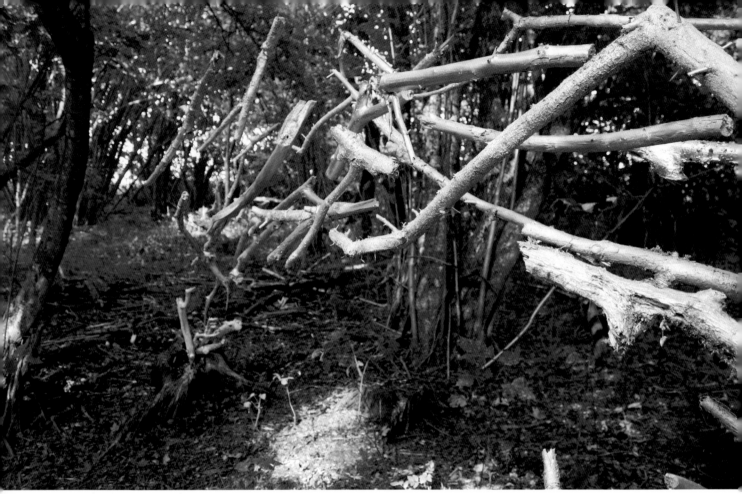

"Pressure" – Artist: Sat One – Spray paint – Munich (Germany), 2010
Info: Usually a spray stream encounters concrete or steel, here it experiences resistance through a grove. Silver particles hit the organic surface, room can be experienced. The searching for "wall" is picked out as a central theme. A pending, surreal situation. A symbol for spraying as such. The expansion of the playground. A metamorphose.

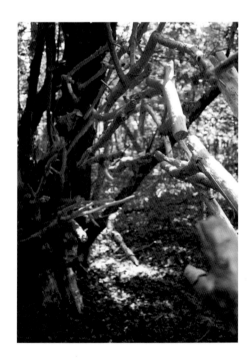

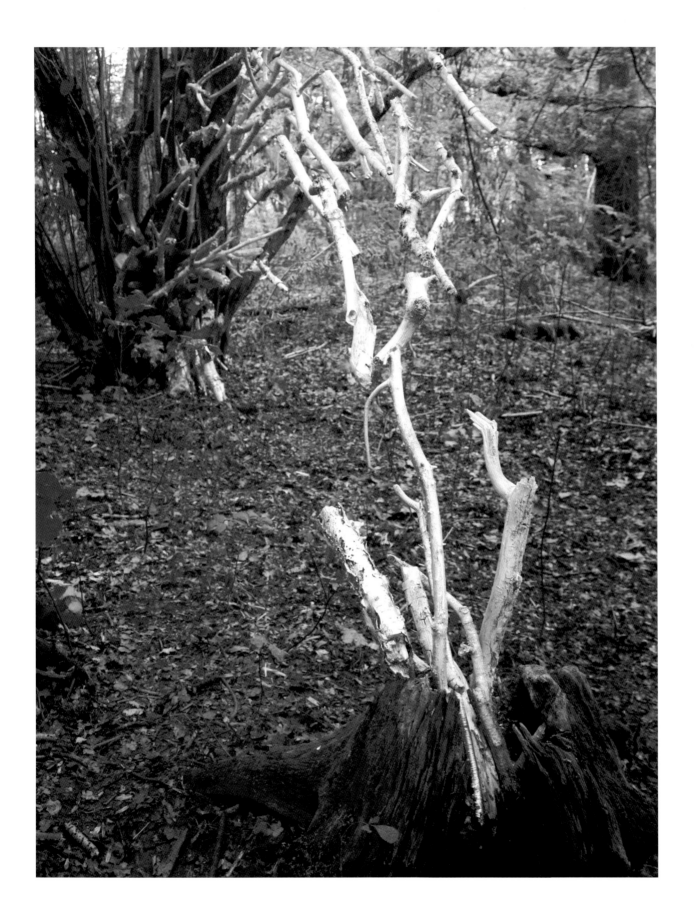

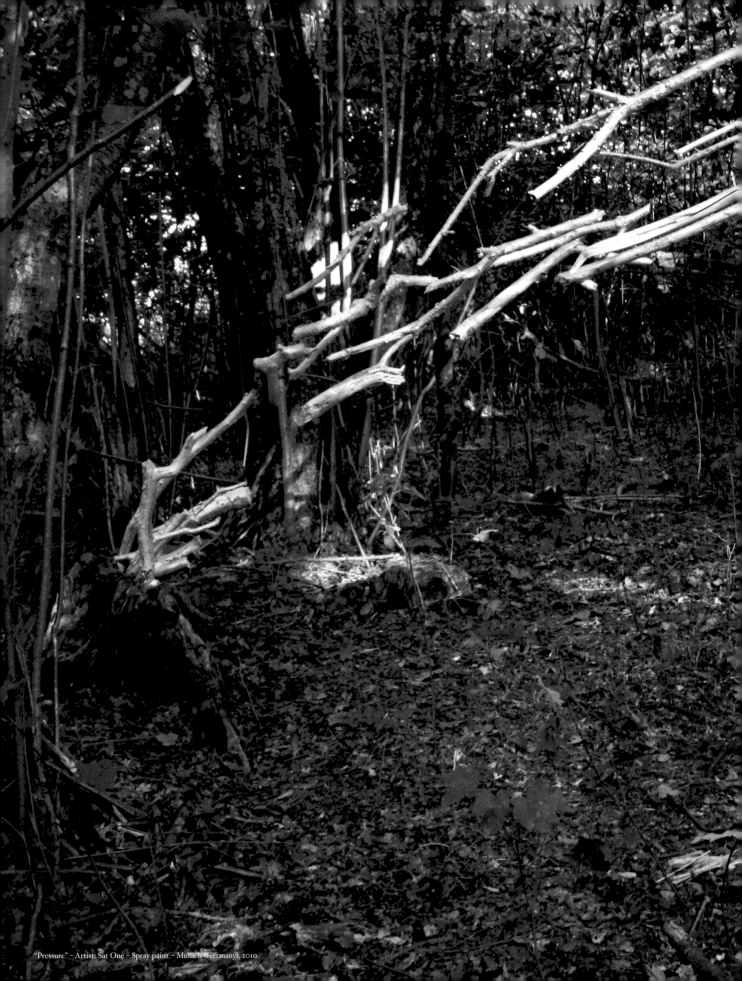

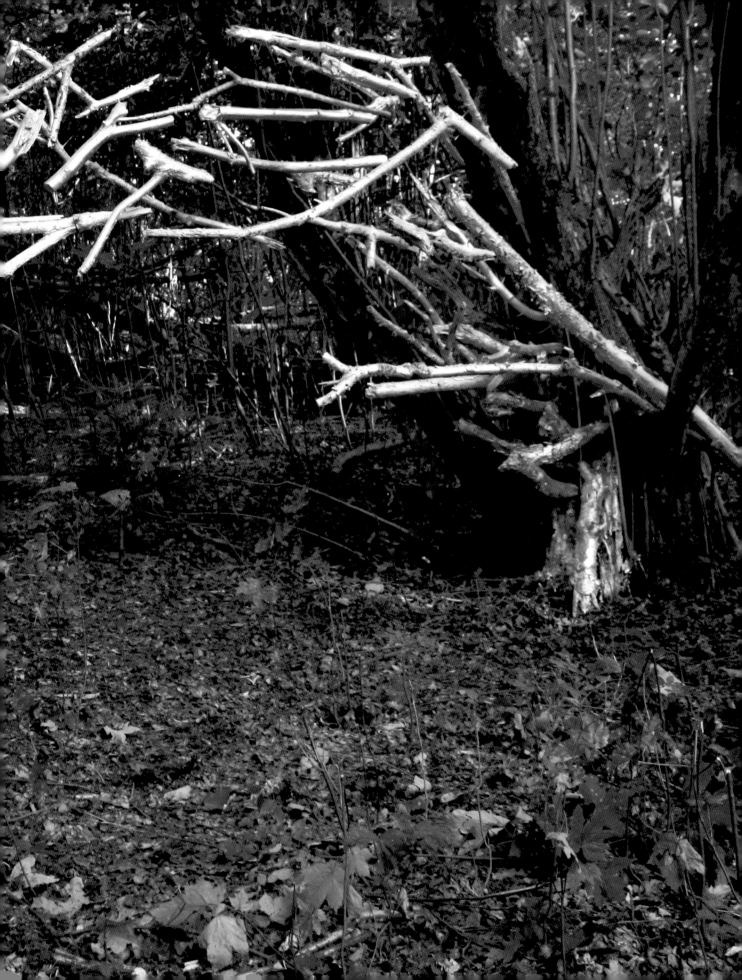

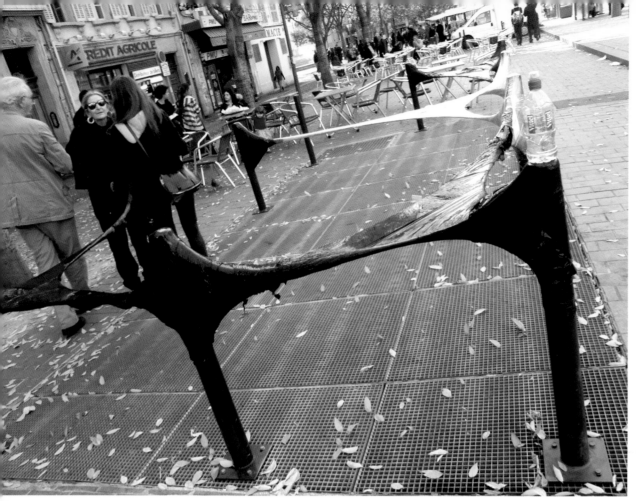

Artist: Cedric Bernadotte – Toulon (France), 2003

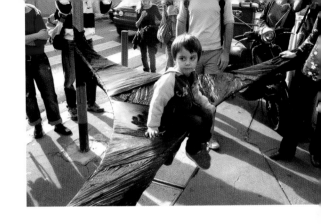

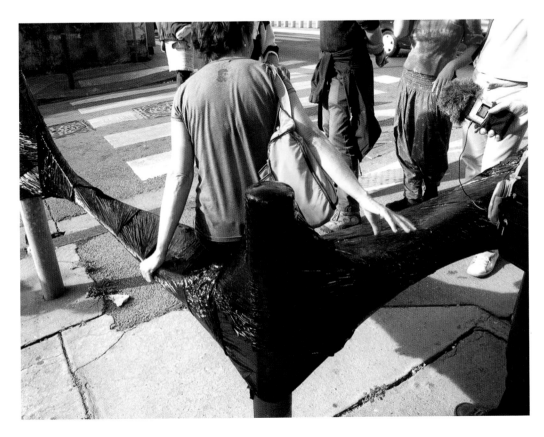

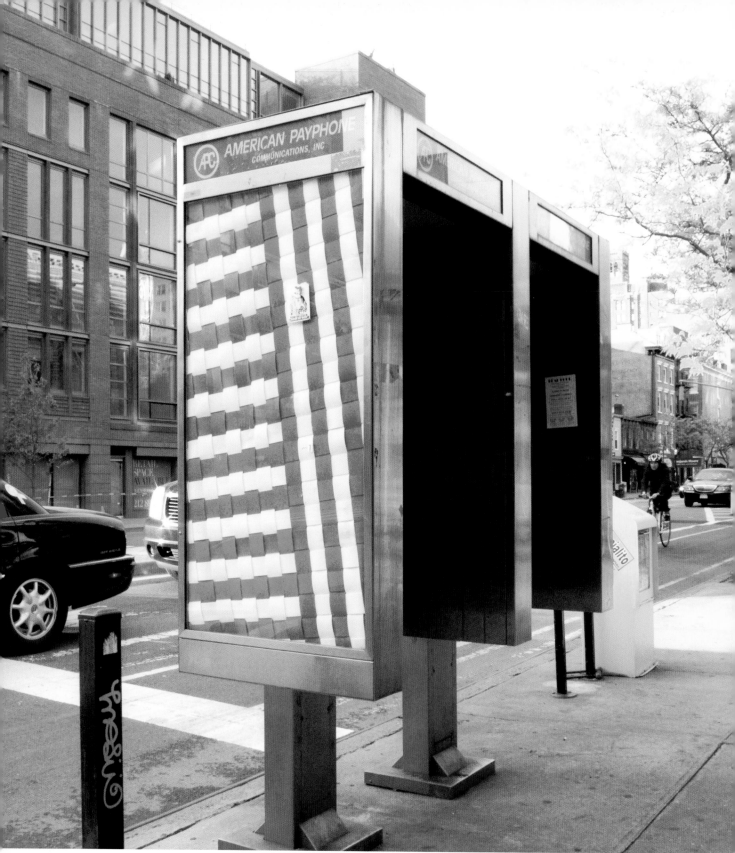

"American Flag" – Artist: Jordan Seiler – New York (USA), 2010

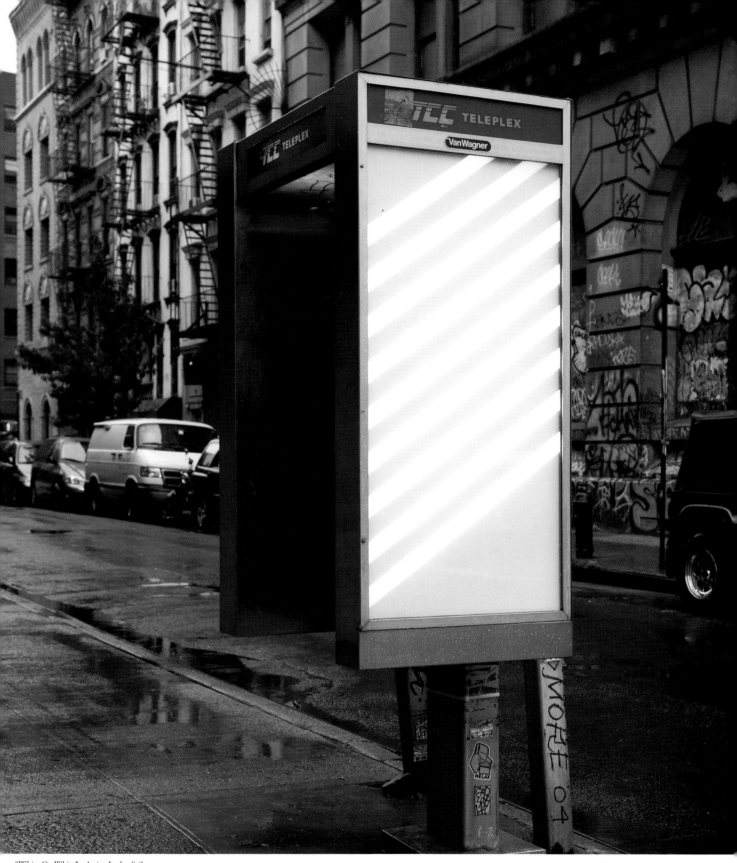

"White On White" – Artist: Jordan Seiler –
Borrowed plexi, white enamel paint – New York (USA), 2008
Info: This project is done by removing the semi opaque plexi glass in NYC phone
booths used to diffuse the light which illuminates the normal advertising content.
Once removed, the plexi is painted with white enamel so that during the day
the image is invisible and by night it glows with an unexpected graphic intensity.
Because one must remove the plexi inside the phone booth to install each piece, the
project continues indefinitely as each installation yields a new surface to work on.

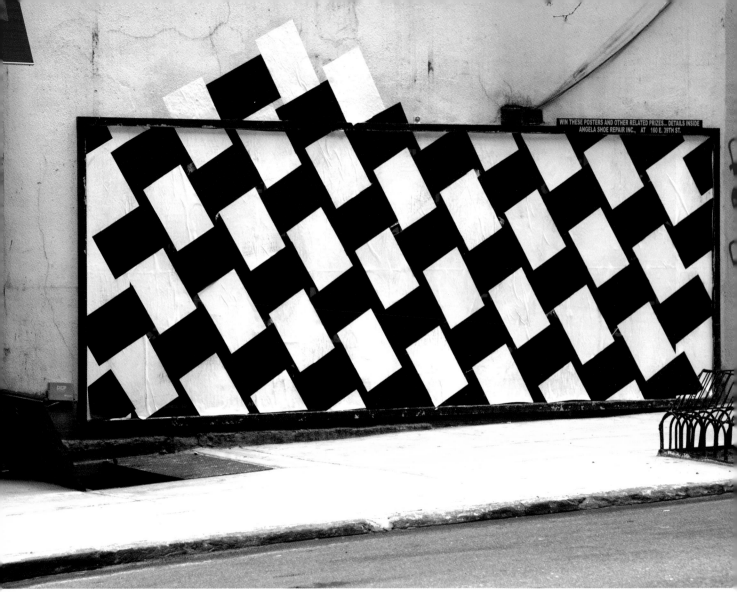

"Weave it!" – Artist: Jordan Seiler – Paper – New York (USA), 2010
Info: The Weave it! project illegally appropriates NPA
City Outdoor advertising locations across NYC

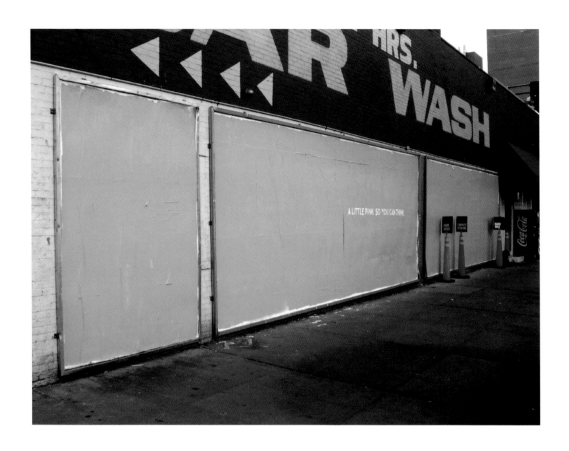

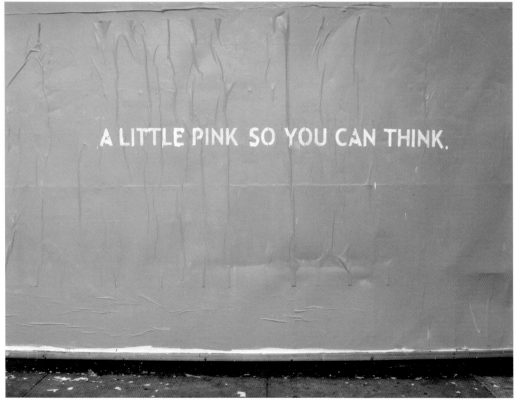

"A Little Pink So You Can Think" – Artists: Jordan Seiler & Posterboy –
Paper – New York (USA), 2010

Artist: Posterboy – New York (USA), 2009
Info: These pieces were created from vinyl advertisements located in the subways of New York City. The ads have their own adhesive making it easy to create collages with nothing more than a razor. They're made in minutes with little or no planning. The outcome depends only on my mood and what posters are available.

Before

Artist: Posterboy – New York (USA), 2009

Artist: Posterboy – New York (USA), 2010

Artist: Posterboy – New York (USA), 2009

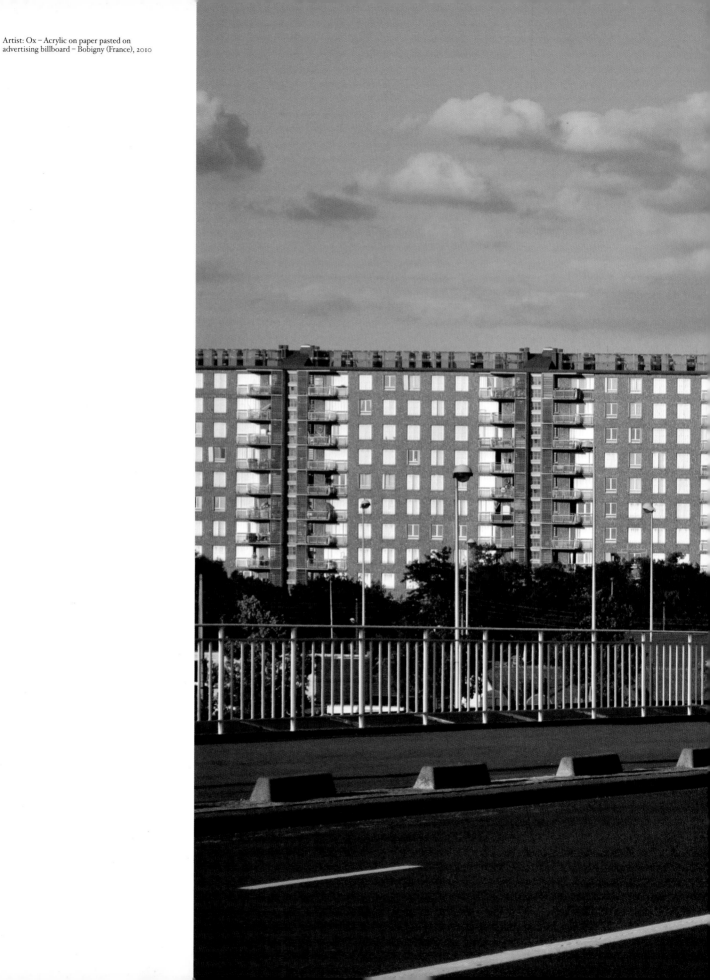

Artist: Ox – Acrylic on paper pasted on
advertising billboard – Bobigny (France), 2010

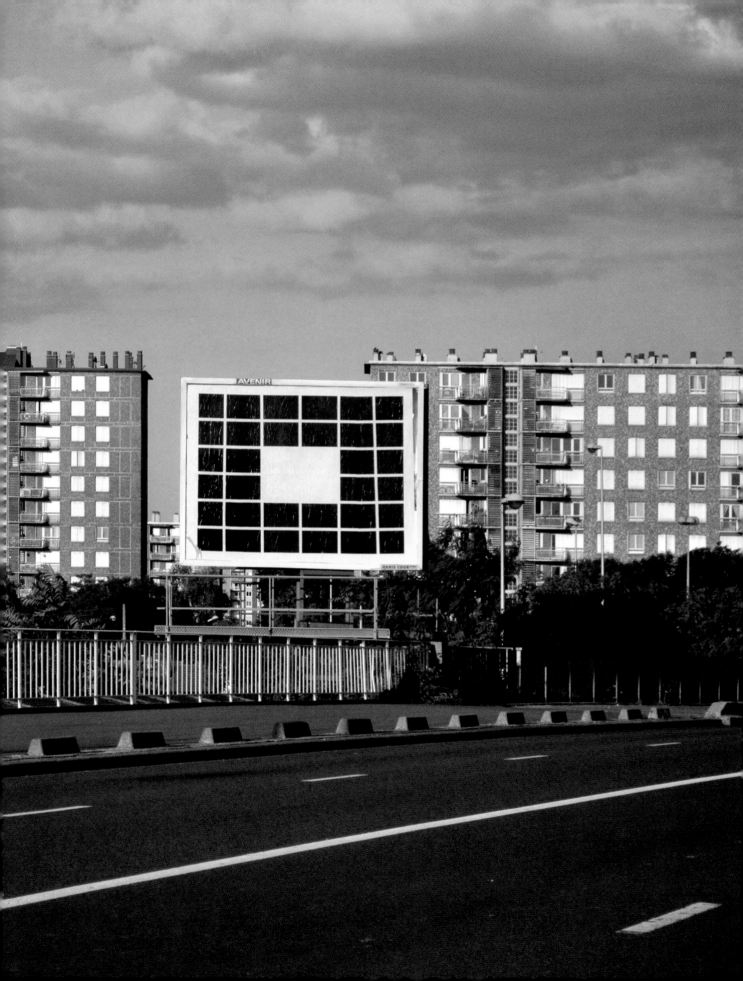

Artist: Ox – Acrylic on paper pasted on advertising billboard –
New York (USA), 2010

Artist: Ox – Acrylic on paper pasted on advertising billboard –
Paris (France), 2006 –
Photographer: Sylvie Pohin

Artist: Ox – Acrylic on paper pasted on advertising billboard –
Paris (France), 2009

Artist: Ox – Acrylic on paper pasted on advertising billboard –
Noisy Le Sec (France), 2010

"Free As A Bird" – Artist: Leon Reid –
Commissioned by CMS Atelier – Jefferson City (USA), 2008

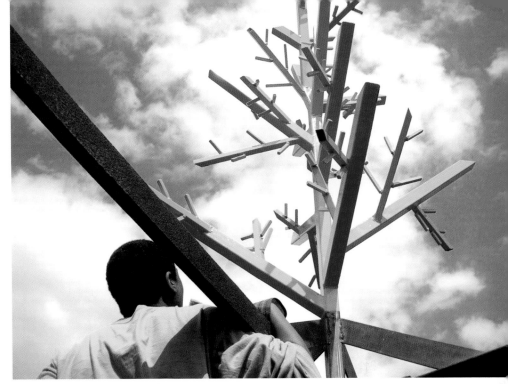

"The Braddock Blossom" – Artist: Leon Reid –
Commissioned by Braddock Redux – Braddock (USA), 2008

"Love Is A Two Way Street" – Artist: Leon Reid –
Commissioned by S.E.S.C. – Sao Paulo (Brazil), 2007

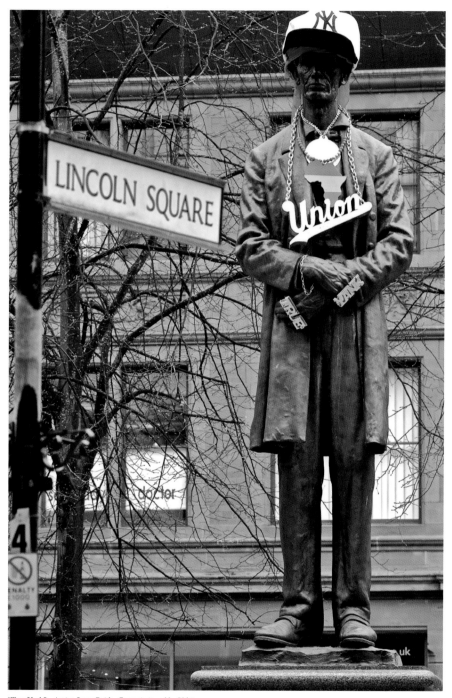

"True Yank" – Artist: Leon Reid – Commissioned by Urbi –
Manchester (United Kingdom), 2009 –
Photographer: Ian Williams

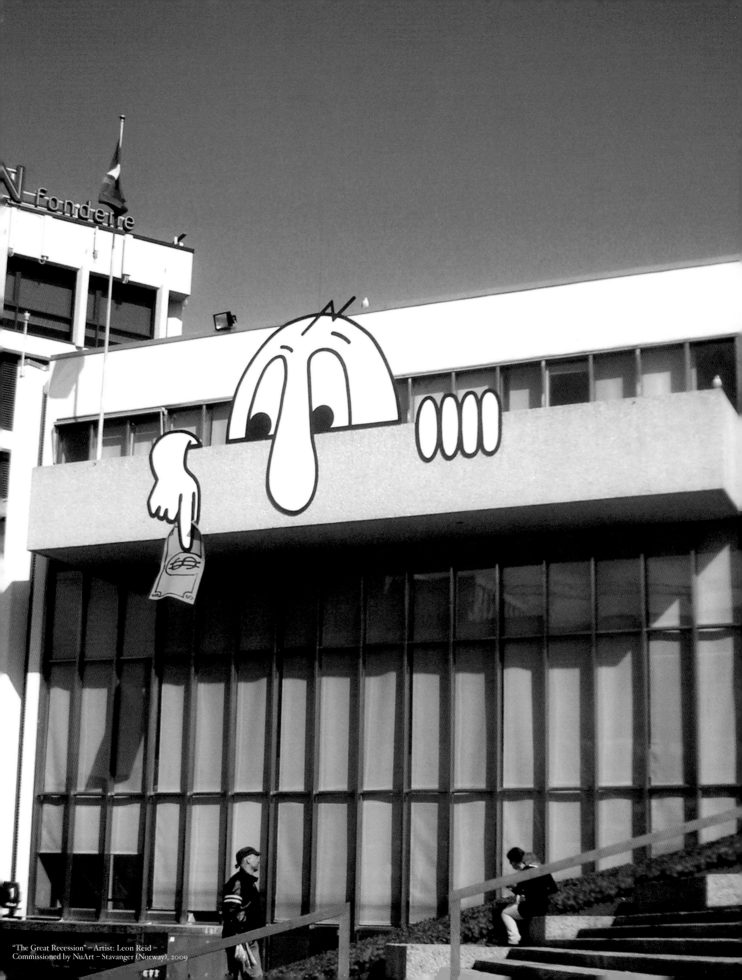

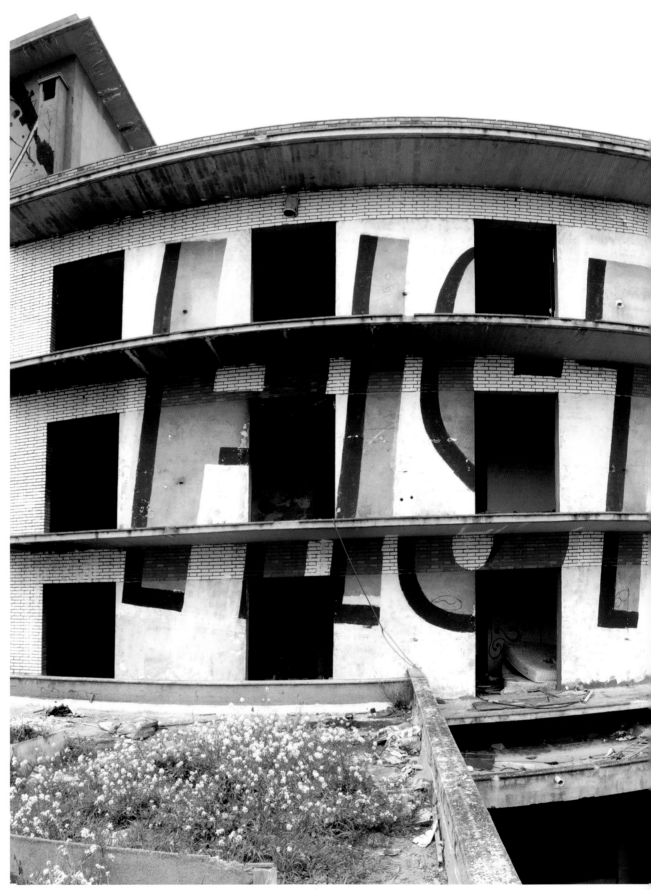

"Historic" – Artist: Ripo – Latex on wall – Barcelona (Spain), 2010

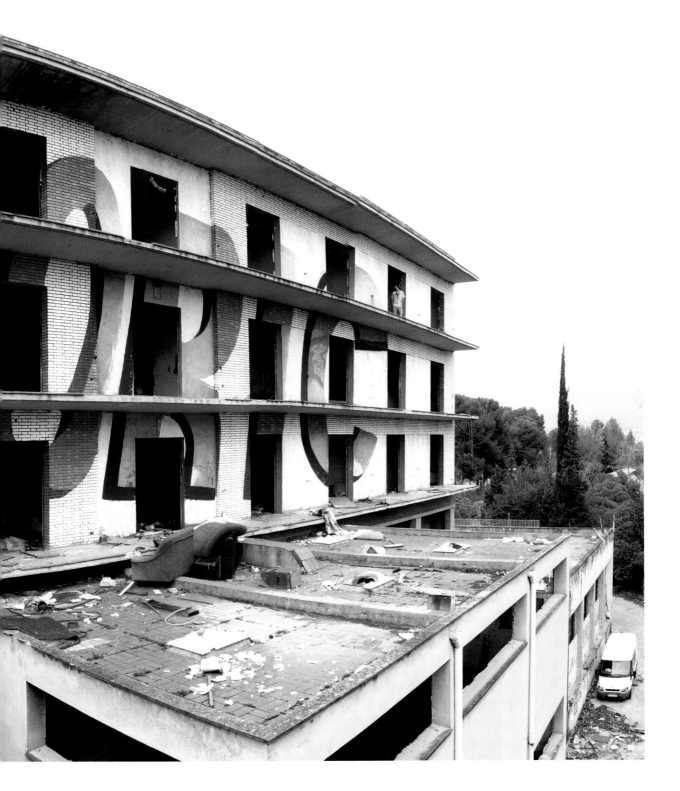

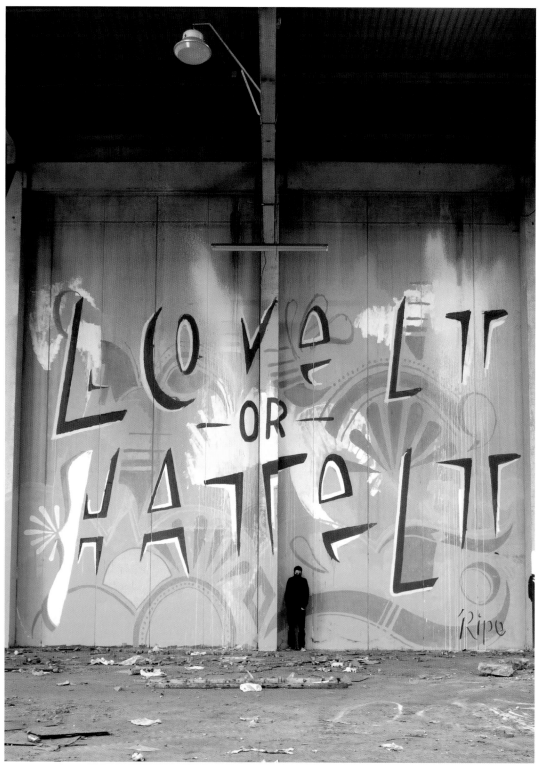

"Love It Or Hate It" – Artist: Ripo – Latex on wall – Barcelona (Spain), 2010

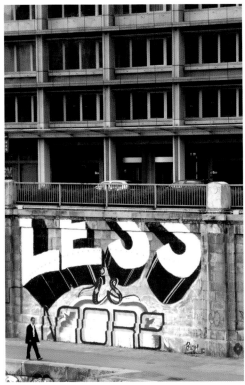

"Less Is More" – Artist: Ripo –
Latex on wall – Vienna (Austria), 2008

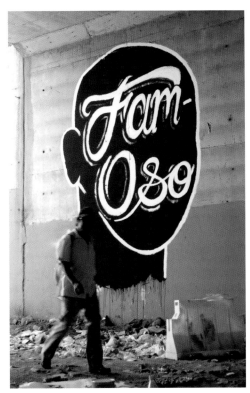

"Famoso" – Artist: Ripo –
Latex on wall – Santiago Chile (Chile), 2008

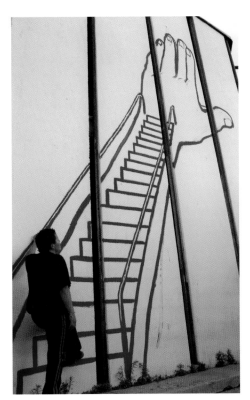

"Arm With Stairs" – Artist: Ripo –
Latex on wall – Inside the Santa Marta
Women 's Prison in Mexico City (Mexico), 2008

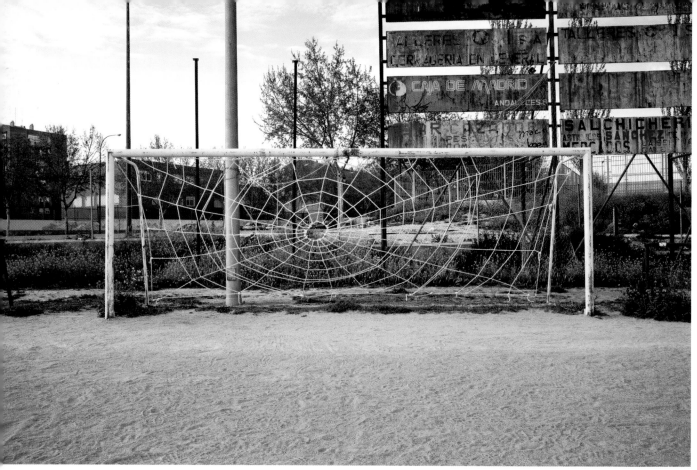

Artist: Spy – Nylon rope – Madrid (Spain), 2009

Artist: Spy – Beach balls and nylon rope – Madrid (Spain), 2009

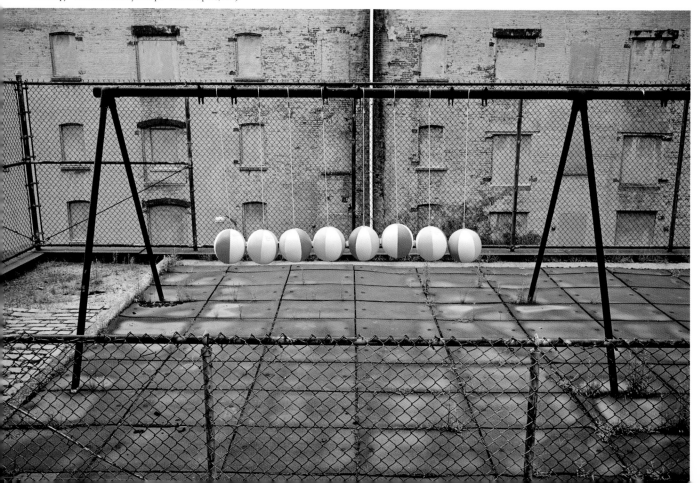

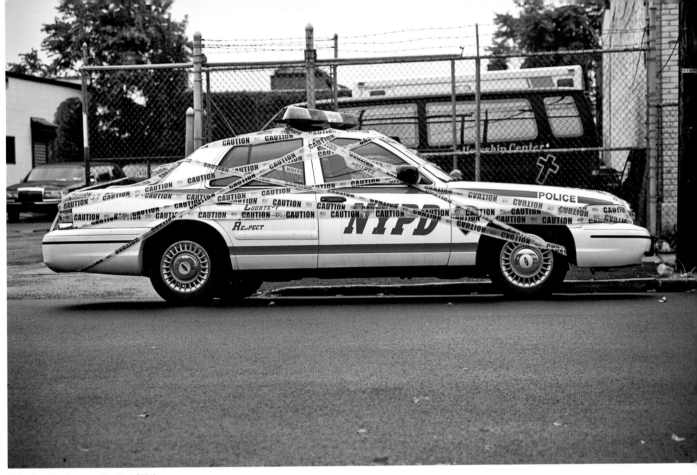

Artist: Spy – Caution tape – New York (USA), 2009

Artist: Spy – White tape – Madrid (Spain), 2009

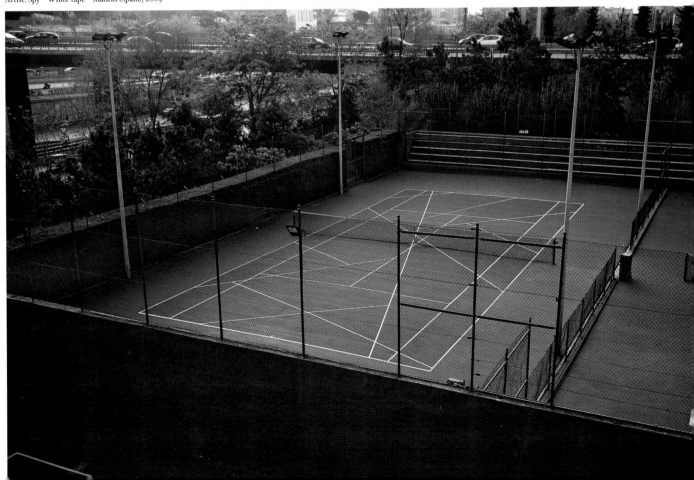

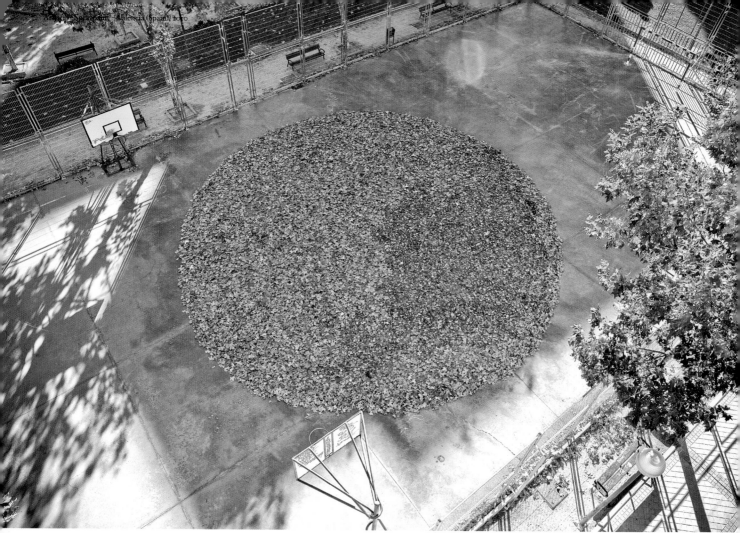

Artist: Spy – Cluster of leaves with a broom – Madrid (Spain), 2009

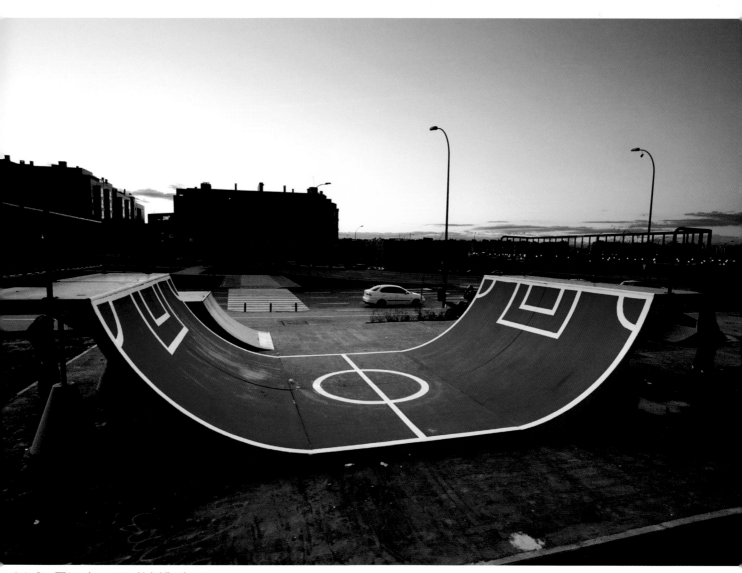

Artist: Spy – White and green paint – Madrid (Spain), 2006

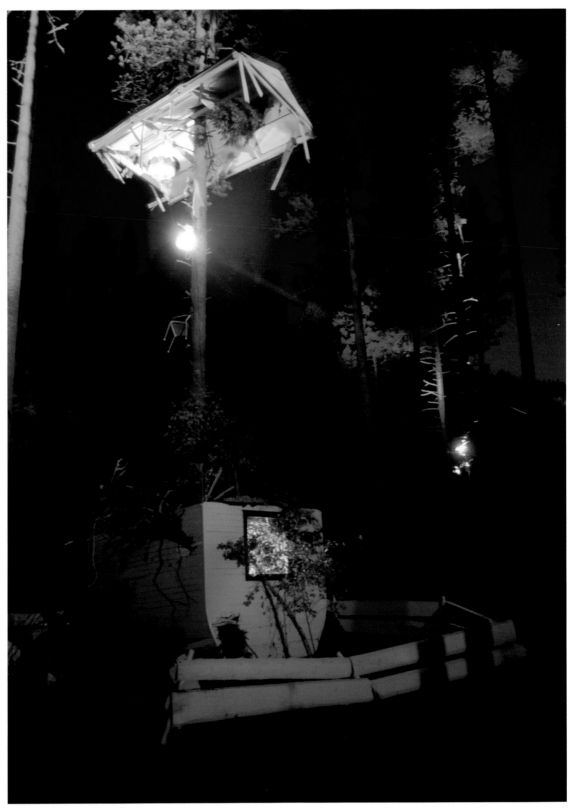

"Bi-Product Of the Process" – Artists: Brad Downey and Erik Tidemann –
Info: Pine tree missles, trees growing really fast, all to destroy one mans house –
Trondheim (Norway), 2009 – Photographer: Thomas Sorgaard

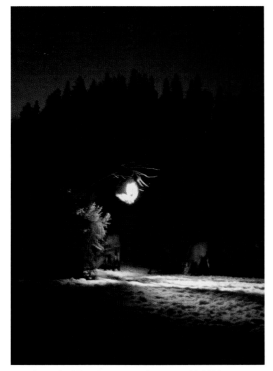

"Decadent Redneck Series" – Artists: Brad Downey and Erik Tidemann –
Info: Two camouflage half deer men soldiers disguised as a giant shrub go on
a military operation to deliver a glowing fur orb to the darkness of the Nor-
wegian wood – Guerilla-Deer, Wing-Man, Digital Video Stills – Trondheim
(Norway), 2010 – Photographer: Thomas Sorgaard

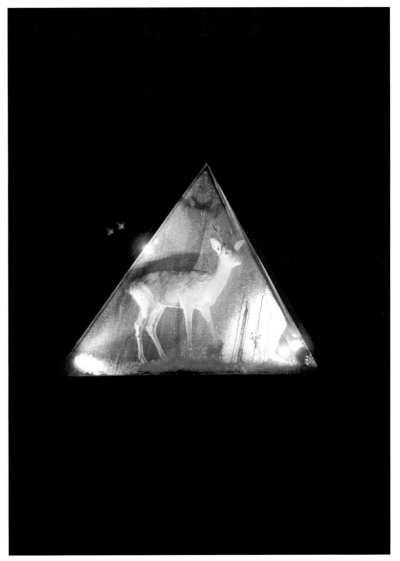

"General 51, The Star Destroyer" – Artists: Brad Downey and Erik Tidemann –
Info: One of the Generals that is leading the battle that will eventually
destroy man – Shaved Taxidermy, Plexiglas, Wood – Trondheim (Norway), 2010

"General 51, The Star Destroyer" – Artists: Brad Downey and Erik Tidemann –
Shaved Taxidermy, Plexiglas, Wood – Trondheim (Norway), 2010

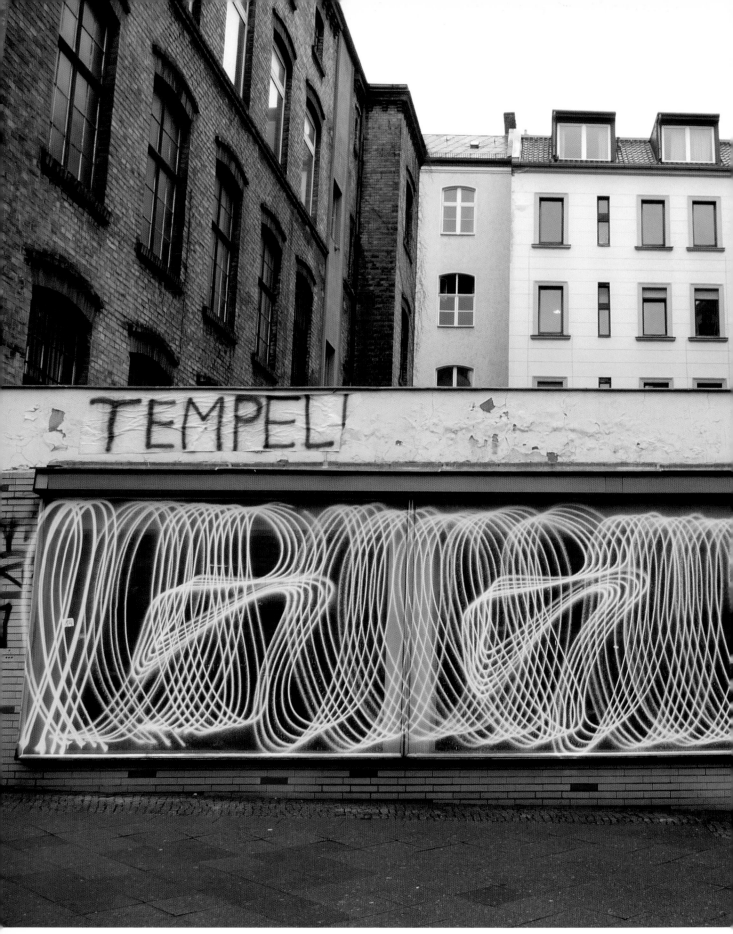

"The Gadget" Artist: Dtagno – Spray paint –
Berlin (Germany), 2008

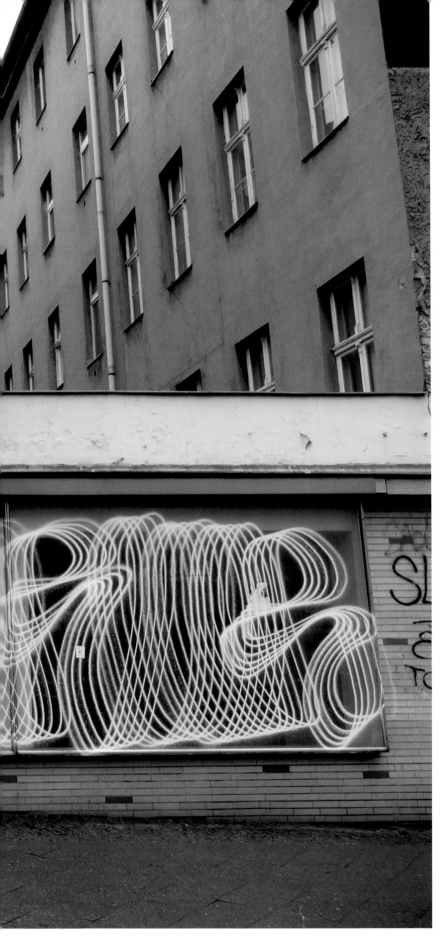

Artist: Dtagno – Spray paint – Berlin (Germany), 2008

"Cocaine" – Artist: Dtagno – Spray paint – Berlin (Germany), 2010

"Diamond" – Artist: Dtagno – Berlin (Germany), 2009

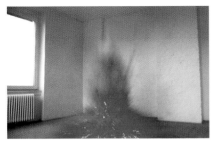

"The Birth Of Mr. Pink" – Artist: Dtagno –
Berlin (Germany), 2009

"Grumpy Grampa" – Artists: Dtagno + Tryone –
Berlin (Germany), 2009

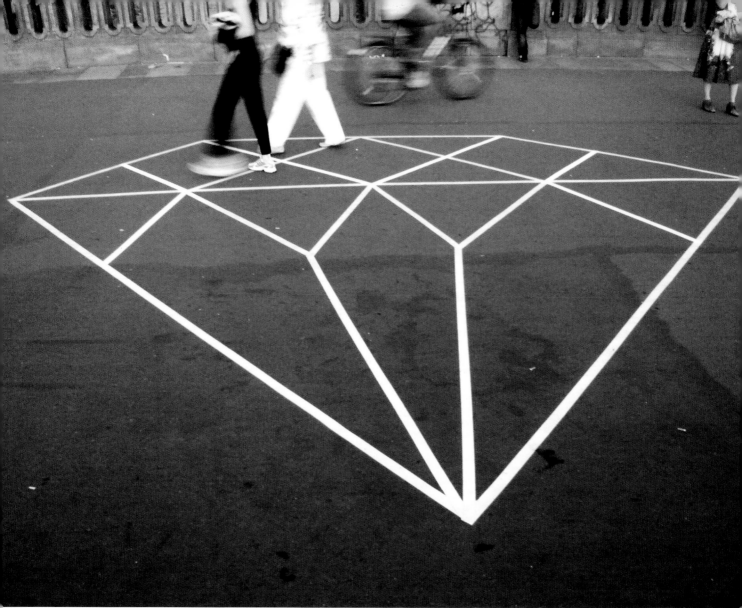

"Diamond" – Artist: C100 – Adhesive tape – Berlin (Germany), 2010
C100: "Normally diamonds are only available/affordable for a small
group of (rich) people – our aim is to change this by giving everyone out
there the possibily to enjoy our diamonds! Diamonds for everyone!"

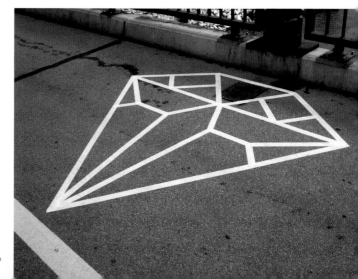

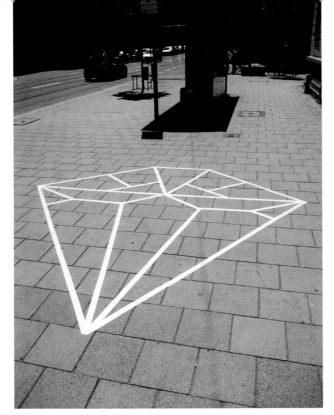

"Diamond" – Artist: C100 –
Adhesive tape – Munich (Germany), 2010

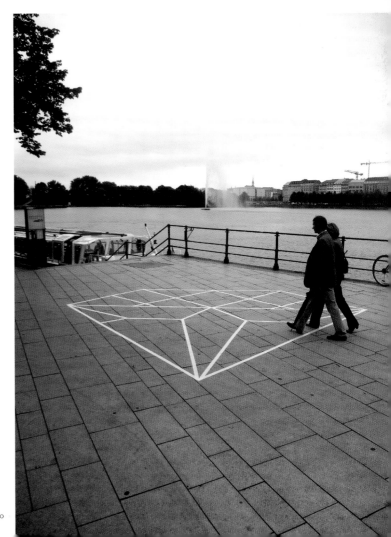

"Diamond" – Artist: C100 –
Adhesive tape – Munich (Germany), 2010

"Diamond" – Artist: C100 –
Adhesive tape – Hamburg (Germany), 2010

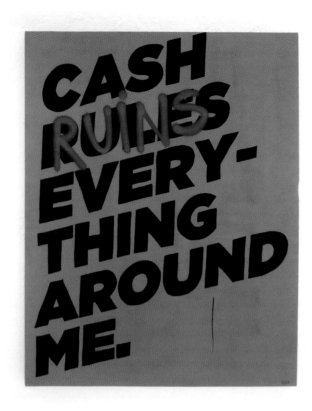

"C.R.E.A.M" – Artist: C100 – Acrylic paint
on canvas – Munich (Germany), 2009

"Untitled" – Artist: C100 – Collage on paper –
Stroke 01 exhibit, Munich (Germany), 2009

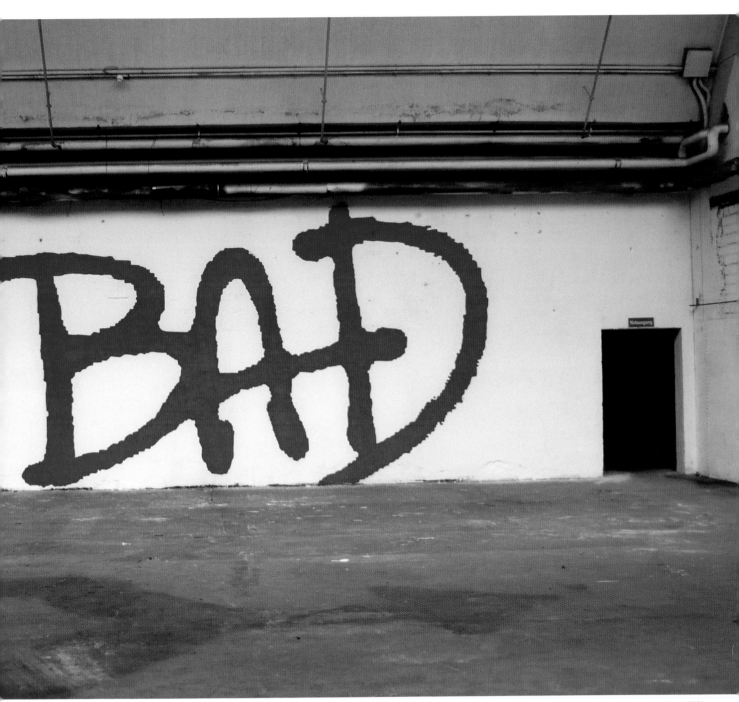

"BAD (Painting the most famous Graffiti tag of the world in XXL)" –
Artist: C100 + The Purple Haze – Latex paint – Munich (Germany), 2008

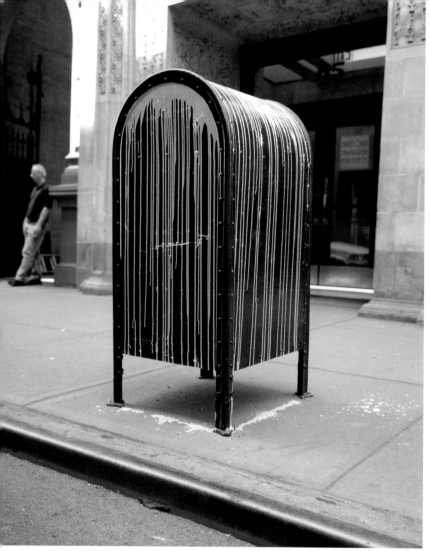

Artist: Krink – Marker on mailbox –
New York (USA), 2008

KR: "This is an early example of using just Krink drips. I
used to write graffiti with Silver Krink on mailboxes, one of
the main differences with this is I stopped writing my name
and started working more abstract and minimal. I got a very
positive response from a wide variety of people and pursued
this aesthetic."

Artist: Krink – Acrylic paint + fire extinguisher –
Philadelphia (USA), 2009

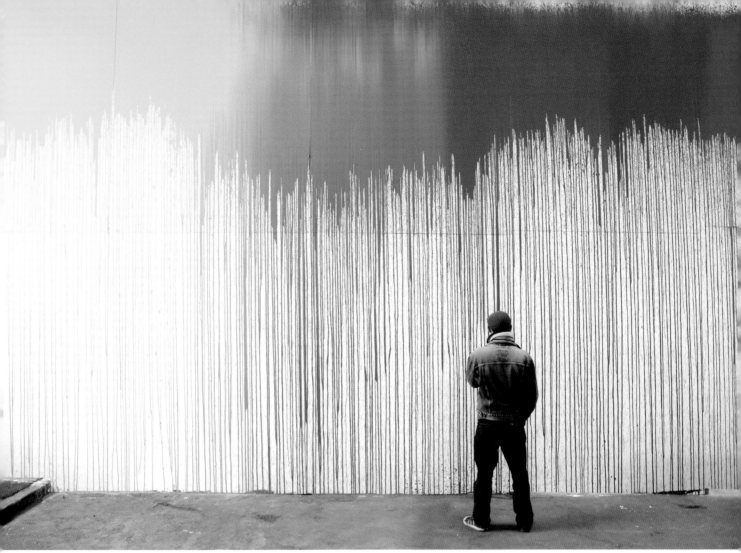

Artist: Krink – Acrylic paint + fire extinguisher –
Moscow (Russia), 2009

Artist: Krink – Acrylic paint + fire extinguisher –
Praha (Czech Republic), 2009

Artist: Krink – Acrylic paint + fire extinguisher –
Hamburg (Germany), 2010

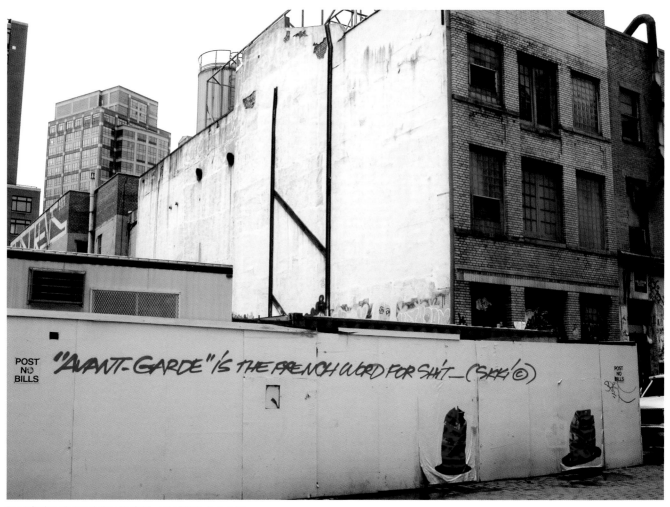

"Avant-Garde Is The French Name For Shit" – Artist: Skki© – Spray paint –
In front of the Deitch Project Gallery in Soho, New York (USA), 2008

At the beginnig of the New York graffiti movement artists used to call themself «Writers».
According to this detail Skki© decided to use «pure» writings with his personal hand-
written calligraphy style which is bending right (contrary to graffiti tags that are mostly
bending to the left for esthetical reasons), also using different languages according to the
geographical place where the text is written. Just like books that are translated in several
languages for different countries, the text written on the wall needs to be understood by
the majority of the public, using their language.

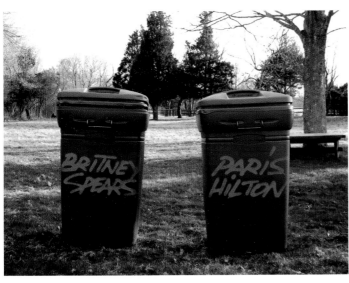

"Britney Spears, Paris Hilton" – Artist: Skki© –
Spray paint – New York (USA), 2008
Skki©: "As a child I knew that the stars only could get brighter – The two
pop icons finally at the right place! I wrote this spontaneously because of the
surrounding where the garbage where standing, a white trash neighborhood
on Long Island, NY, where many teenage girls dream to be like them ... in a
brighter future!

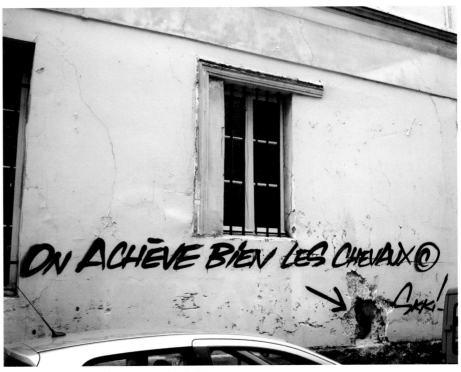

"On Acheve Bien Les Chevaux! (They kill horses, dont they?)" –
Artist: Skki© – Spray paint – Paris (France), 2007
Skki©: "... is a famous expression. I wrote that text and pointing an arrow
to the open hole because of this beautiful old building in the Marais in Paris,
where the front wall was falling appart, and nobody was doing anything to
fix it!"

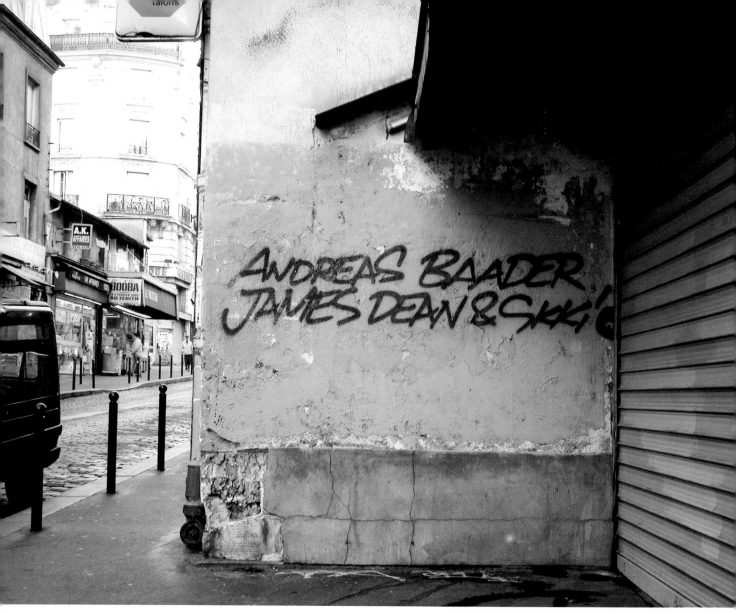

Artist: Skki© – Spray paint – Paris (France), 2008

Skki©: "In 2006 I started this series of "Name Dropping": The practice of casually mentioning important people during a conversation in order to impress in «cultural» places in Paris. So I associated my "nom de guerre" to important figures related to movie, fashion, literature or contemporary art. By associating iconographic figure's name to my name at the end I created a «question mark» for the public to guess, knowing that most of the public in our urban contemporary environment dont know or give a shit about tags anymore. For most of them it is simply a form of colored pollution with spray painted names who mean nothing to them and are associated with teen faceless vandals disobeying the law of mister clean! So starting the "Name Dropping" project. I was like "I 'm giving you the two names of «people you already know by their name and whose face is stuck in the hard drive of your memory". I had many reaction to that "Name Dropping" game – questions like: "Who the fuck is Skki© ?" – "What is the link between the three names?" – "Does Skki© think he's as famous like x or y ?" – "The good, the bad & THE UGLY?". In fact each name has a link, like for example «Rebel attitude» – I used two characters, one real and the other fictional:
– Andreas Baader was one of the leaders of the German left-wing militant organization Red Army Faction, also commonly known as the Baader-Meinhof group. Andreas represent the true rebel who fight the power! With his organisation, they terrorised the German authorities during the late 60's till his death by suicide in 1977.
- James Dean is the rebel Made in Hollywood. American actor and a cultural icon, he's best embodied in the title of his most celebrated film "Rebel Without a Cause". He died in 1955 in a car accident, driving his Porsche 550 Spyder.
– & Skki© (Who the fuck is he?)

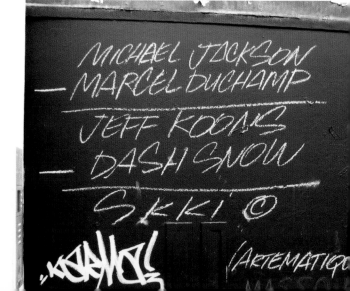

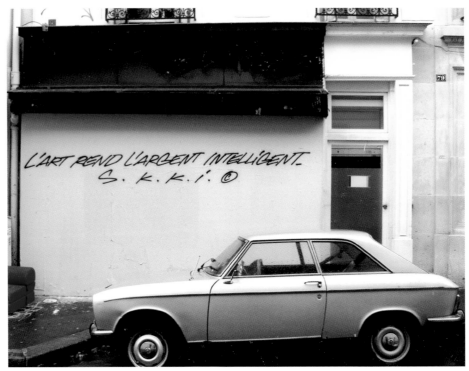

"L'Art Rend l'Argent Intelligent" – Artist: Skki© –
Spray paint – New York (USA), 2008
Skki©: "Art makes the money intelligent! Later on someone wrote next to my
text on the lower right corner "Sorry but money makes art intelligent". It was
a reaction to the financial context of 2008/2009 where Wall Street crashed,
but somehow the art market was staying up and investor/collectors were
keeping high profile!"

"Michael Jackson, Marcel Duchamp, Jeff Koons, Dash Snow, Skki©"
Artist: Skki© – Spray paint – Paris (France), 2008
Skki©: "Arthematique (arthematic), a subtracting fraction of various
personnalities related to contmporary art and music …
Step 1. Make sure the bottom numbers (the denominators) are the same
Step 2. Subtract the top numbers (the numerators). Put the answer
over the same denominator.
Step 3. Simplify the fraction = SKKI©"

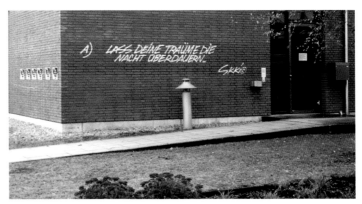

"Lass Deine Träume Die Nacht Überdauern" – Artist: Skki© – Spray paint –
Art Total festival organised by ik Reinking, Lüneburg (Germany), 2009
Skki©: "May your dream be longer than the night" (in German) it was my answer to the
bibliothek of Leuphana University of Lüneburg where students are reading books till late
at night … "

 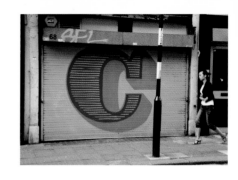

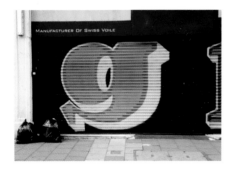 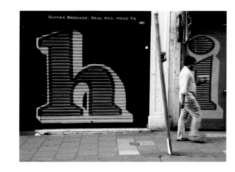 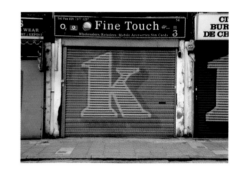

 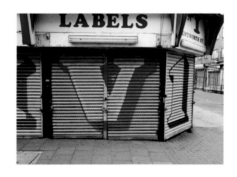 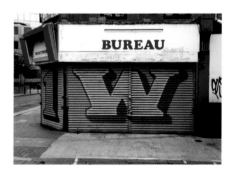

Artist: Eine – Spray paint – London (United Kingdom), 2010
Info: Complete Alphabet on roller shutters

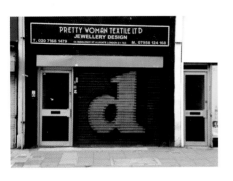

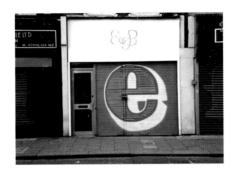

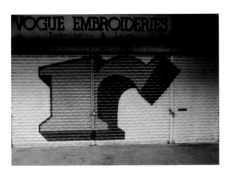

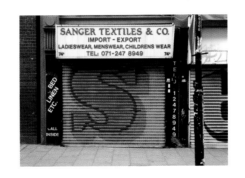

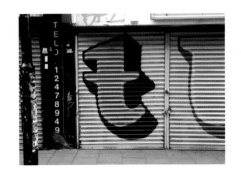

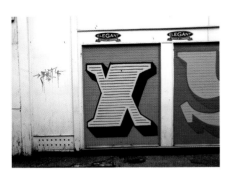

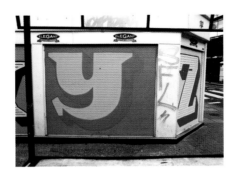

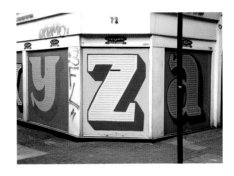

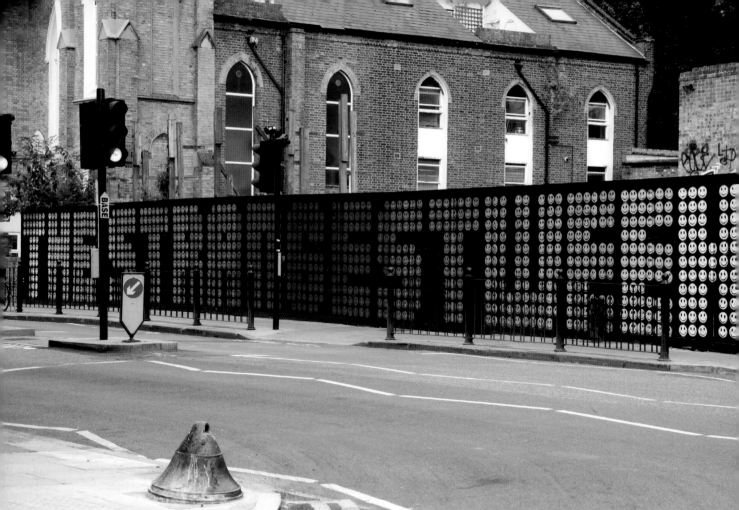

"The Strangest Week" – Artist: Eine – Spray paint –
London (United Kingdom), 2010
Info: A painting by Eine was given to president Obama by Samantha Cameron
(the wife of David Cameron), and currently hangs in the White House. Feet
firmly on the ground Eine teamed up with RYCA the week after to paint this
piece in Hackney, East London. With a font comprised entirely of dots with
smiley faces it turned into a marathon session with Ben choosing the wording
"The Strangest Week" as a fitting comment on seven days which saw one of his
paintings gifted to President Obama and hung in the White House. –
Photographer: Steve Cotton/artofthestate.co.uk

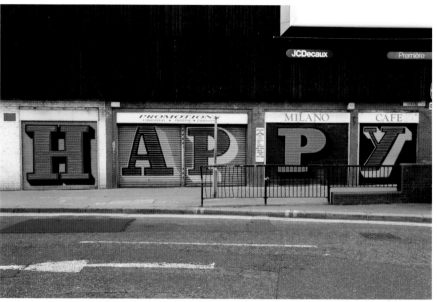

"Happy" – Artist: Eine – Spray paint – London (United Kingdom), 2010

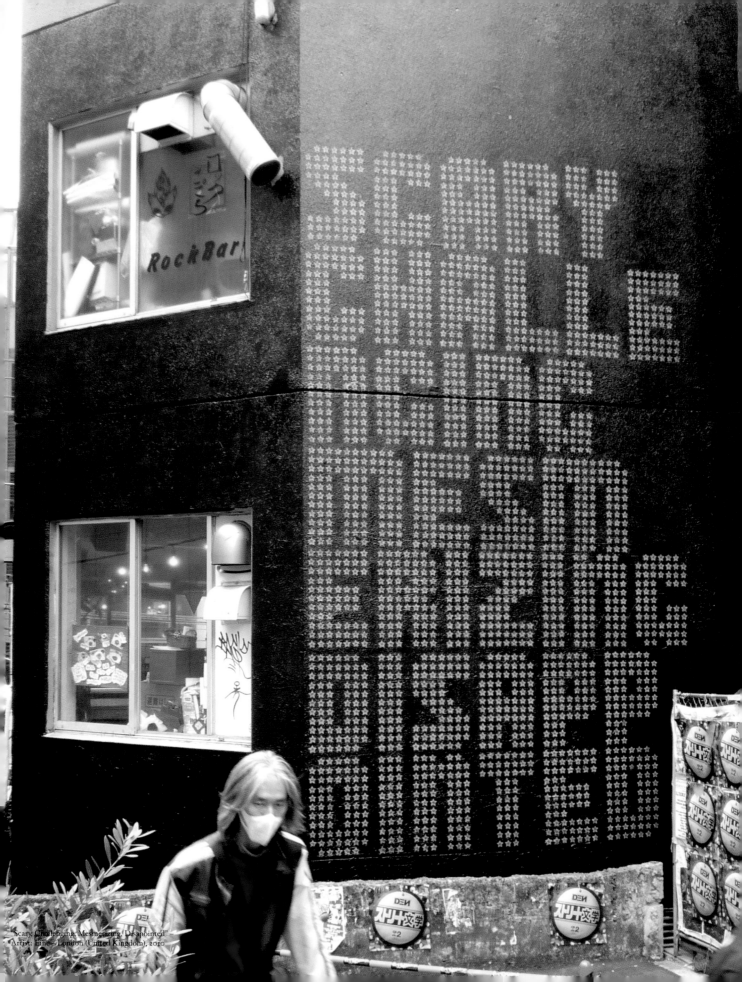

"Scary, Challenging, Mesmerizing, Disapointed"
Artist: Eine – London (United Kingdom), 2010

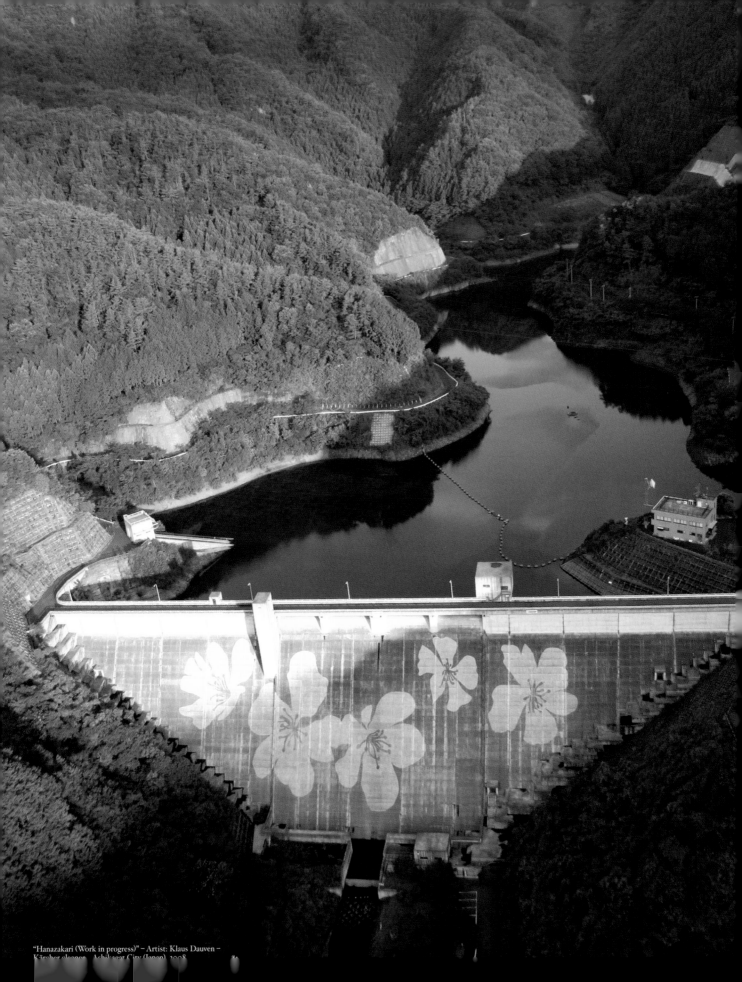

"Hanazakari (Work in progress)" – Artist: Klaus Dauven –
Kärcher cleaner, Ashikagat City (Japan), 2008

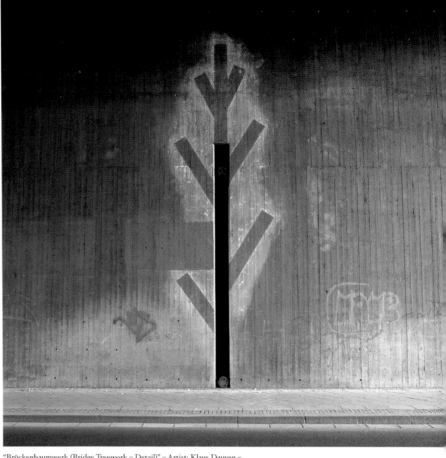

"Brückenbaumwerk (Bridge Treework – Detail)" – Artist: Klaus Dauven –
Kärcher cleaner, 7,20m x 2,15m – Bochum (Germany), 2007 –
Photographer: Max Busch

"Untitled" – Artist: Klaus Dauven – Kärcher cleaner, 1,10m x 1,80m –
Aachen (Germany), 2001 – Photographer: Max Busch

115

"Untitled" – Artist: Klaus Dauven – Kärcher cleaner, 1,10m x 1,80m –
Aachen (Germany), 2001 – Photographer: Max Busch

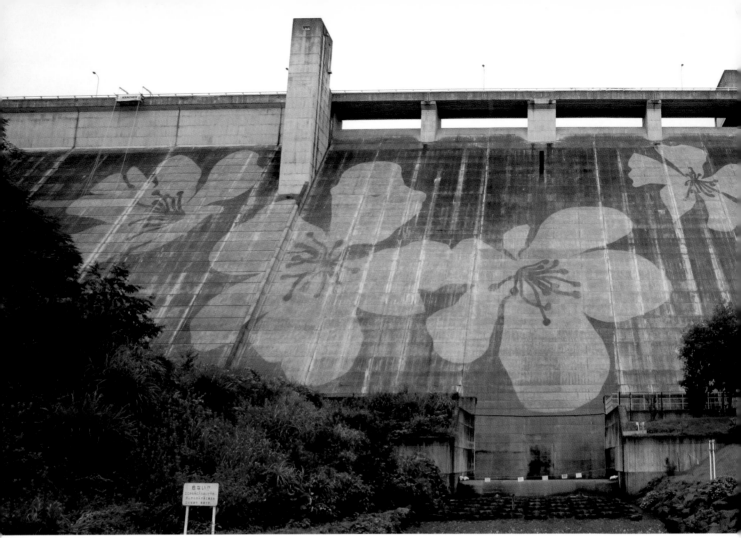

"Hanazakari" – Artist: Klaus Dauven –
Kärcher cleaner – Ashikagat City (Japan), 2008 –
Klaus: "The drawing was created with high-pressure cleaners between 20 and 26
July 2008 on the Matsdagawa Dam. The 228-metre wide and 56-metre high dam
is near Ashikagat city, about 80 kilometres north of the Japanese capital Tokyo."

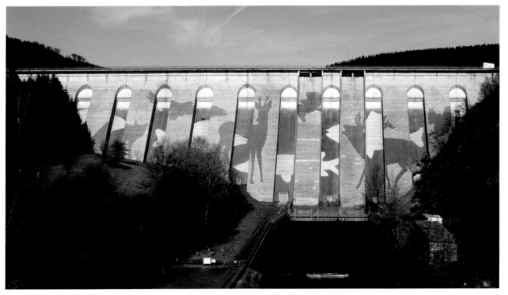

"Wild-Wechsel (Deer Pass)" – Artist: Klaus Dauven –
Kärcher cleaner, 282-metre wide; 54,6-metre high –
Oleftal Valley Dam, Hellenthal near Euskirchen (Germany), 2007

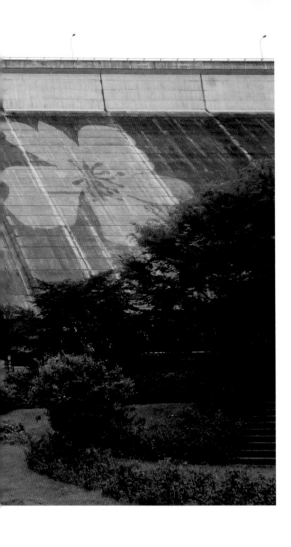

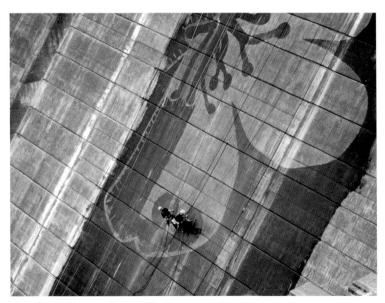

"Hanazakari (work in progress)" – Artist: Klaus Dauven –
Kärcher cleaner – Ashikagat City (Japan), 2008

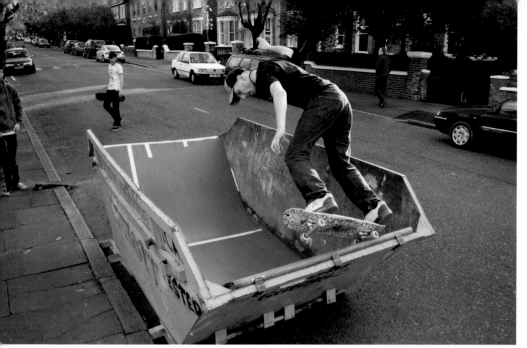

"Skip Conversion – Skate Ramp" – Artist: Oliver Bishop-Young –
London (United Kingdom), 2008
Oliver: "Matching the properties of a reclaimed material to a suitable use
can be all it takes to keep a material from becoming landfill. Hardboard
made a great mini skate ramp in the skip. Sidewalk magazine sent Pete
King to try it out." –
Photographer: Thomas Valenzuella

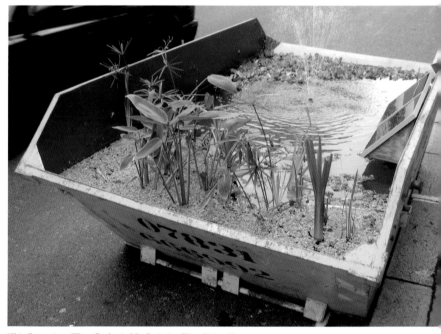

"Skip Conversion – Water Garden At Mint" – Artist: Oliver Bishop-Young –
London (United Kingdom), 2008
Oliver: "This was a response to a commission proposed by Mint. An exhi-
bition of work from both established designers such as Tord Boontje and
Marije Vogelzang as well as recent graduate work were to form an exhibition
around the theme of nature during the London Design Festival 2008. In
response I created a water garden that brought a gentle beauty to the street
outside Mint. The piece made use of discarded bricks and tiles as well as
incorporating a solar powered fountain and diverse mix of water plants." –
Photographer: Thomas Valenzuella

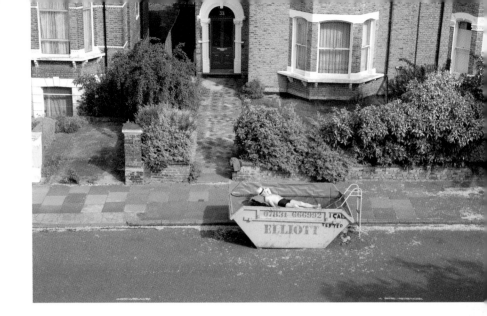

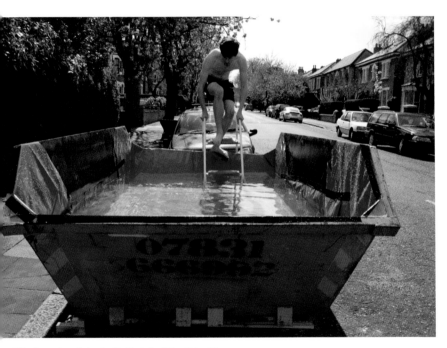

"Skip Conversion – Swimming Pool" – Artist: Oliver Bishop-Young –
London (United Kingdom), 2008
Oliver: "Utilising the skips container like attributes and some damp proof
membrane, the skip can become a swimming pool. It forms an interesting
object interacting with both the private home and public street. Passers
by are bemused at the sight of someone floating in a skip and approach to
find out more. Converting skips is a great tool for bringing the community
together and making use of waste resources and space. And, after a long hot
day, how good it is to plunge into your very own pool." –
Photographer: Thomas Valenzuella

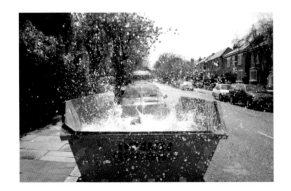

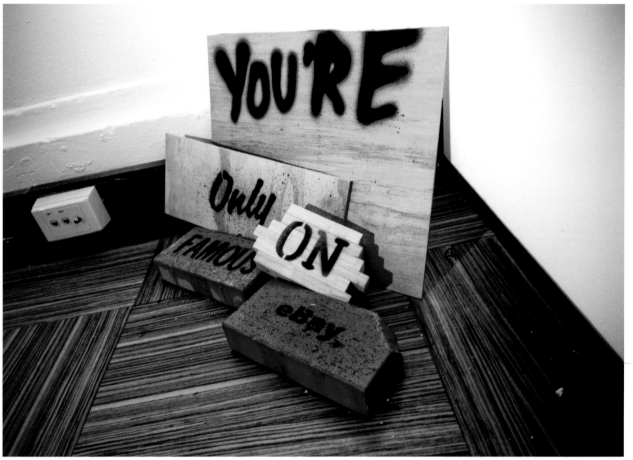

"You 'Re Only Famous On eBay" – Artist: Numskull –
Sydney (Australia), 2008
Numskull: "This was a last minute installation for my solo show in Sydney,
2008. At the time I was noticing a lot of lo-brow and street artists who were
originally famous for their work on the street, getting more fame for their
work on eBay than on walls."

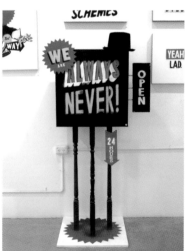

"We Are Always Never Open" – Artist: Numskull –
Sydney (Australia), 2008
Numskull: "Hand built wooden sculpture at Ambush
Gallery, 2009, Sydney, Australia. My main purpose for
building this was to display a contradiction as strangely
as possible. Most brands or advertising over-offer. This
thing offers and denies at the same time."

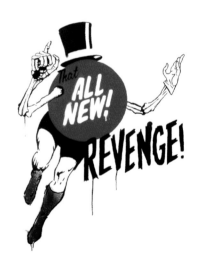

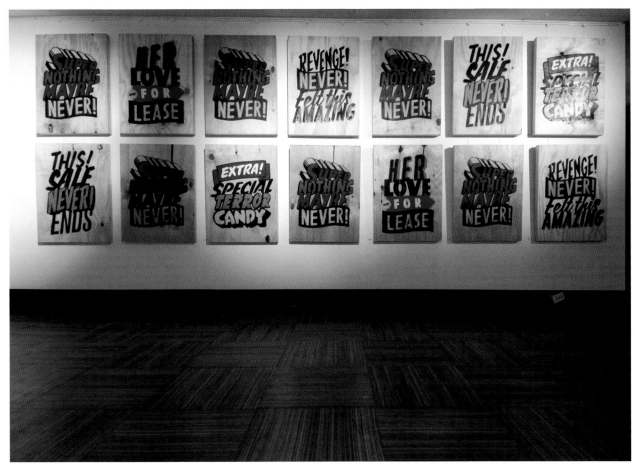

"Text messages" – Artist: Numskull – Sydney (Australia), 2008
Numskull: "From my exhibition in Sydney, 2008 called "Super Nothing
Maybe Never". These pieces are all stencil on hand built wooden boxes.
I take inspiration for these pieces from my surroundings here in australia
and where I travel. I take one word from a sign and throw it in with
another sign I see down the road to get a totally different message."

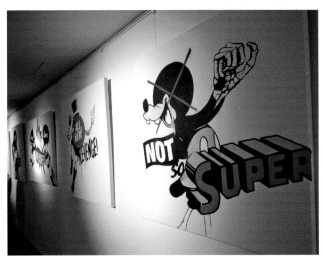

"That All New Revenge" & "Not So Super Anymore" –
Artist: Numskull – Sydney (Australia), 2008
Numskull: "Too many heroes everywhere I look. Advertising, internet,
art and everyday life. I create characters to be the most un-heroic,
useless heroes possible."

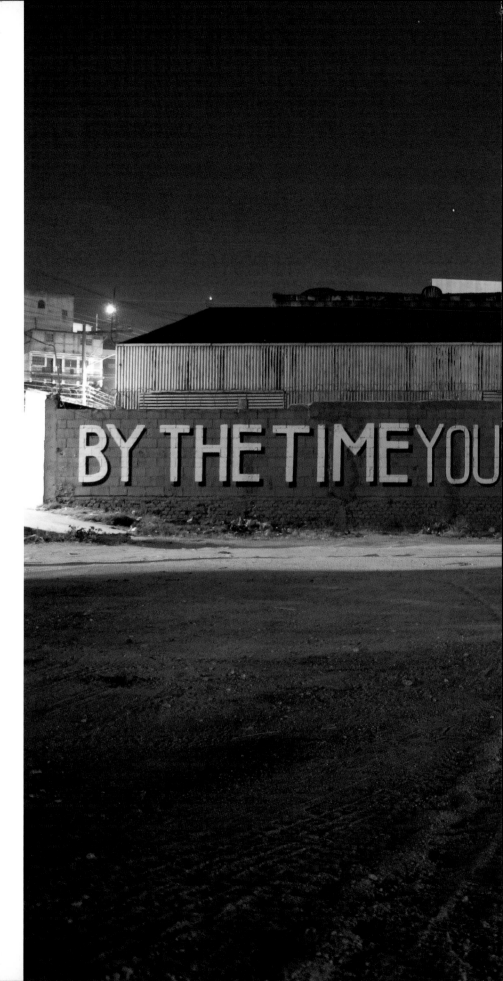

"By The Time You Read This I'll Already Be Gone" –
Artist: Above – Guatemala City (Guatemala), 2008
Above: "It was a calm Sunday afternoon and I was leaving for
Mexico the next morning. I had some left over paint and some
time on my hands. Two hours later and a few beers with some
friends, this piece was completed."

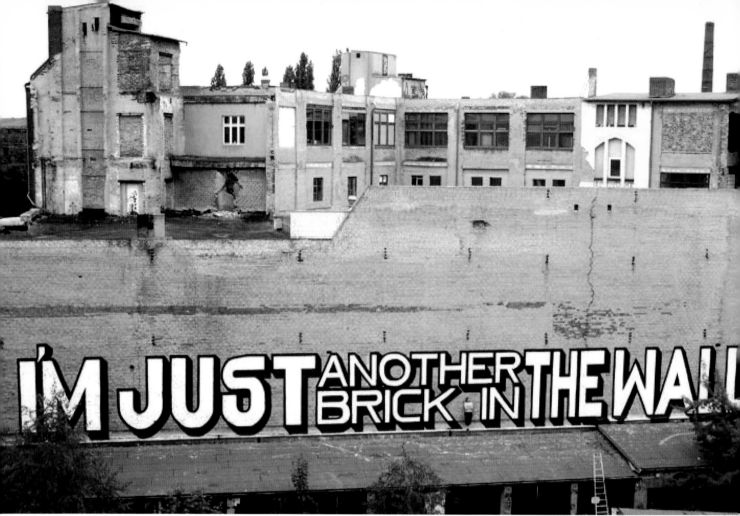

"I'm Just Another Brick In The Wall" –
Artist: Above – Berlin (Germany), 2008
Above: "Rome wasn't built in 1 day, nor was this wordplay
painting. I'm not 100% sure but I think this might be the
longest wordplay painting I've done? Brick by brick this piece
was built and finally finished. "Victory belongs to the most
Persevering." – Napoleon Bonaparte

"Half Hearted" – Artist: Above – Valparaiso (Chile), 2008
Above: "This painting was done «Half hearted». Believe only
half of what you see, and a forth of what you hear."

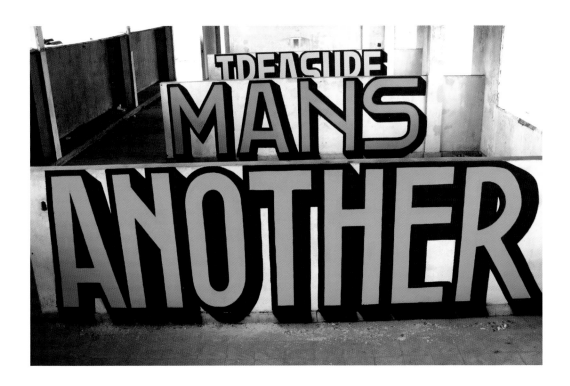

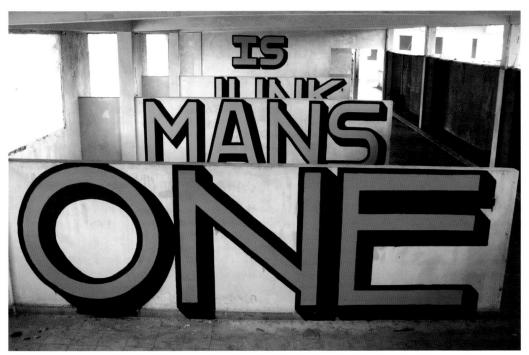

"One Mans Junk Is Another Mans Treasure" – Artist: Above – Valparaiso (Chile), 2008
Above: "It's very interesting to see the difference of «value» people put on objects!
The owner of this buildings only interest was to sale the property and didn't give a
damn about the actual building itself. How do I know? Because he told me!"

"Damokles 2012" − Artist: Nomad − Berlin (Germany), 2009

"Eternal" – Artist: Nomad – Canary Islands (Spain), 2009

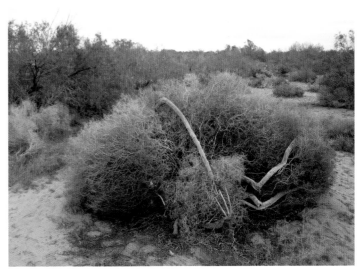

"Untitled" – Artist: Nomad – Canary Islands (Spain), 2009

"Alte Fotze" – Artist: Nomad – Berlin (Germany), 2009

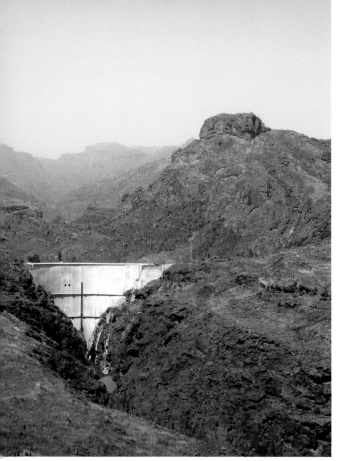

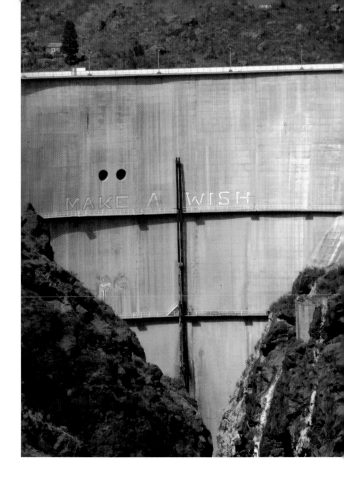

"Make A Wish" – Artist: Nomad –
Soria barrage, Gran Canaria (Spain), 2010

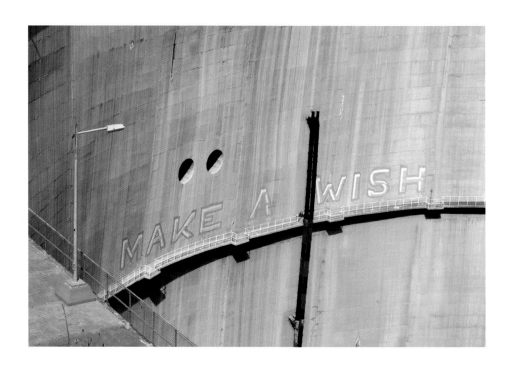

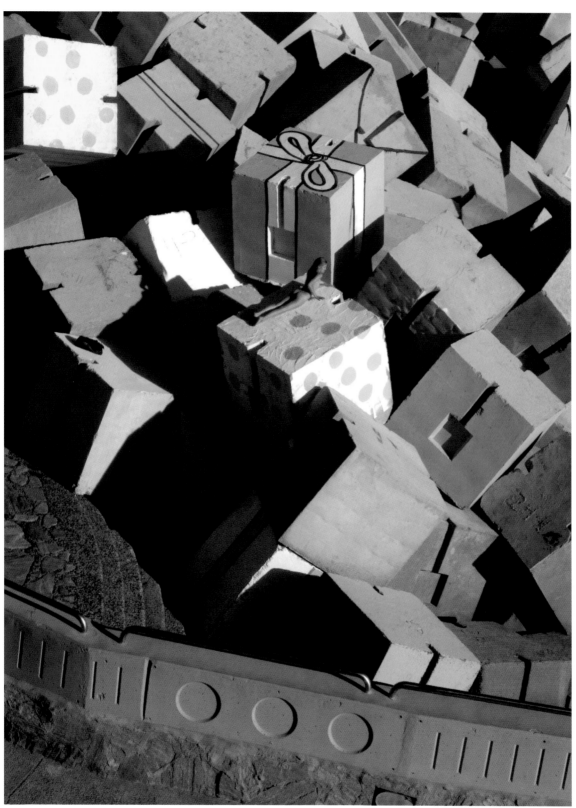

"Lovebombing / Alea Acta Est" – Artist: Nomad –
Canary Islands (Spain), 2009

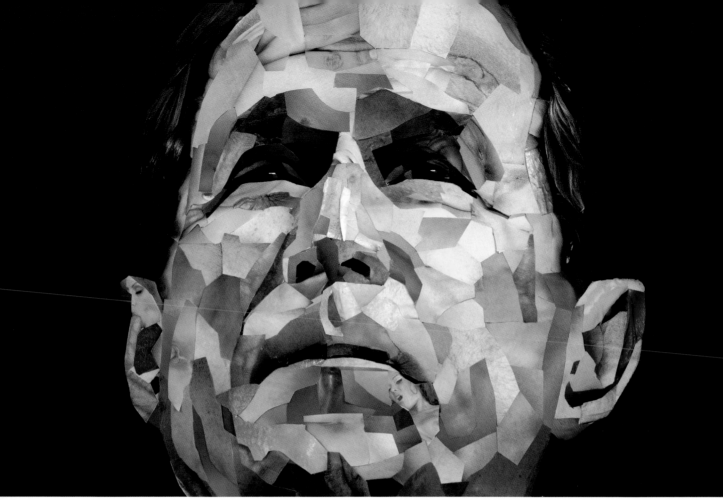

"Bush" – Artist: Jonathan Yeo – Collage, 103cm x 70cm –
London (United Kingdom), 2007

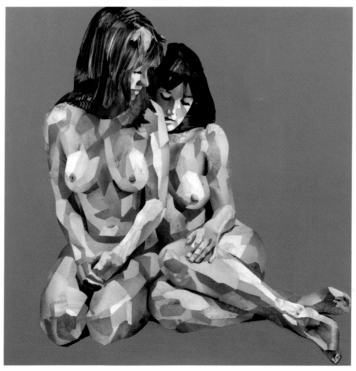

"Pepper and Catherine" – Artist: Jonathan Yeo –
Collage – London (United Kingdom), 2007

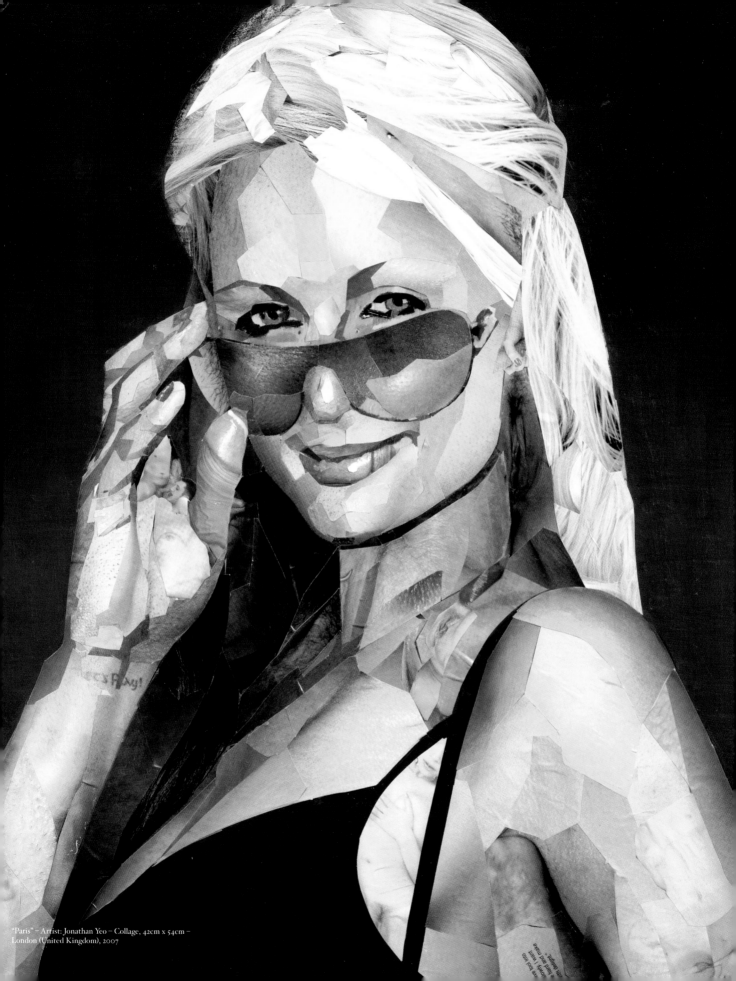

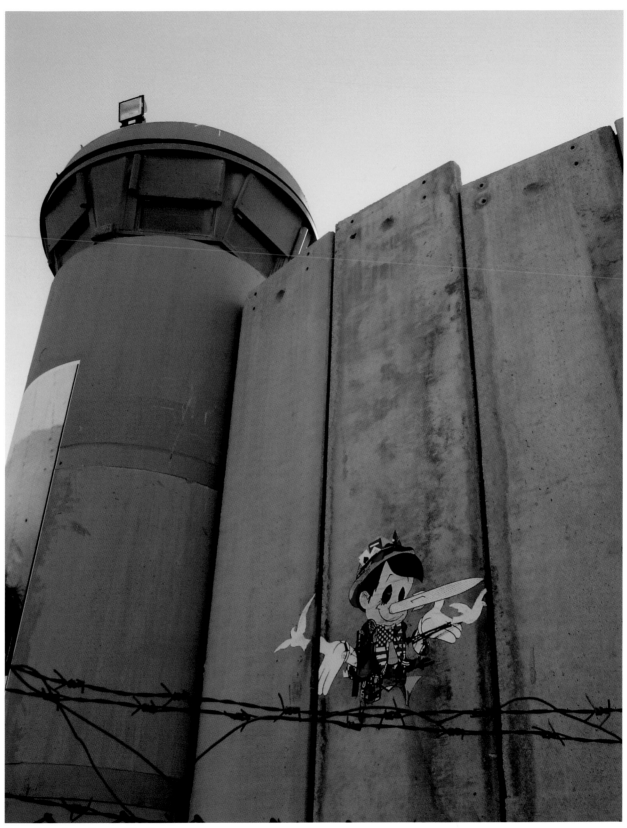

"Who to Believe (Santas Ghetto Bethlehem)" –
Artist: Paul Insect – Separation Wall (Palestine), 2007

"Happy Dreams" – Artist: Paul Insect –
6 colour screen print – Picturesonwalls.com – 2009

"Untitled" – Artist: Paul Insect – Acrylic and spray paint on Canvas –
Lazarides Outsiders show, London (United Kingdom), 2009

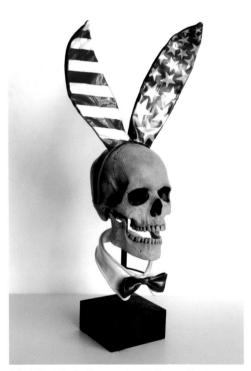

"Miss July" –Artist: Paul Insect – 1 of 12 Dead bunny girl sculptures
bronze, enamel flake paint, cocobolo wood, stainless steel –
"Poison" Solo Show London (United Kingdom), 2008

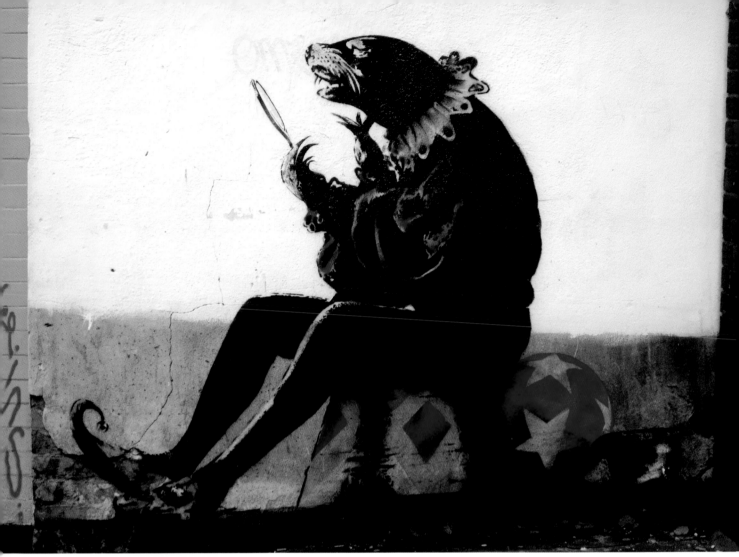

"Seal Performer" – Artist: Paul Insect –
Spray paint – London (United Kingdom), 2009

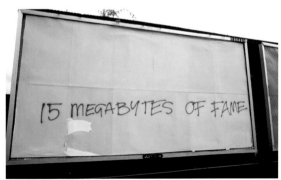

"15megabitesoffame" – Artist: Paul Insect –
Spray paint – Billboard – London (United Kingdom), 2008

"Sad Tree" – Artist: Paul Insect –
Spray paint – London (United Kingdom), 2010

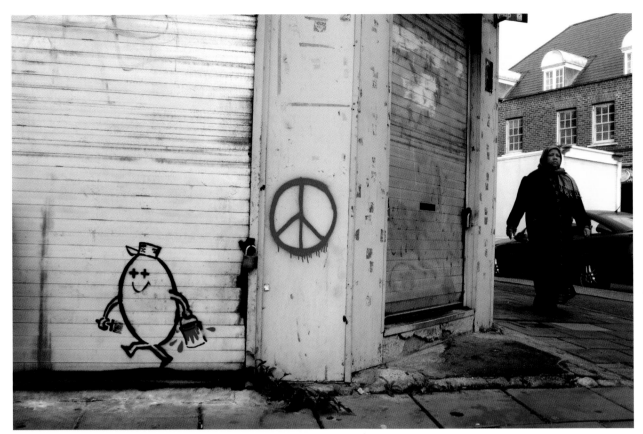

"Egg Painter" – Artist: Paul Insect –
London (United Kingdom), 2009

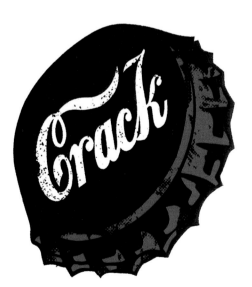

"Crack" – Artist: Paul Insect –
London (United Kingdom), 2010

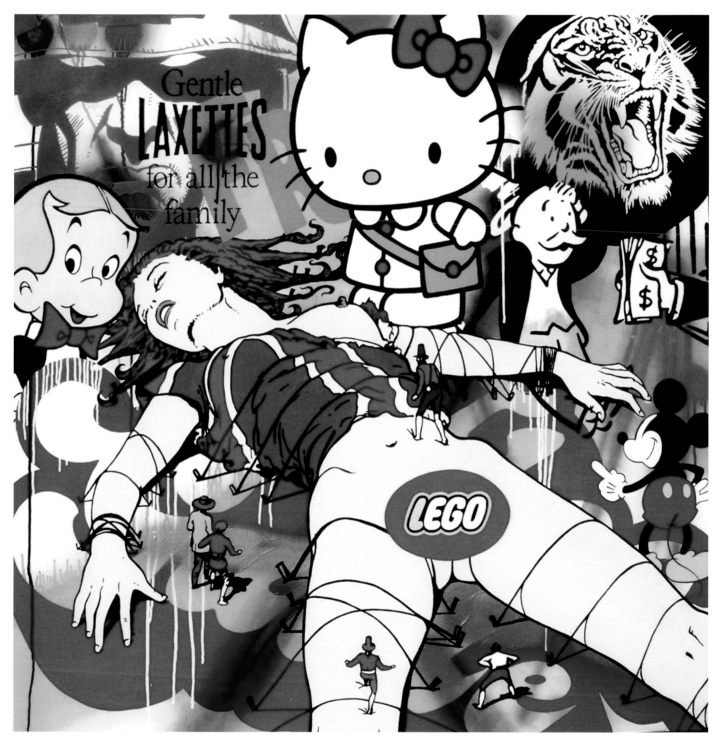

"Gentle Laxettes For All The Family" – Artist: Ben Frost –
Acrylic and aerosol on board, 1.2m x 1.2m – 2006

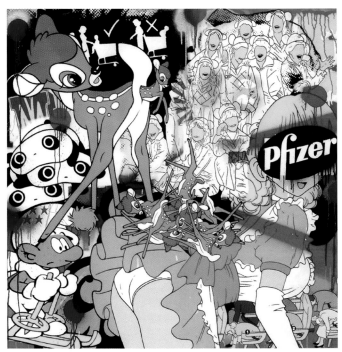

"Kmart After Dark" – Artist: Ben Frost –
Acrylic and aerosol on board, 1.2m x 1.2m – 2006

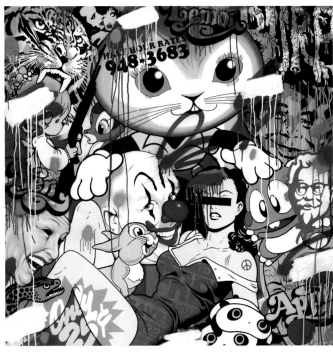

"Every Man Has His Price" –Artist: Ben Frost –
Acrylic and aerosol on board, 1.2m x 1.2m – 2008

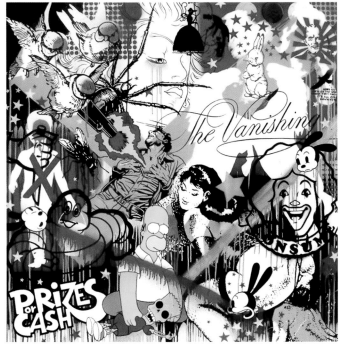

"Vanishing" – Artist: Ben Frost –
Acrylic and aerosol on board, 1.2m x 1.2m – 2008

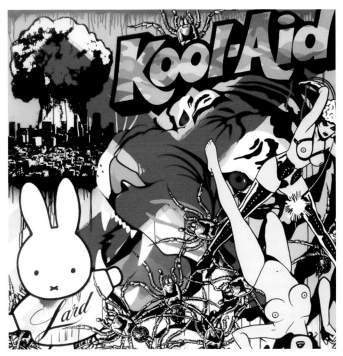

"Spiders In The Chandelier" – Artist: Ben Frost –
Acrylic and aerosol on board, 1.2m x 1.2m – 2006

"Silver Island Mountain I" – Artist: Carol Hummel – Macrame cord –
Wendover (Salt Flats), Utah (USA), 2007
Info: The Silver Island Mountain works were completed during a Center
for Land Use Interpretation (CLUI) art residency in Utah during the
summer of 2007. This series explores the repercussions of injecting
(wo)man-made synthetic material into natural environments highlighting
the environmental challenges facing the pristine landscapes.

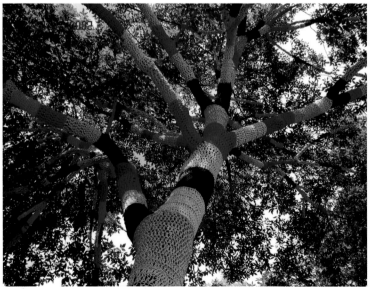

"Tree Cozy" – Artist: Carol Hummel – Macrame cord –
Cleveland Heights, Ohio (USA) 2005
Info: Tree Cozy is a tree – a natural object representing masculinity
and strength – covered with a crocheted cozy – an emphatically
handmade blanket representing femininity and comfort. On the
most obvious level, it is a piece of clothing, personifying the tree
and enhancing the beauty of nature. On another, the brightly colored
cozy wraps the tree in personal and cultural nostalgia evoking
memories of bygone times and places when life was good. On yet
another level, the cozy simultaneously caresses and encases the
tree fluctuating between comforting blanket and suffocating cover-up.

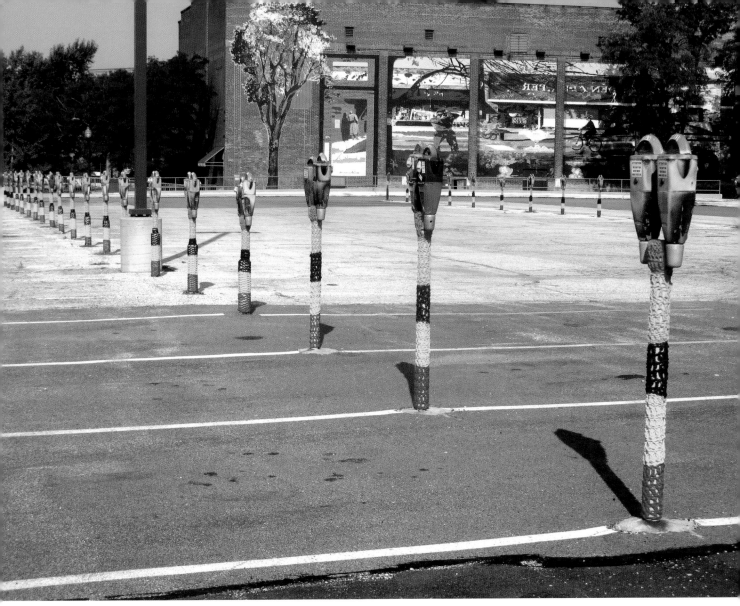

"Knitscape Cedar-Lee" – Artist: Carol Hummel – Macrame cord –
Cleveland Heights, Ohio (USA) 2005
Info: Knitscape Cedar-Lee is the first of a series of urban interventions which
encourage community ownership of public spaces by injecting contemporary art
into communities with the assistance of the people that live in them. Sponsored
by Heights Arts, this project involved crocheting cozies for 185 parking meters,
15 light poles and 3 trees in a small urban neighborhood in northeast Ohio.
Conceptually this project addresses issues of comfort versus confinement.
While still confined by the societal rules and regulations of parking meters,
the colorful coverings provide a degree of comfortable ownership of the process.

"Dump at Steamboat" – Artist: Carol Hummel – Macrame cord –
Steamboat Springs, Colorado (USA), 2008
Info: Dump at Steamboat was created during an art residency with
Colorado Art Ranch. Like many scenic communities in the US,
Steamboat Springs is experiencing explosive population growth that
has created many community challenges and concerns, key among them
the protection of the environment in the face of major development.
This piece highlights a critical concern related to population growth --
garbage. The (wo)man made viruses blossom amongst the piles of waste
and seep toward the pristine hills and mountains surrounding the dump
highlighting the challenges of population growth, consumerism, and
environmental protection.

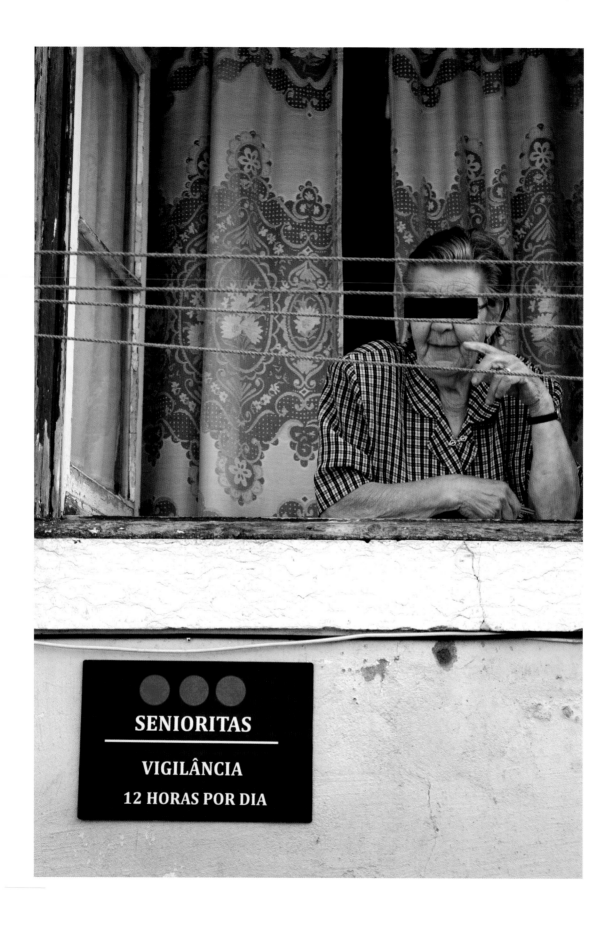

SENIORITAS

VIGILÂNCIA
12 HORAS POR DIA

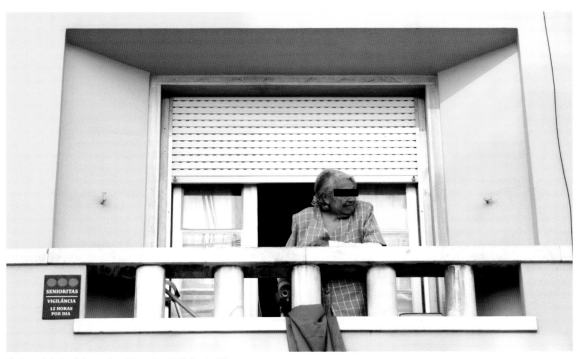

"Senioritas"– Artist: Cabracega in collaboration with Collective CC –
Print on cardboard – Anjos, Lisbon (Portugal), 2010
Info: Senioritas was born based on the surveillance company Securitas and by
observing an everyday behavior (not just) on the streets of Lisbon, which easily
could become a new service.

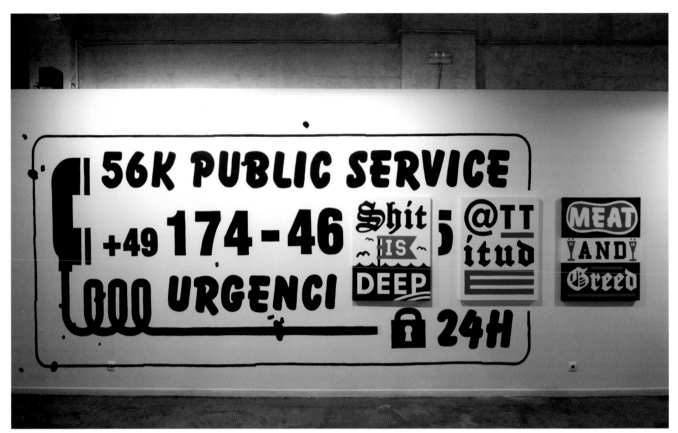

Artist: 56K – Heliumcowboy Artspace group exhibition
"Das Herz Von St. Pauli" at Iguapop Gallery, Barcelona (Spain), 2009

Artist: 56K – Sticker – Barcelona (Spain), 2009

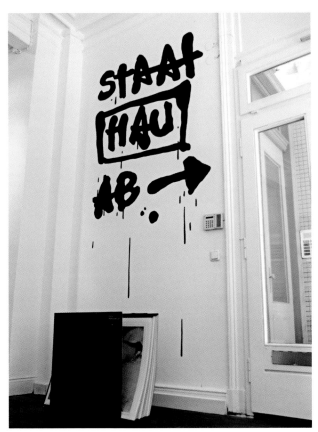

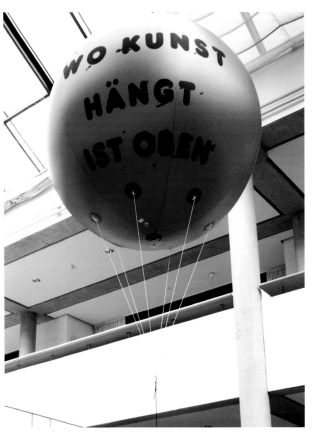

"Staat Hau Ab!" – Artist: 56K – Wallpainting at Gudberg
agency headquarters – Hamburg (Germany), 2010

"Wo Kunst Hängt Ist Oben" – Artist: 56K – Installation at Leu-
phana University Lüneburg curated by Rik Reinking, Lüneburg
(Germany), 2009

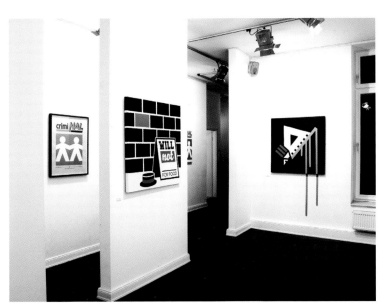

Artist: 56K – Exhibition "The Icecream Van In My
Neighbourhood Plays Helter Skelter" at Vicious Gallery,
Hamburg (Germany), 2009

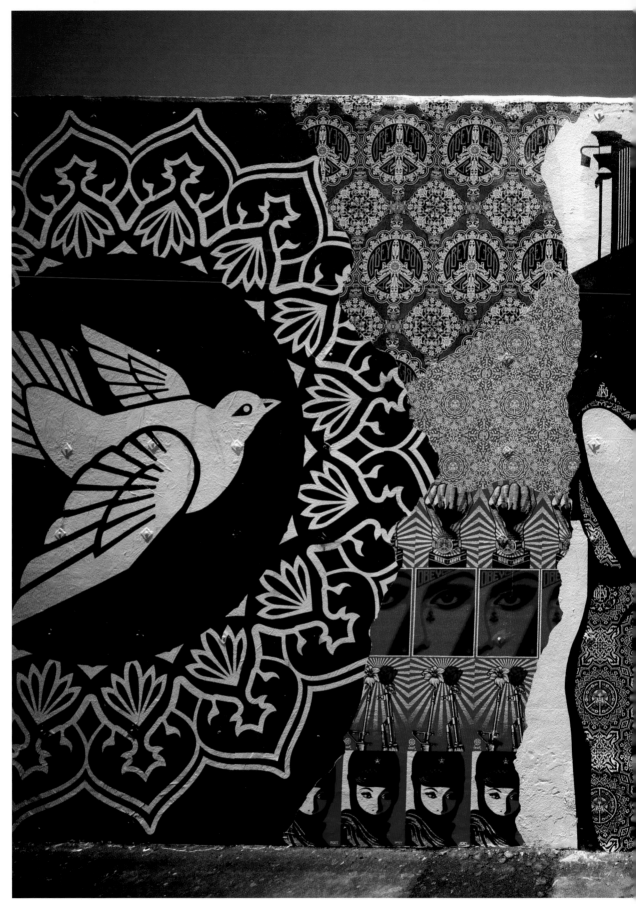

Artist: Shepard Fairey – San Diego (USA), 2010 –
Photographer: Geoff Hargadon

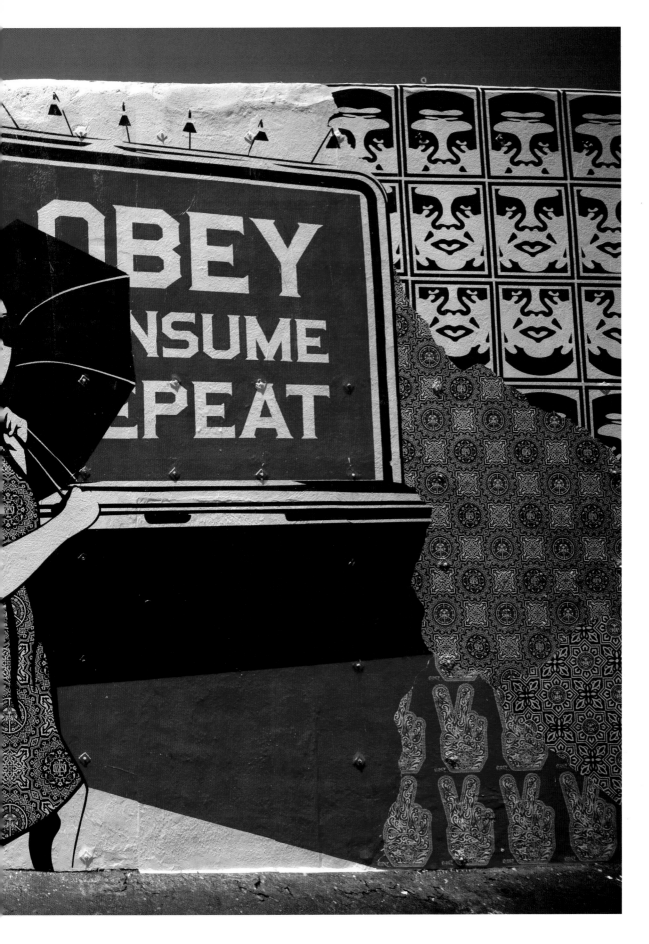

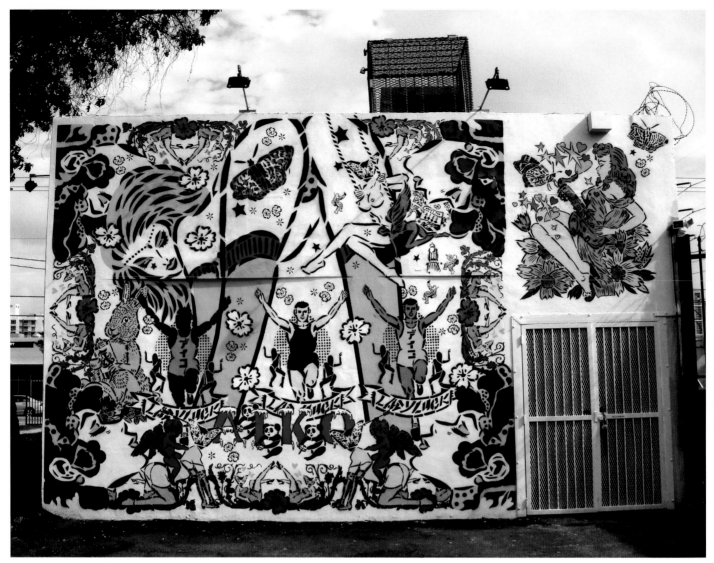

"The Wynwood Wall Project (curated by Tony Goldman & Jeffrey Deitch)" –
Artist: Aiko – Miami (USA), 2009

Aiko working at Wynwood Wall Project in Miami (USA), 2009 –
Photographer: Martha Cooper

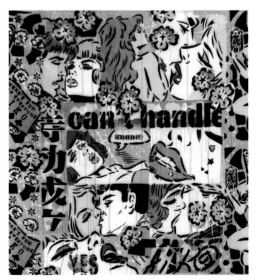

"Love Again Again" – Artist: Aiko –
Mixmedia on canvas – 2010

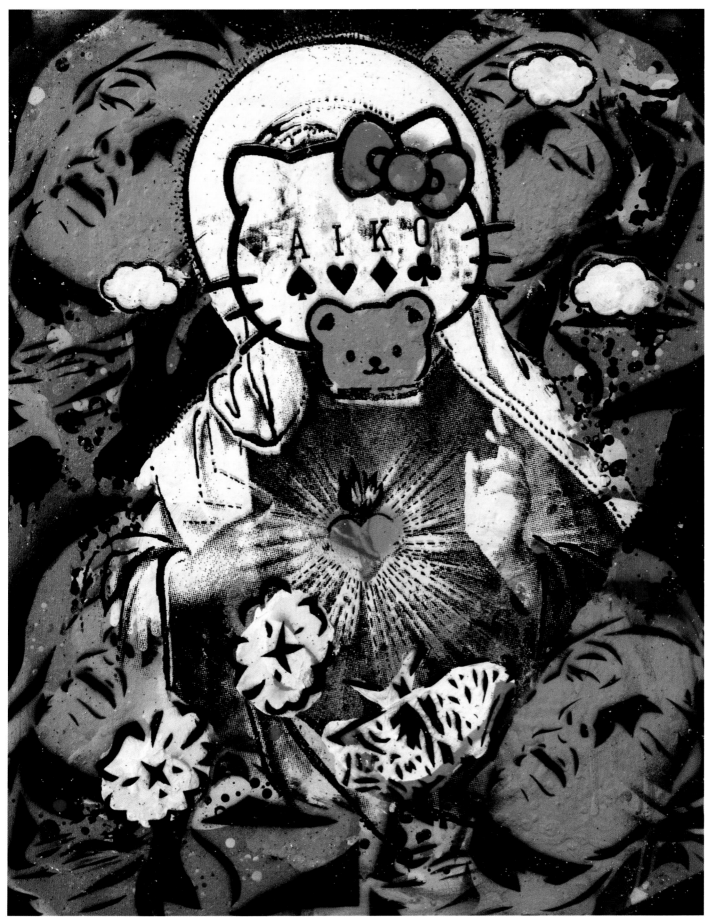

"Ecstacy" – Artist: Aiko –
Mixed media on wood – 2010

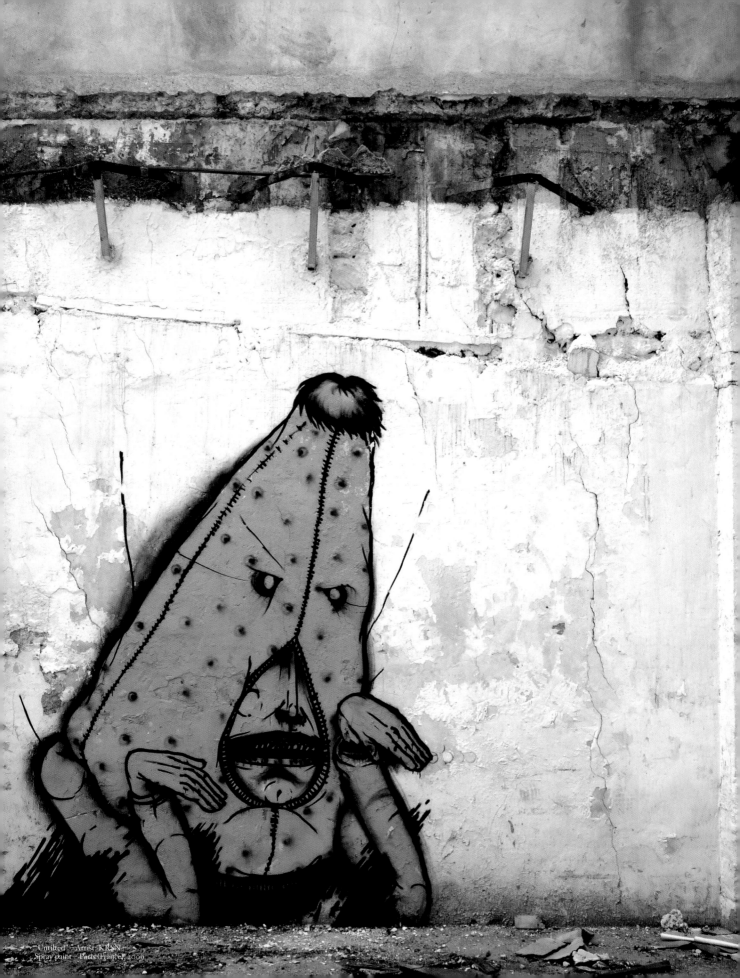

"Les Petits Oiseaux" – Artist: KRSN – Mixed techniques
(A0 Giclée® poster) – Paris (France), 2009

149

"Elevasion" – Artist: SheOne – Spray paint on London Underground
carriage installation – Rooftop, London (United Kingdom), 2010

"Transcend" – Artist: SheOne – Spray paint on canvas, 7ft x 10ft –
Installation Gallery view, from the solo show "Exit Without Saving",
Union Works, London (United Kingdom), 2007

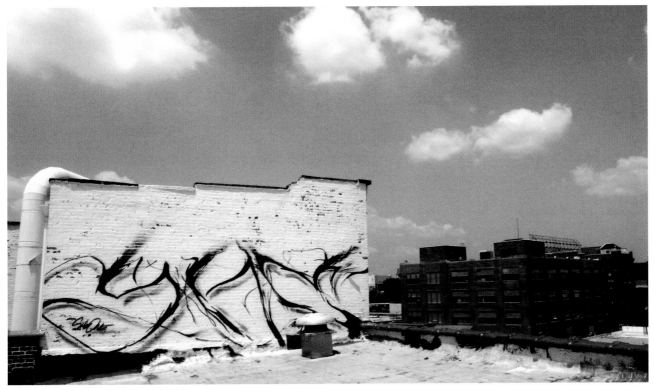

"She (Dedicated To Crash One)" – Artist: SheOne – Spray paint –
Secret rooftop, The Bronx, New York (USA), 2010

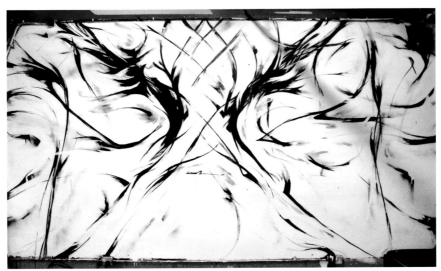

"JCXIII" – Artist: SheOne – Spray paint and emulsion. 6ft x 10ft approx. –
Installation mural, London (United Kingdom), 2010

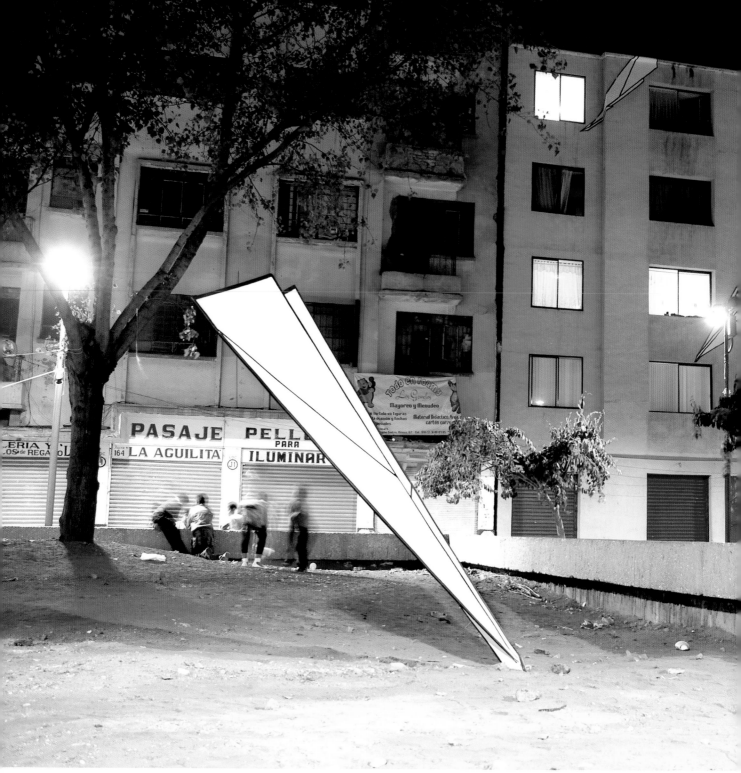

"Avionazo En La Plazuela (Plane Crash in the Square)" – Artist: Said Dokins –
Urban Intervention (Paper airplane wheatpastes, airplane sculpture) –
Plaza de la aguilita (Eagle´s Square), Mexico City (Mexico), 2010

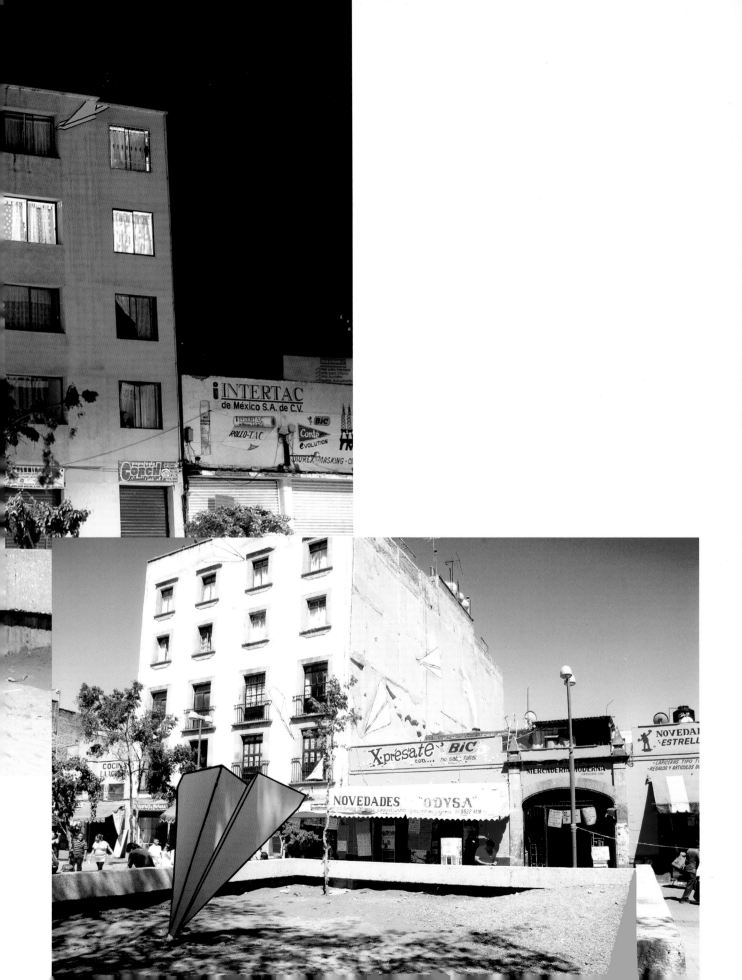

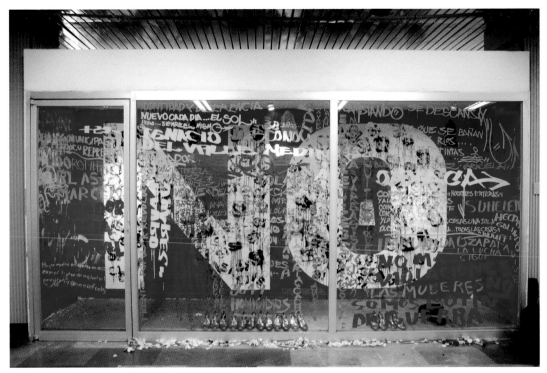

"She Loves Me, She Loves Me Not – Nick Cave" – Artist: Said Dokins –
Durational performance (8 hours) – Subway station Mexico City (Mexico), 2009

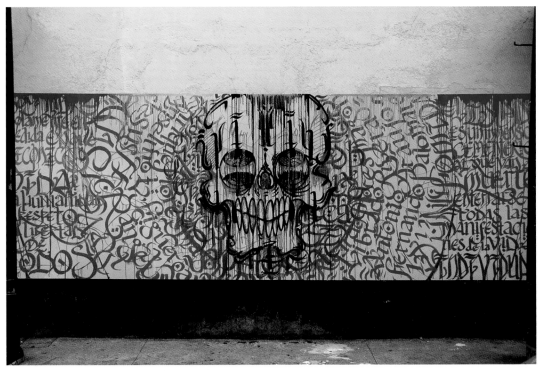

"Espectros De Magón y Bakunin. (Magón and Bakunin spectra)" –
Artist: Said Dokins – Urban Intervention – Coloquio Internacional "migraci-
ón y revolución" INAH. (International Colloquy Migration and Revolution)
organized by the Direction of Historical Studies of the National Institute of
Anthropology and History (INAH) – Mexico City (Mexico), 2010

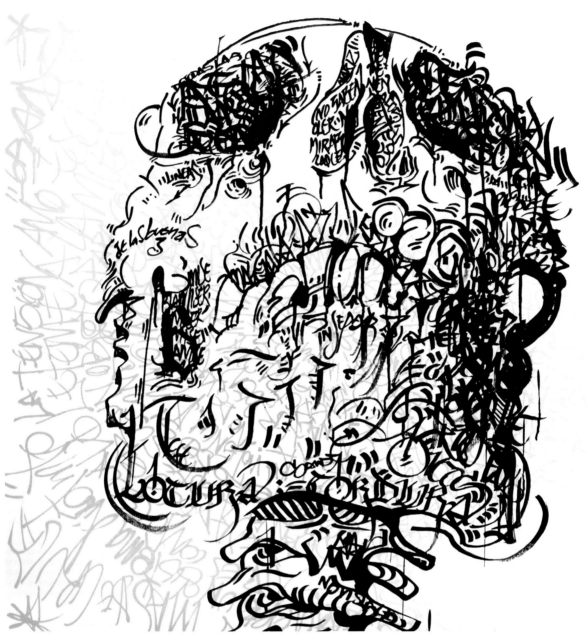

"Los Condenados De La Tierra (The Wretched Of The Earth)" –
Artist: Said Dokins – Krink and molotow ink/canvas – Mexico City (Mexico), 2010

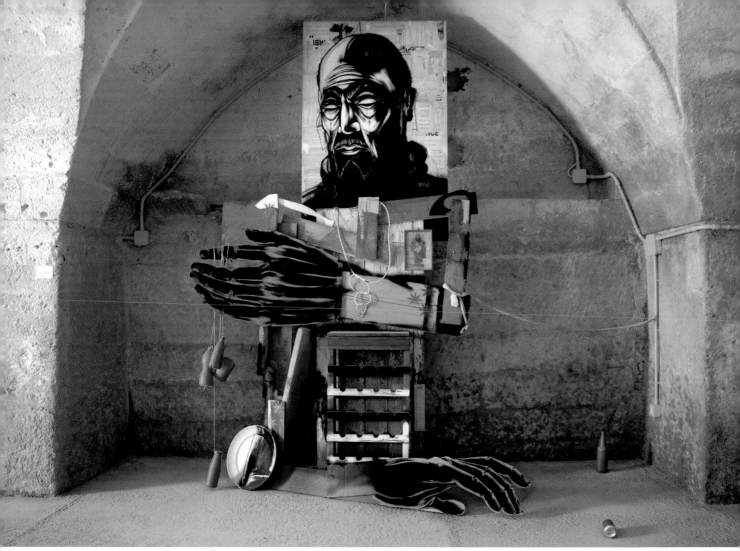

"Ciro Fame" – Artist: Dave Kinsey – Installation – Los Angeles (USA), 2010

"Head Trip" – Artist: Dave Kinsey –
Mixed media on canvas – Los Angeles (USA), 2010

"Continuum II" − Artist: Dave Kinsey −
Mixed media on canvas − Los Angeles (USA), 2010

"The Last Chair" − Artist: Dave Kinsey −
Mixed media on canvas − Los Angeles (USA), 2010

"Give Peace A Change" – Artist: Samuel Francois – Mixed media –
Collective show "Zero Gravity" at Galerie des Beaux-Arts de Metz (France), 2008 –
Photographer: Pierre Debusschere

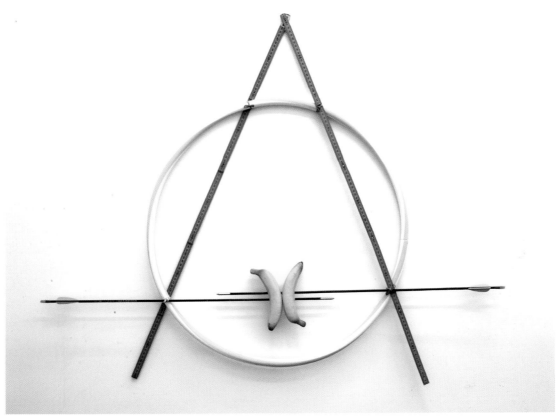

"Anarchie" – Artist: Samuel Francois – Mixed media –
Solo show "Let's Get Cool" at Galerie Jeanroch Dard, Paris (France), 2008 –
Photographer: G. Zaccarelli

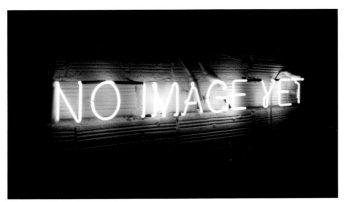

"No Image Yet" – Artist: Samuel Francois – White Neon –
Solo show "Wait & See" at Cripta747, Turin (Italy), 2010

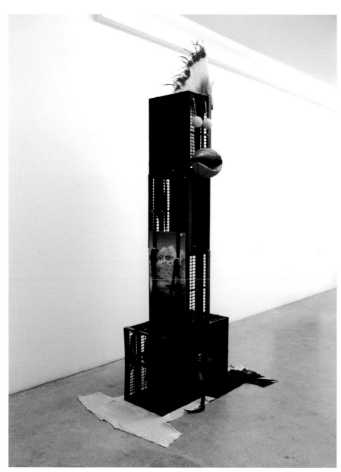

"Totem Zulu" – Artist: Samuel Francois – Mixed media –
Solo show "Zuper!" at Milieu Bern (Switzerland), 2009 –
Photographer: V. Meyner

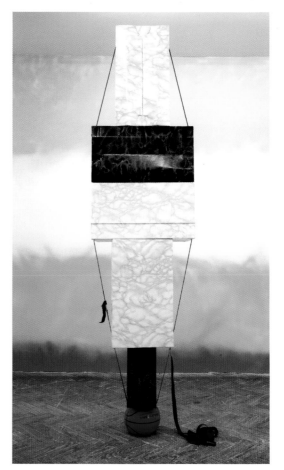

"Totem" – Artist: Samuel Francois – Mixed media –
Solo show "Let's Get Cool" at Galerie Jeanroch Dard, Paris (France), 2008 –
Photographer: G. Zaccarelli

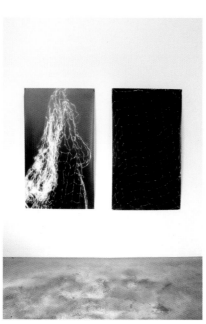

"Spontaneous 11 & 12" – Artist: Samuel Francois –
Spray paint on paper – Berlin (Germany), 2010

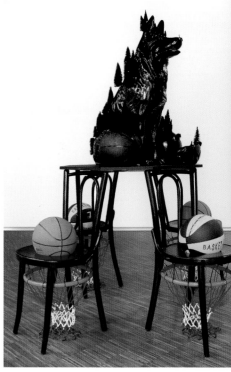

"Doggie Dunk" – Artist: Samuel Francois – Mixed media –
Collective show, Galerie Justin Morin at espace Bortier Bxl (France),
Photographer: Claire Decet

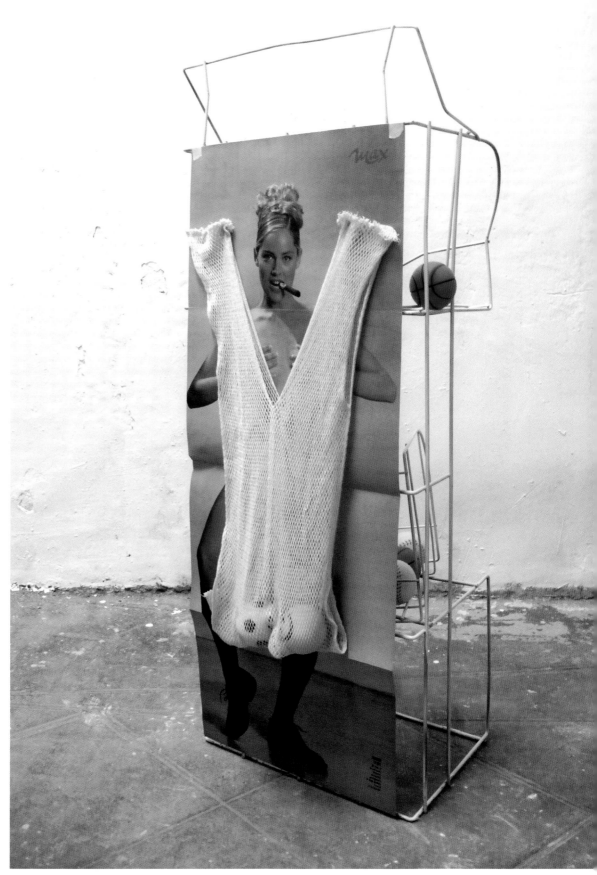

"Untitled (Sharon Iron)" – Artist: Samuel Francois – Mixed media –
Solo show "Wait & See" at Cripta747, Turin (Italy), 2010

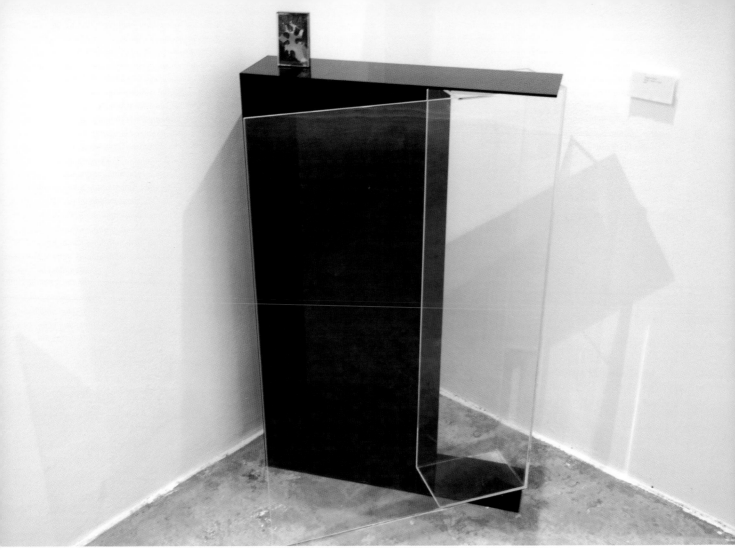

"(C-90) Bigger And Deffer"– Artist: Mark Drew – Plastic acrylic cassette
case sculpture – China Heights Gallery, Sydney (Australia), 2008

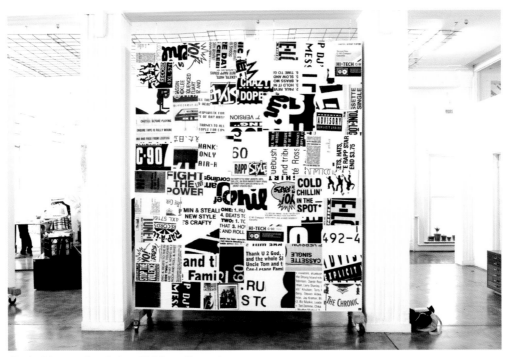

"(C-90) Exhibition installation" – Artist: Mark Drew – Xerox copies –
Don't Come Gallery, Melbourne (Australia), 2009

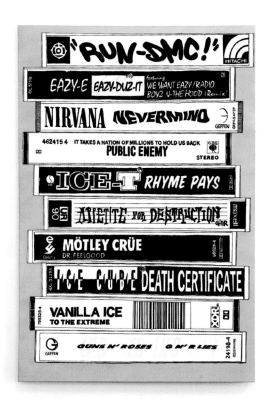

"(C-90) Early Days" – Artist: Mark Drew – Acrylic on canvas,
22cm x 178cm – Don't Come Gallery, Melbourne (Australia), 2009

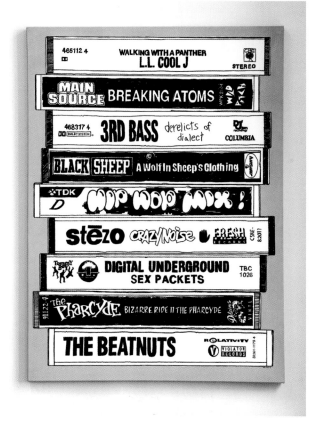

"(C-90) Eye Jammie" – Artist: Mark Drew – Acrylic on canvas,
91cm x 122cm, – Don't Come Gallery, Melbourne (Australia), 2009

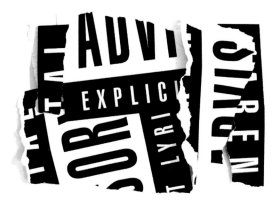

"Advisory" – Artist: Mark Drew – A1 digital print on paper –
China Heights Gallery, Sydney (Australia), 2009

"Housecall" – Artist: Mark Drew – A4, gocco print on paper –
Semi-Permanent Exhibition, Sydney (Australia), 2010

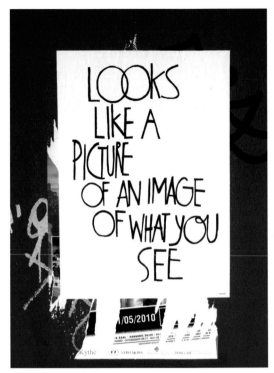

"Looks Like A Picture Of An Image Of What You See" – Artist: Erosie – Poster – Eindhoven (The Netherlands), 2010

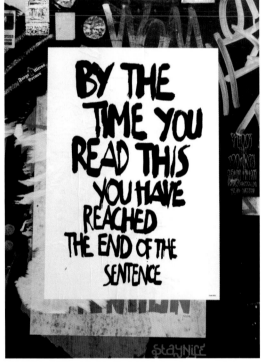

"By The Time You Read This You Have Reached The End Of The Sentence" – Artist: Erosie – Poster – Eindhoven (The Netherlands), 2010
Info: "The poster series refers to the marketing techniques used by commercial ad campaigns and the use of the street as a medium to do so. The difference between commercial and independent use of public domain has become extremely blurry, but to me still is an important aspect. The posters play with how a message is designed, what type of visual rhetoric is used in relation to what it actually tries to say. In this case both form and function have been reduced to an absolute pointless minimum, questioning why the poster is there to start with. But that is up to the viewer to decide."

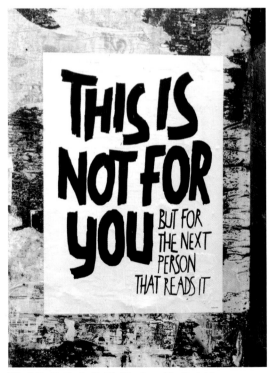

"This Is Not Fot You But For The Next Person That Reads It" – Artist: Erosie – Poster – Eindhoven (The Netherlands), 2010

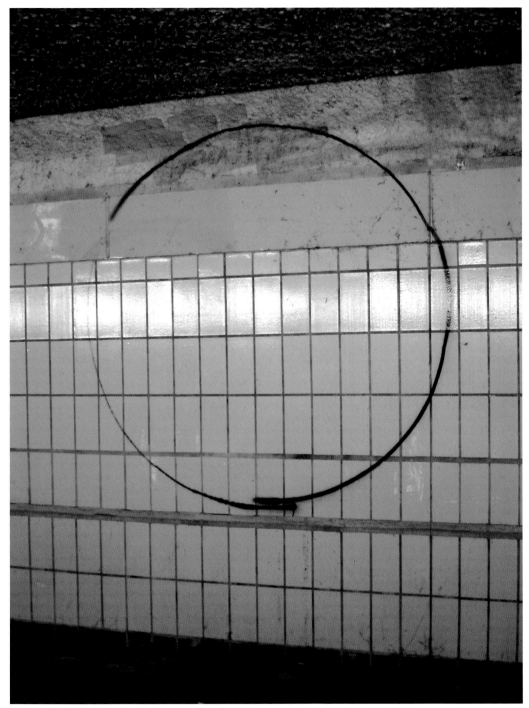

"The Perfect Circle" – Artist: Erosie –
Spray paint – Eindhoven (The Netherlands), 2009
Erosie: "In the past 17 years of doing graffiti I quit doing graffiti a couple of
times. Not very successful, since there is something about it that keeps crawling
back to you, that is just permanently stuck in your system. I think a lot of the
work I've been doing lately is not strictly matching the codes of graffiti, but
still refers to it one way or the other. The beauty of the act, the instant way
of using skills, the way of communicating, the illegal aspect, the visual power,
just to name a few. Doing a perfect freehand circle seemed like a powerful way
of referring to the traditions in art and a nice full circle way of finally quitting
graffiti. Again."

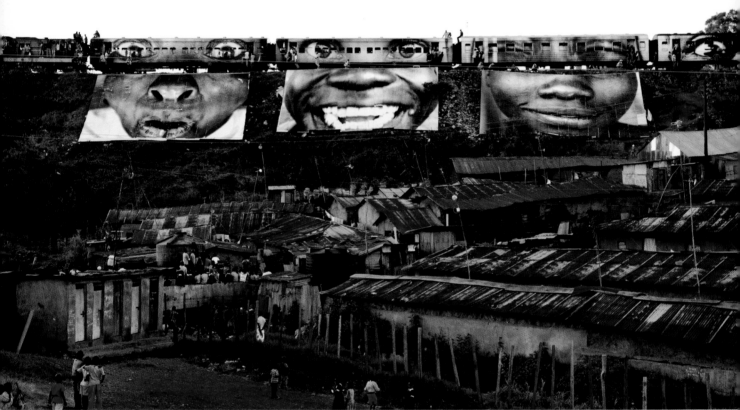

"28 Millimetres, Women Are Heroes" – Artist: JR –
Action in Kibera Slum Nairobi (Kenya), 2009.
JR: "We used 200 corrugated sheets to build the bottom of the 3 faces. At the end of
the action, we unbuilt them and distribute all sheets to build new classrooms for the
school. This picture is taken from the school's backyard ... "

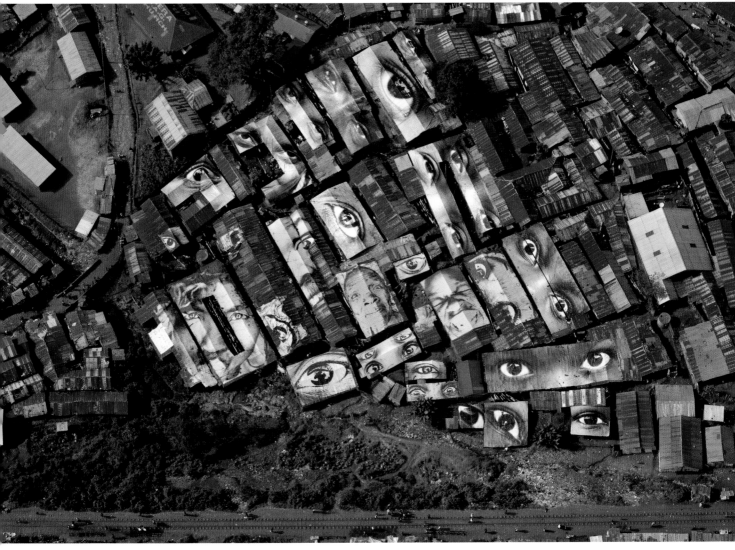

"28 Millimetres, Women Are Heroes" – Artist: JR –
Action in Kibera Slum, rooftops, Nairobi (Kenya), 2009.
JR: "We went back to Kibera to cover another 1800 meter square of rooftop next to
the previous ones. The texture of the banners protect the house from leaking and are
kept by the community over the years. A non-commercial book has been spread to the
community, signed by the women from the project. The same action was previously done
in Spain and Brazil."

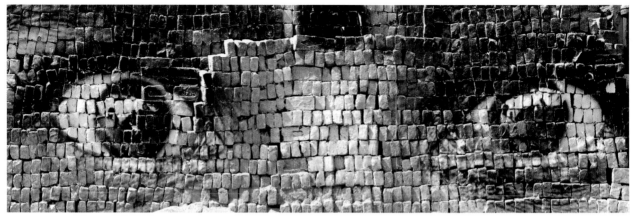

"28 Millimetres, Women Are Heroes" – Artist: JR –
Really technical pasting ... – Action in New-Delhi (India), 2009

"28 Millimetres, Women Are Heroes" – Artist: JR –
Exhibition in San Diego (USA), 2010
JR: "Within the context of the exhibition «Viva la Revolucion –
A dialogue with the Urban Landscape». Indeed!" –
Photographer: Geoff Hargadon

"28 Millimetres, Women Are Heroes" Artist: JR, Vhils –
Exhibition in Los Angeles (USA), 2010.
JR: "First collaboration with Vhils who uses to sculpt portraits in
the walls. In this way the portrait will stay for years ... Well done." –
Photographer: Eden Tyler

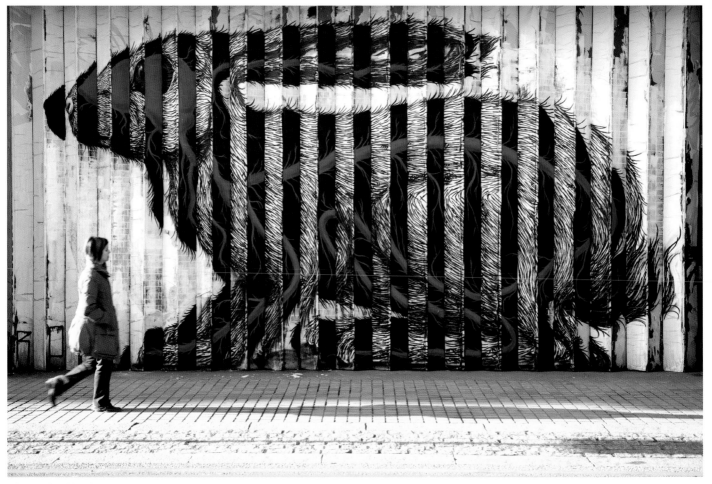

"The lenticular Rabbit – frontal view" – Artist: ROA –
Freehand spray can – London (United Kingdom), 2009
ROA: "It was December in London, freezing my fingers off by
the cold pressure from the cans in my hands. Painting this piece
made me sometimes dizzy. To get the two angles in perspective and
meanwhile standing in West London in the street constantly been
approached by people was a mental and puzzle skill test!" –
Photographer: RomanyWG

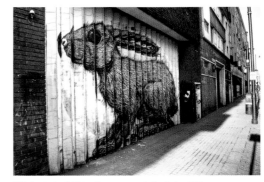

"The lenticular Rabbit – fleece perspective" – Artist: ROA –
Freehand spray can – London (United Kingdom), 2009 –
Photographer: RomanyWG

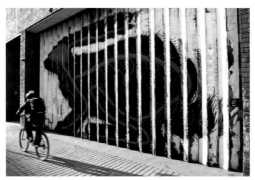

"The lenticular Rabbit – nerve system perspective" – Artist: ROA –
Freehand spray can – London (United Kingdom), 2009 –
Photographer: RomanyWG

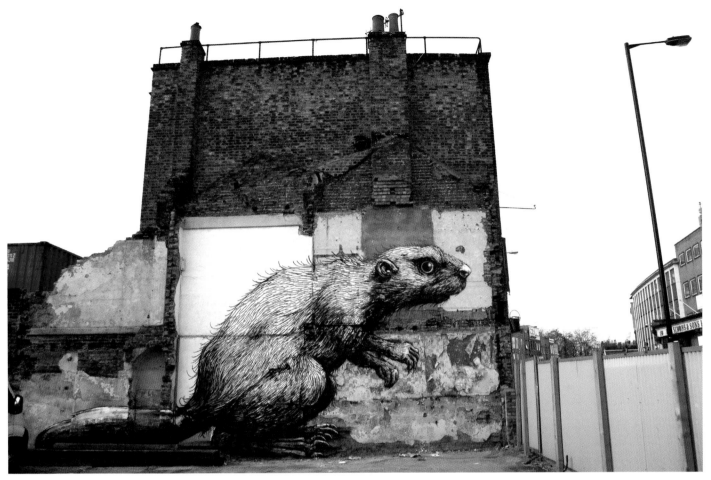

"Beaver" – Artist: ROA – Ghent (Belgium), 2009

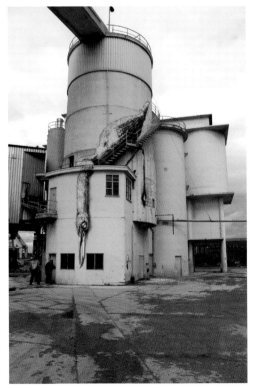

"The Hanging Bird" – Artist: ROA – Ghent (Belgium), 2009

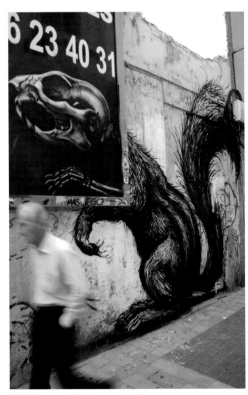

"Rabbit" – Artist: ROA – Zaragosa (Spain), 2010

"Barcelona Neta" – Artist: Sixe – Centre de
Cultura Contemporània de Barcelona (Spain), 2009

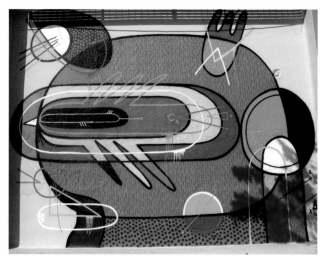

"Mutanteanimal" – Artist: Sixe – Badalona (Spain), 2010

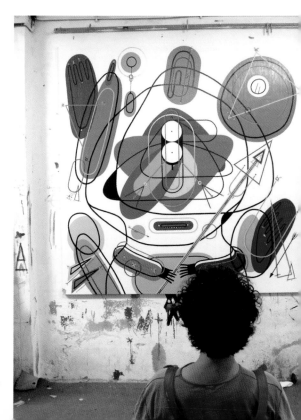

"Guerreros" – Artist: Sixe – Barcelona (Spain), 2009

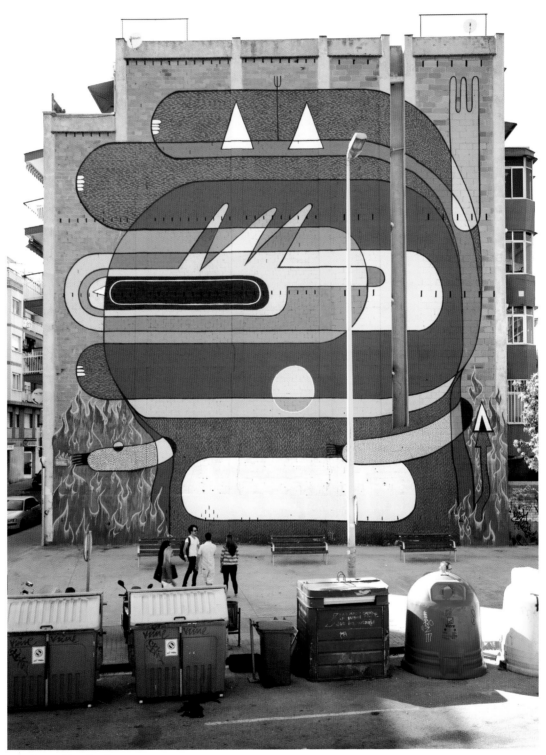

Artist: Sixe – Badalona, (Spain), 2010

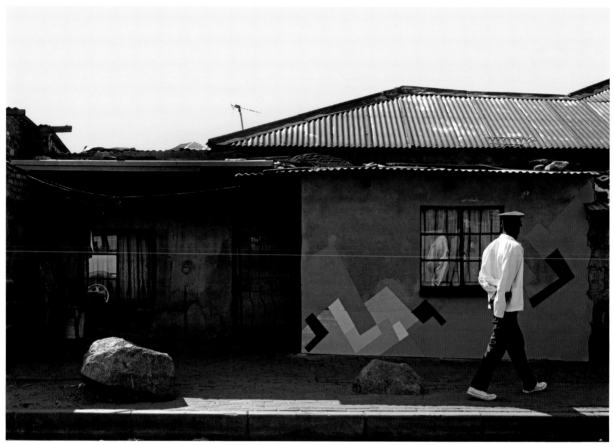

Artist: Nuria – South Africa, 2010

Artist: Nuria – Palma de Mallorca (Spain), 2010

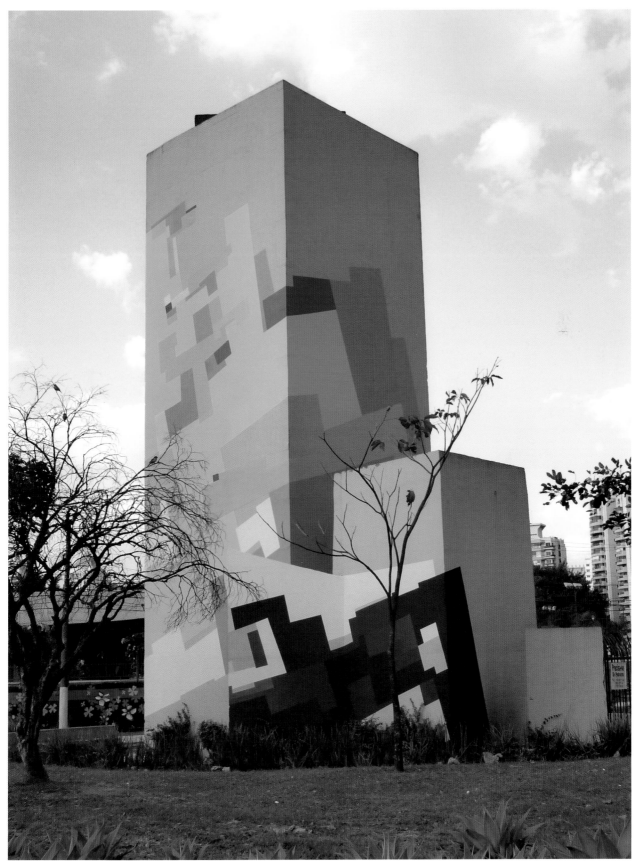

Artist: Nuria – Sao Paulo (Brasil), 2010

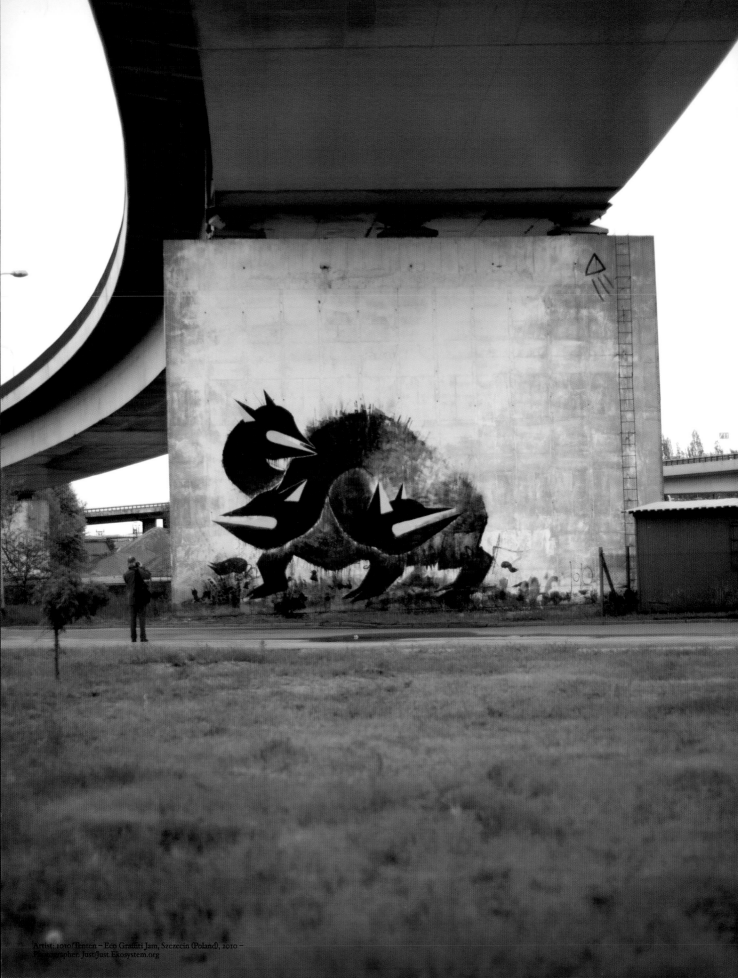

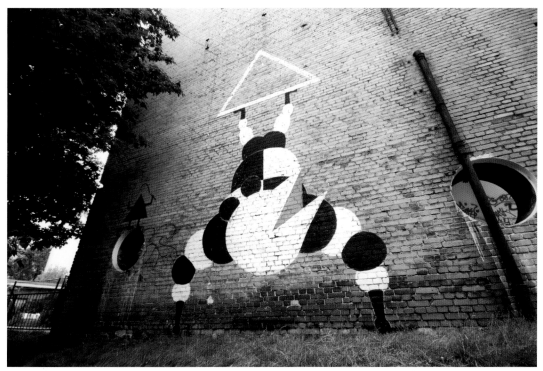

Artist: 1010/Tenten – Urbanaffairs 2, Berlin (Germany), 2009 –
Photographer: Just/Just.Ekosystem.org

Artist: 1010/Tenten – Frappantgebäude, Hamburg (Germany), 2009 –
Photographer: Just/Just.Ekosystem.org

"Emdiment" – Artist: 1010/Tenten – Hamburg (Germany), 2009 –
Photographer: Just/Just.Ekosystem.org

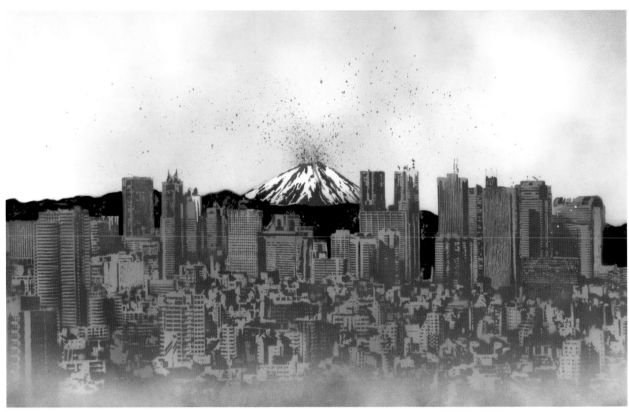

Artist: Nick Walker – Stencil on canvas – 2010

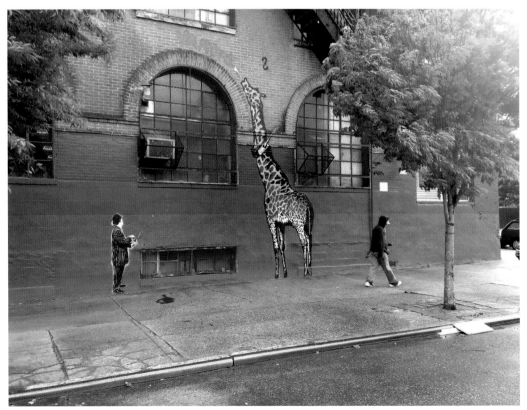

Artist: Nick Walker – Stencil – New York (USA), 2010

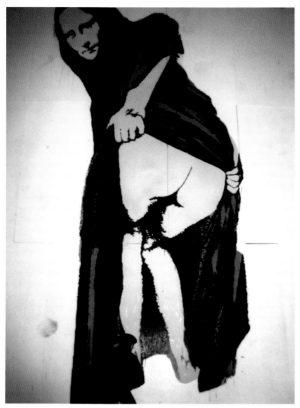

Artist: Nick Walker – Stencil – 2010

Artist: Nick Walker – Stencil – 2010

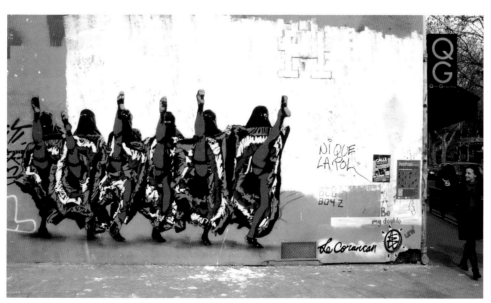

Artist: Nick Walker – Stencil – Paris (France), 2010

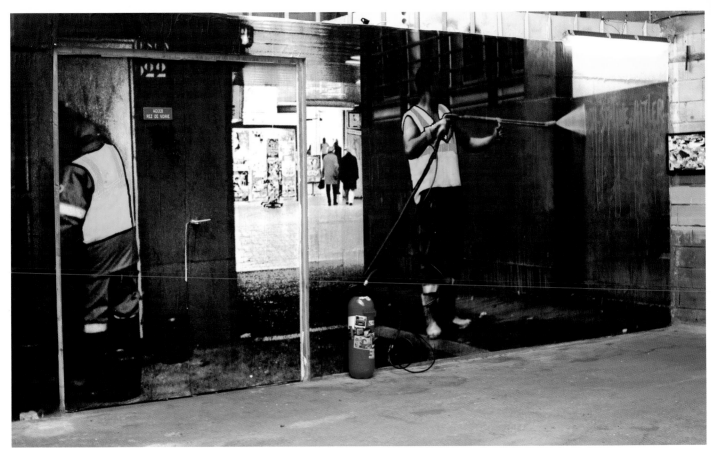

"Buff" – Artist: G* – Poster – Paris (France), 2009

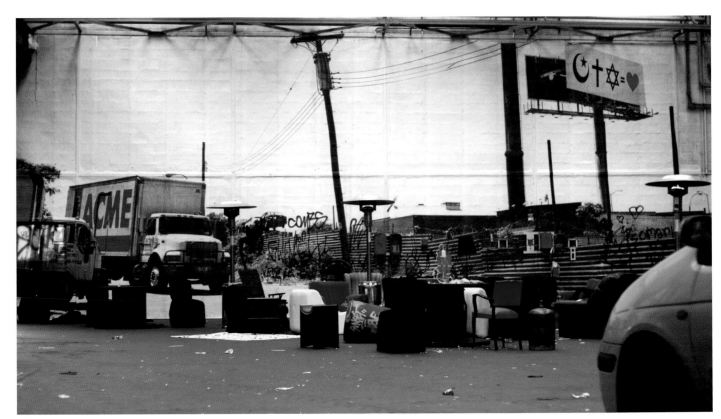

"Acme" – Artist: G* – Poster – Paris (France), 2009

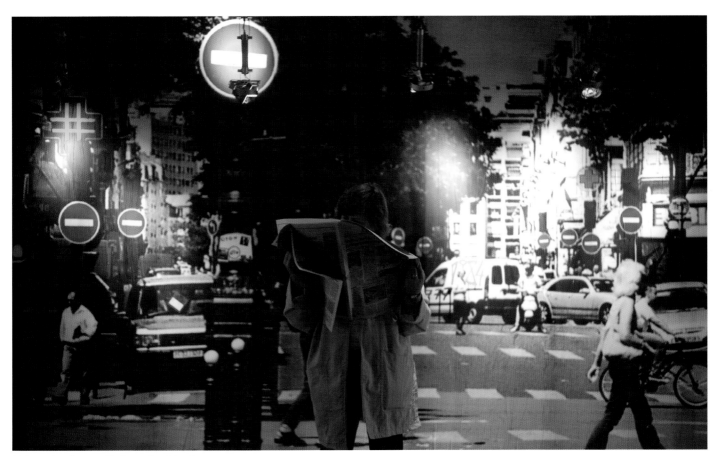

"Forbidden Street" – Artist: G* – Poster – Paris (France), 2009

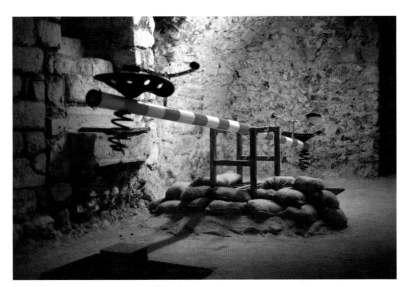

"Le Trebuchet" – Artist: G* – Poster – Paris (France), 2009

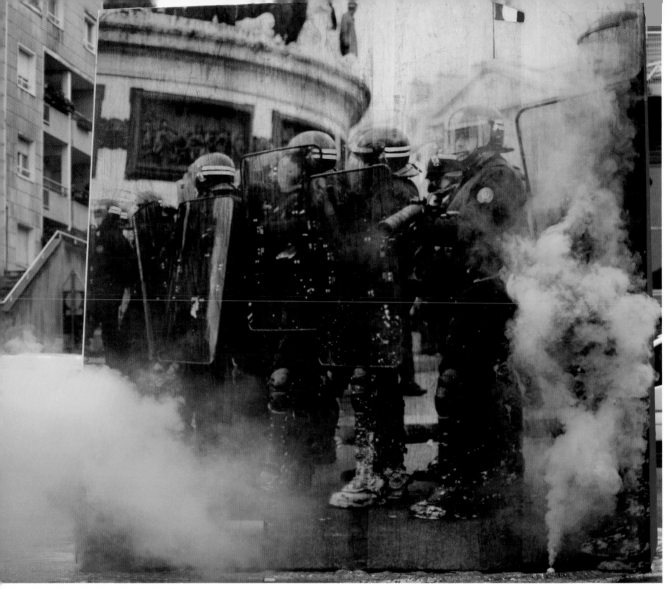

"Inside Riots Before" – Artist: G* – Paris (France), 2009

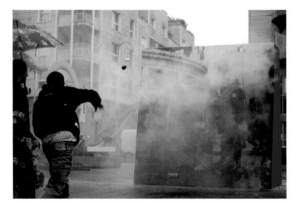

"Inside Riots Action" – Artist: G* – Paris (France), 2009

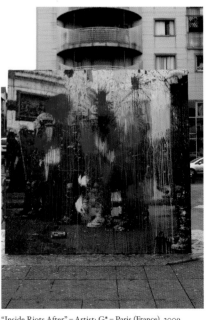

"Inside Riots After" – Artist: G* – Paris (France), 2009

"Mauer Before" – Artist: G* – Poster – Paris (France), 2009

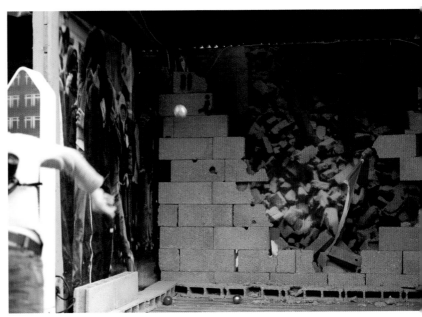

"Mauer Action" – Artist: G* – Poster – Paris (France), 2009

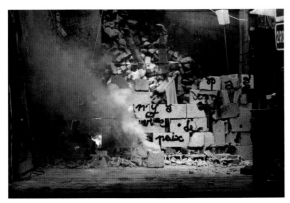

"Mauer After" – Artist: G* – Paris (France), 2009

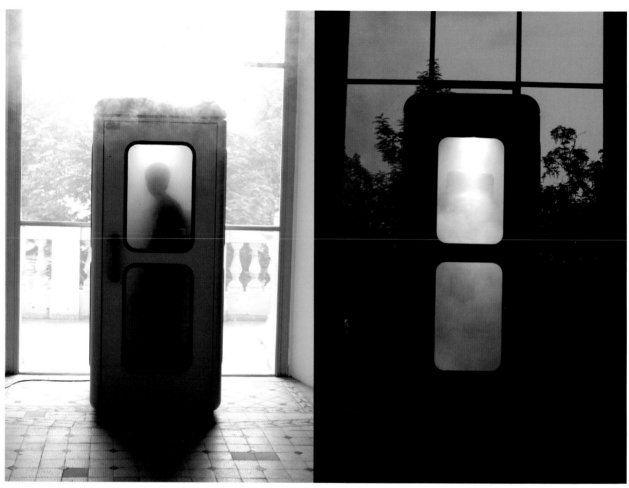

"Paradise Garage" – Artist: Benjamin Röder – Phone booth,
PA, strobe, fog machine, 240cm x 90cm x 100cm –
Munich (Germany), 2007

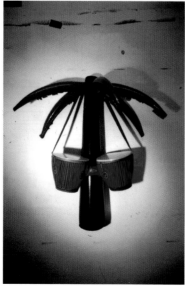

"Bingo" – Artist: Benjamin Röder –
Fragments of plastic toys, 120cm x 70cm –
Munich (Germany), 2009

"Bongo" – Artist: Benjamin Röder –
Fragments of plastic toys, 120cm x 70cm –
Munich (Germany), 2009

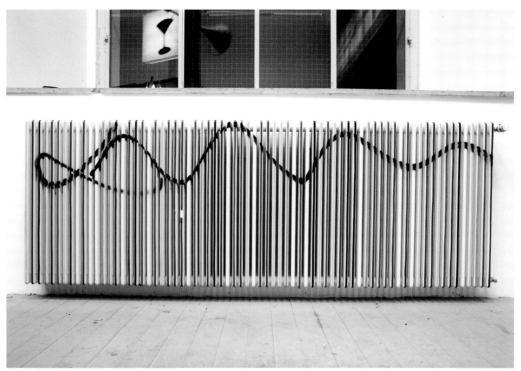

"Record Rack (Part of the installation "Record Box)" –
Artist: Benjamin Röder – Radiator, isolation tape, spray paint,
400cm x 140cm – Munich (Germany), 2009

"Chrome Lagoon" – Artist: Benjamin Röder –
Aluminum tubes, palm, blue flash light (7m x 4m x 7m) –
Munich (Germany), 2010

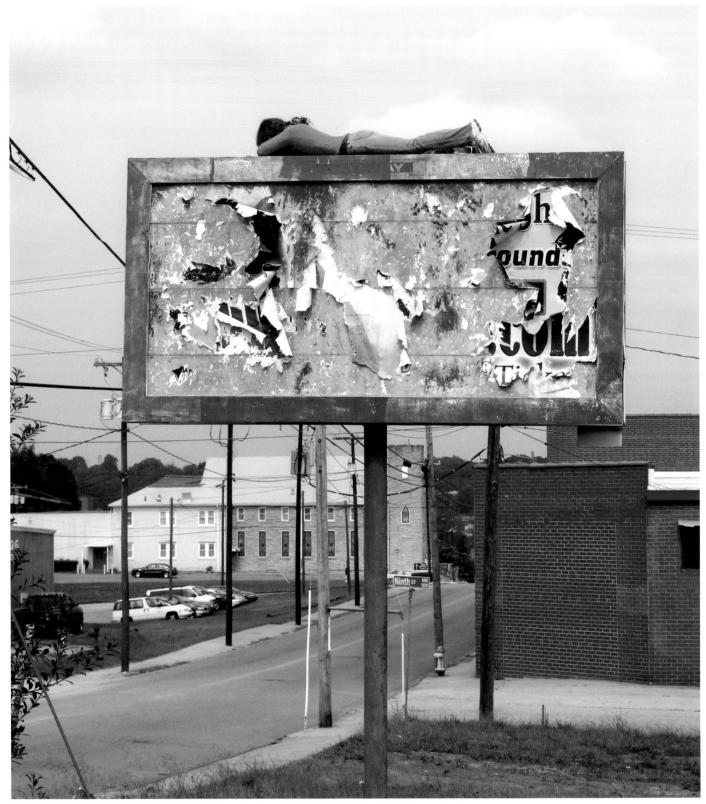

Artist: Mark Jenkins – Mixed media -
Winston, Salem (USA) 2009

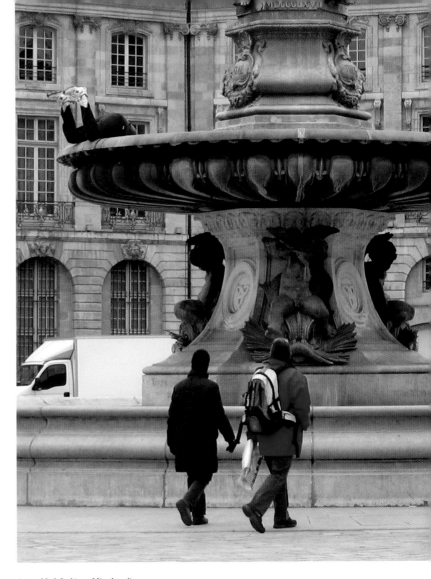

Artist: Mark Jenkins – Mixed media -
Bordeaux (France), 2008

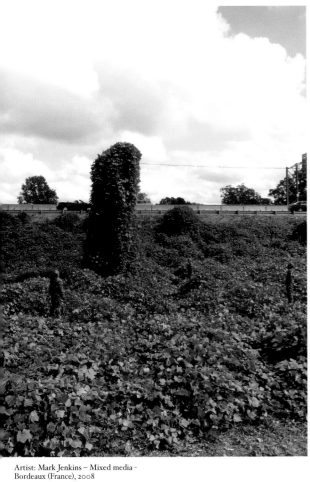

Artist: Mark Jenkins – Mixed media -
Bordeaux (France), 2008

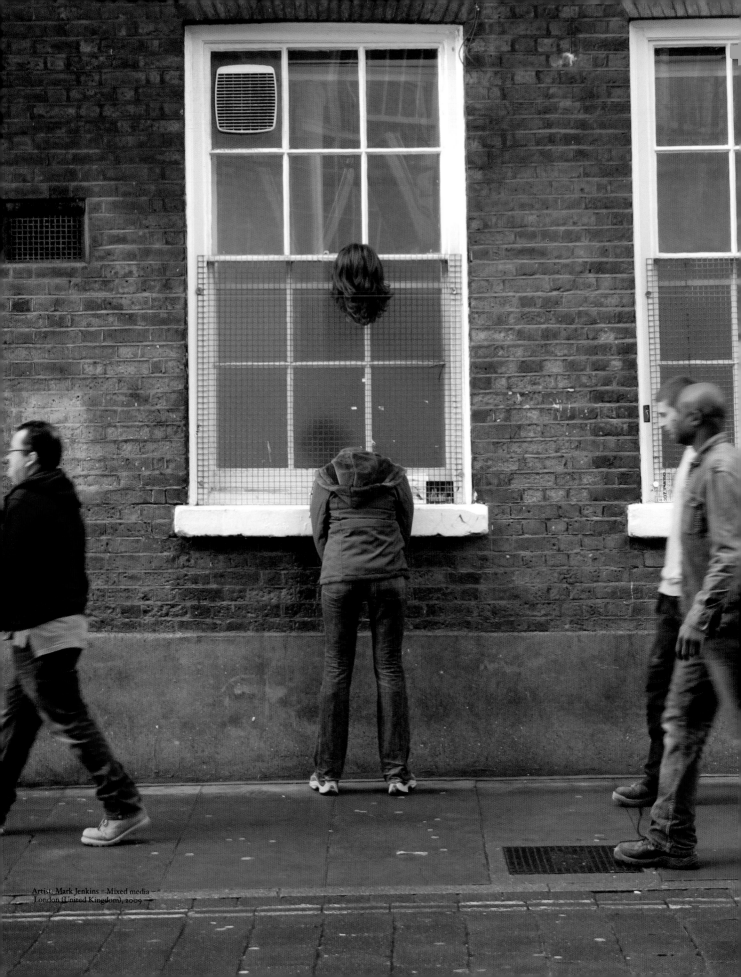

Artist: Mark Jenkins – Mixed media
London (United Kingdom), 2009

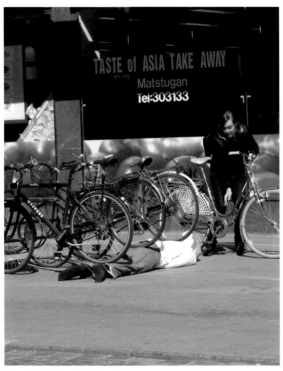

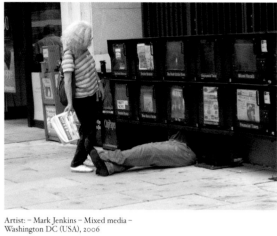

Artist: – Mark Jenkins – Mixed media –
Washington DC (USA), 2006

Artist: Mark Jenkins – Mixed media –
Malmo (Sweden), 2009

Artist: Mark Jenkins – Packing tape –
Bordeaux (France), 2008

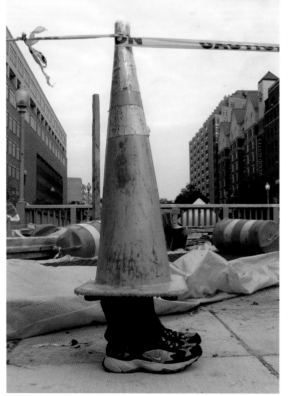

Artist: Mark Jenkins – Mixed media –
Washington (USA), 2006

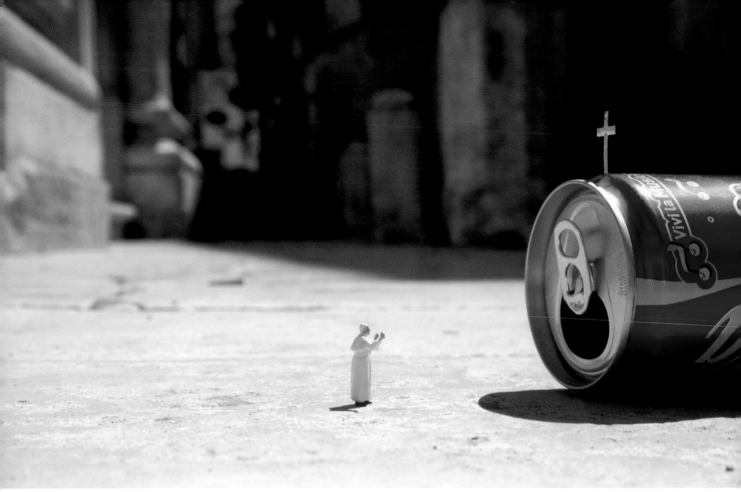

"Glory" – Artist: Slinkachu –
Grottaglie (Italy), 2009

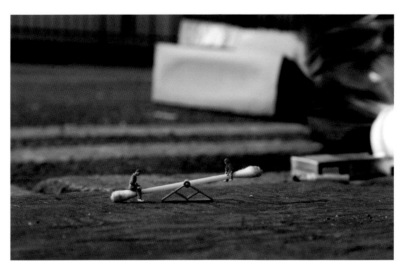

"Next Year, Eurodisney" – Artist: Slinkachu –
London (United Kingdom), 2010

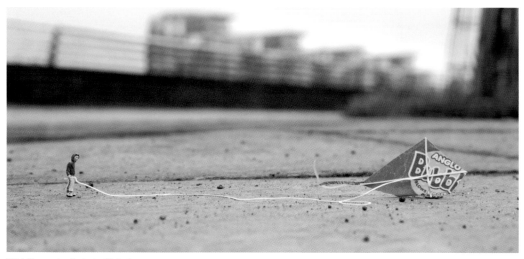

"High Expectations" – Artist: Slinkachu –
London (United Kingdom), 2010

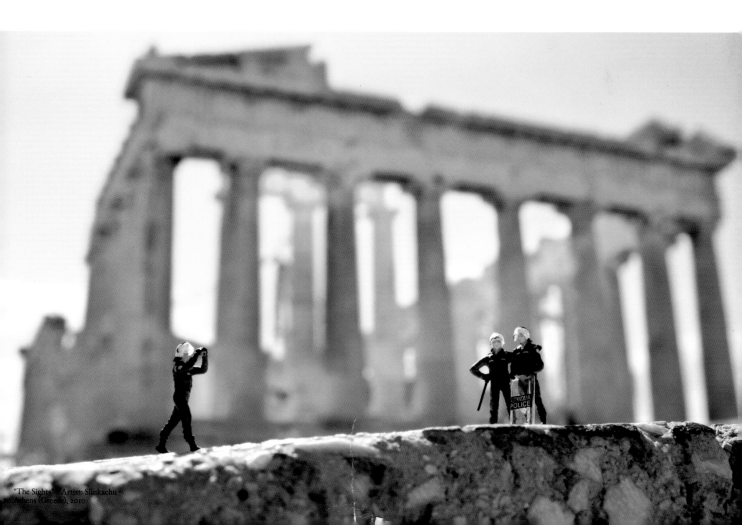

"The Sights" – Artist: Slinkachu –
Athens (Greece), 2010

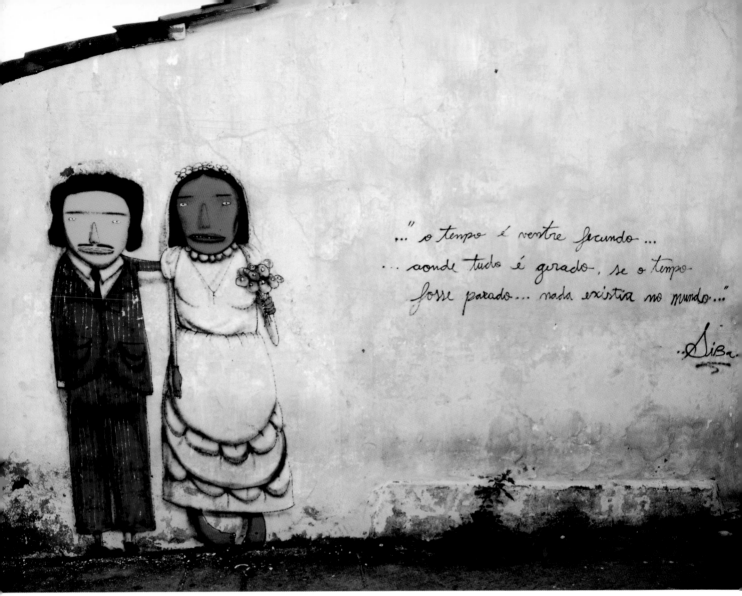

..." o tempo é ventre fecundo ...
... aonde tudo é gerado, se o tempo
fosse parado ... nada existia no mundo ..."

..Siba.

Artist: Os Gemeos – Spray paint – Nazare da Mata (Pernambuco), 2008

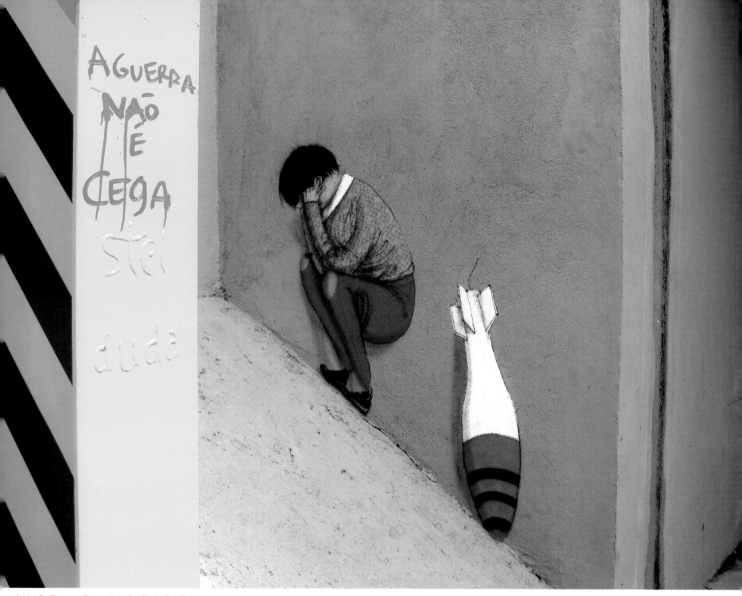

Artist: Os Gemeos – Spray paint – Sao Paulo (Brasil), 2010

Artist: Eltono – Latex paint – Hotel España, Hanoi (Vietnam), 2010
Eltono: "At the end of June 2010 I was invited by the Spanish embassy in
Hanoi to paint the facade of the Sen Thang Long hotel, close to the Old
Quarter. I spent 20 days there and was helped by Duy, Bái, Thăng y Nhi,
four painters used to extreme working conditions, who ended being my
hosts and allowed me discover the city and Vietnamese culture in a very
unusual and authentic way."

"Flamingo Beach Lotel" – Artist: Evol – Installation in a corridor of a low-budget art hotel in Neukölln (Berlin) – Berlin (Germany), 2007

"Caspar-David-Friedrich-Stadt" – Artist: Evol – Dresden (Germany), 2009
Evol: "Installation in a 10*8m hole on the ground of the abandoned slaughterhouse area
in Dresden. Probably the former foundation of a huge boiler plant to derive soap from
rendered beef fat or other utilization of carcass. However, even 15 years after closing
down, it still smells nauseating. The main slaughterhouse complex was built in 1906
by Hans Erlwein, Kurt Vonnegut's novel "Slaughterhouse Five" also takes place there.
Caspar David Friedrich painted the area called "Ostragehege" in 1832, and my favorite
footnote is that his father was a soap-boiler."

"Interferences" – Artist: Urban Blooz –
Poster – Milan (Italy), 2007

"Ballon #1" – Artist: The Wa –
Mixed media – Stockholm (Sweden), 2009

"Ballon #2" – Artist: The Wa –
Mixed media – Hong Kong (China), 2009

"Lollipop" – Artist: The Wa –
Mixed media – Berlin (Germany), 2008 –
Photographer: Giuseppe Morittu

"Bitte Keine Reklame (No Advertising, Please)" –
Artist: The Wa – Poster – Berlin (Germany), 2007
Info: These posters look exactly like stickers usually
used on mailboxes to avoid unwanted advertising.

"Abstractor (Before)" – Artist: Ji Lee –
Installation – New York (USA), 2010
Info: Transforming a video billboard into a piece of public art.

"Abstractor (After)" – Artist: Ji Lee –
Installation – New York (USA), 2010

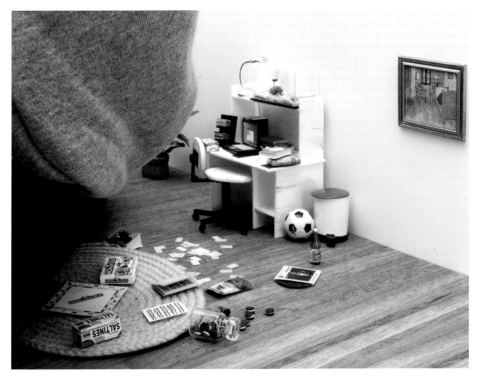

"Squozen"– Artist: Ji Lee –
Installation – New York (USA), 2010

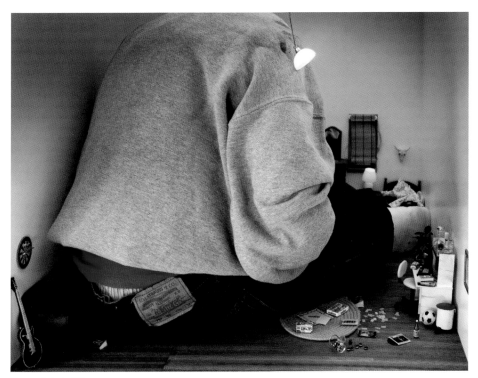

"Squozen"– Artist: Ji Lee –
Installation – New York (USA), 2010

"Parallel World"– Artist: Ji Lee –
Installation – New York (USA), 2010

"Duchamp Reloaded"– Artist: Ji Lee – Installation – New York (USA), 2010
Info: In 1913, Marcel Duchamp took found objects from the streets and placed
them in museums. 96 years later, if Duchamp were alive, he may want to do the
very opposite.

"The Bubble Project" – Artist: Ji Lee –
Installation – New York (USA), 2010

Artist: Skewville – Norway, 2010

Artist: Skewville – New York (USA), 2010

Artist: Skewville – New York (USA), 2010

Artist: Skewville – New York (USA), 2010

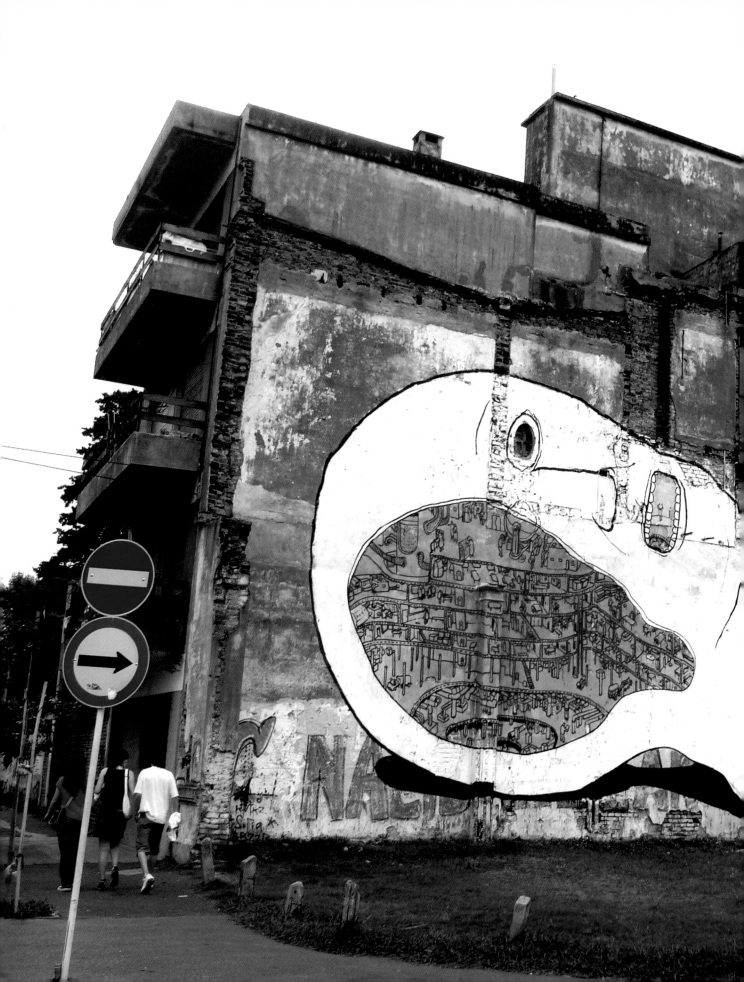

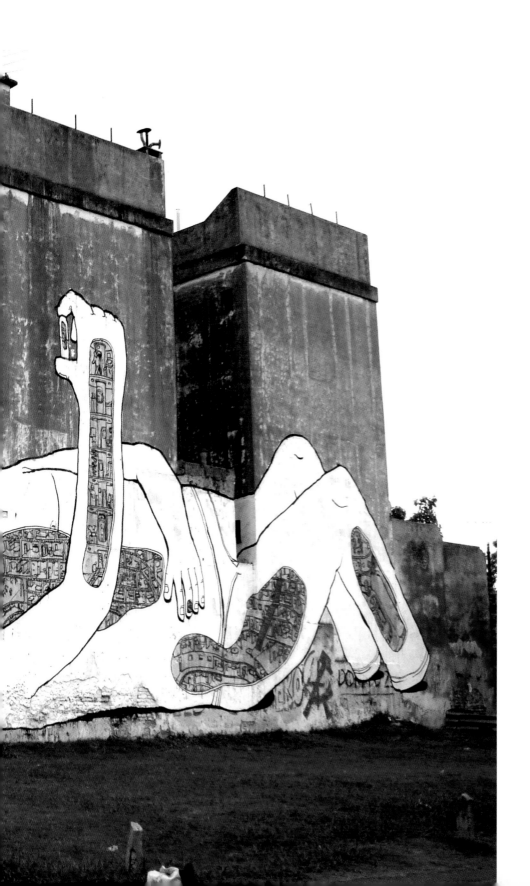

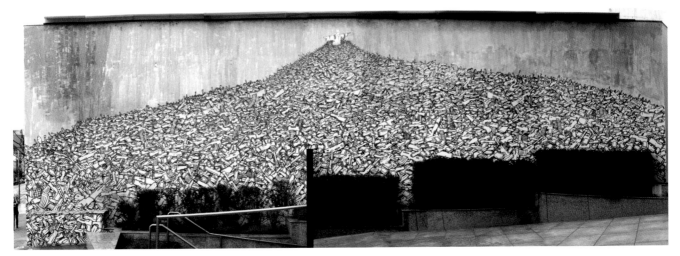

Artist: Blu – Sao Paulo (Brasil), 2009

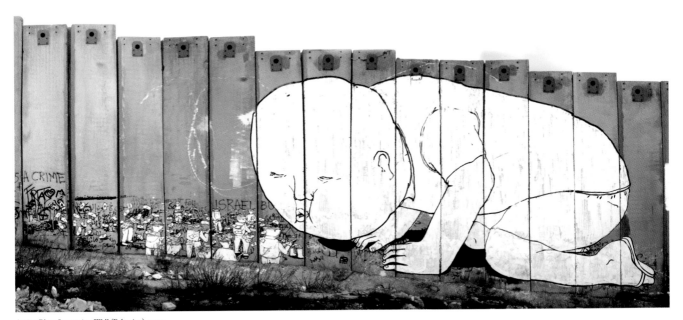

Artist: Blu – Separation Wall (Palestine), 2007

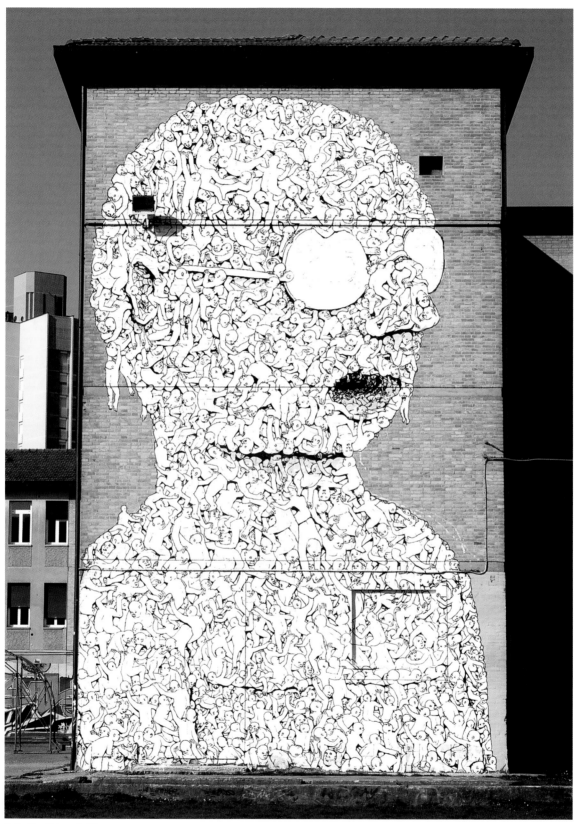

Artist: Blu – Bologna (Italy), 2010

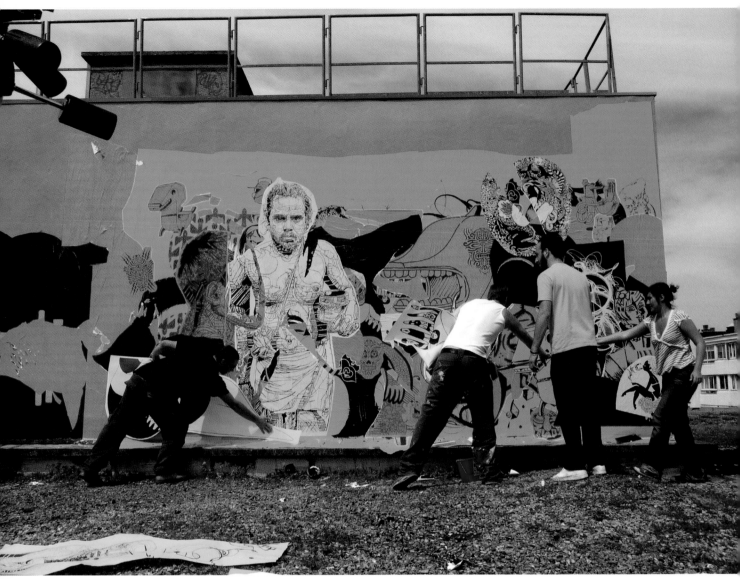

Artists: 9me Concept –
Collage – Paris (France), 2010

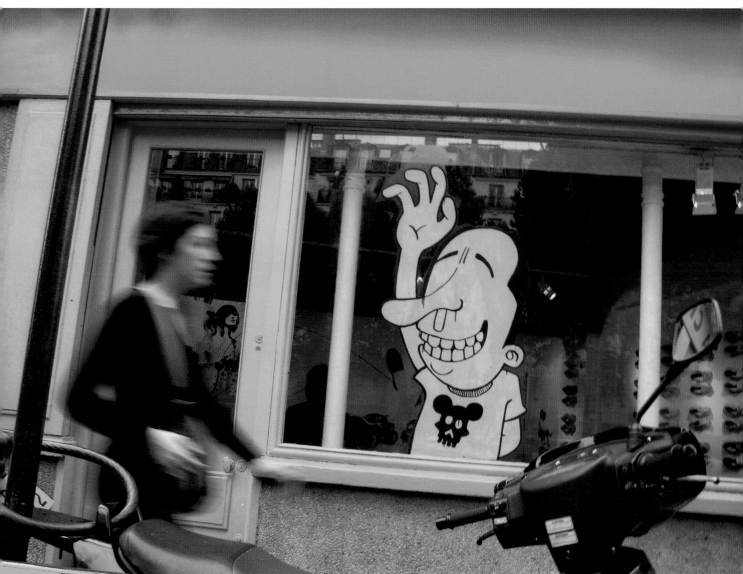

Artist: Mambo – Paris (France), 2010

Info

56K – Ole Utikal aka 56K is an Hamburg based designer and artist. Working 24 hours a day as a graphic designer he spends the rest of his time doing wallpaintings, sticker campaigns and screenprint editions. His work is characterized through a simplified imagery rooted in urban culture and a very unique sense of digressive humor – www.56kpublicservice.de

Above – *1981, Above has been creating public art since 1995. Above is an international contemporary street artist who keeps his identity concealed and is widely known for his multi-layer/full color social and political stencils, spinning wooden "Arrow Mobile" installations, and large mural "Word Play" paintings. Above started traditional graffiti of tagging freight trains in California in 1995. Above moved to Paris at the age of 19 where he started painting his trademark arrow (pointing above) all around the city. Since then Above has been consistently traveling around the world doing many large self-financed "Tours" with each tour exploring a new medium or style of artworks. Above's tenacity to travel the world and push his artistic limits is what makes many people admire and respect this young artist. Above has been successful in putting his street artworks in over 60+ cities in 45+ different countries around the globe making Above one of the major players in the "Street art" realm – www.goabove.com

Aiko (Nakagawa) – Born in Tokyo, currently resides in New York since late '90. She has been an influence on the contemporary art scene since she co-founded the Brooklyn-based international art collective, Faile in 1999. In 2006, Aiko left Faile to focus on her solo work, which exhibits a grittiness inspired by the streets. Floral designs, girl cartoons and street pop culture images are all incorporated on her mixed media works. Aiko utilizes both stencil and silkscreen print techniques to create her vibrant large-scale works which often transform "Cupcake" images to playfully portray feminine sexuality and beauty. Being an immigrant from Japan, Aiko has herself been discovering Americana–type pop imagery and recreating it in an innovative way. She has recently shown her works at MoMa PS1 in New York, Brooklyn Museum in New York, MACRO Future in Rome, and Shanghai MoCA in China – www.ladyaiko.com

Ana Ellmerer – *1985 Cologne (Germany), lives and works in Munich (Germany) – www.anaellmerer.com

Arno Piroud – A Paris (France) based artist and designer – www.starnocity.com

Ben Frost – Known for his kaleidoscopic Pop Art, mash-up paintings that take inspiration from areas as diverse as graffiti, collage, photorealism and sign-writing. Subverting mainstream iconography from the worlds of advertising, entertainment and politics, he creates a visual framework that is bold, confrontational and often controversial. With a blatant disrespect for the signifiers of our visual culture, he creates multi-layered surfaces of refreshing intensity. He has been exhibiting throughout Australia and internationally over the last 12 years, including solo shows in London, New York and San Francisco, as well as group shows in Beijing, Amsterdam, Berlin and Singapore – www.benfrostisdead.com

Benjamin Röder – lives and works in Munich (Germany) – www.benjaminroeder.com

Blu – www.blublu.com

Brad Downey – *1980 in Louisville (USA) – braddowney.com

Christian C100 Hundertmark – *1974 in Munich. His first graffiti sketch "Batman" in 1989 was the ignition for 10 years of Graffiti writing, followed by studies in graphic design and starting to work on streets again in 2000. In 2008, French publishing house Pyramyd's released a book series with their "Design And Designers" book series. Christian lives and works in Munich – www.c100studio.com, www.christianhundertmark.com

Carol Hummel – *1951, Carol holds a Bachelor of Science degree in Photojournalism and a Master of Fine Arts degree in Sculpture. She travels extensively doing art projects and has recently completed large-scale site responsive projects in Ohio, Utah, Colorado, Ireland and India. Her current interest lies in focusing attention on social and environmental issues through her art – www.carolhummel.com

Cedric Bernadotte – www. cedricbernadotte.com/streetart

Conor Harrington – www.conorharrington.com

Dave the Chimp – Born in London, lives in Berlin, where he likes to draw, ride skateboards, make masks, and publish fanzines, but doesn't like to write biographies for books, especially as all that information is on his website! – www.davethechimp.co.uk – www.themonkeysmasks.tumblr.com – www.fotolog.com/chimp243

Delta – www.deltainc.nl

Dtagno – *1976 in Munich (Germany), works and lives in Berlin – www.dtagno.de

East Eric – www.easteric.net

Eine – www.einesigns.co.uk

Eltono – *1975 in Paris (France), lives and works in Madrid (Spain) – www.eltono.com

Erik Tidemann – *1982 in Trondheim (Norway) – www.eriktidemann.com

Erosie – Jeroen Erosie, *1976, lives and works in Eindhoven – www.erosie.net

Escif – With influences coming from mural painting, Escif's work falls in a category of "Urban language", mainly articulated throught the recuperation and appropiation of forgotten and disused spaces. He uses illustration as a line of thought, an attempt at facing up to fears, reflections, restlessness and personal contradictions. He likes working with limited media, offering a variety of ways in which the art can be interpreted. Above all he incides at the experimentation from his works. The obvious relationship between the illustrations and the environments wich surround them presents an encouragement to the spectaor who wishes to approach them. The limits between experience and representation are often not so clear to see. His work lies in an artistic no-mans-land, unappreciated by the more orthodox graffiti mouvement owing to the improper bending of the rules and shunned by the world of more convencional illustration, who consider a wall in the Street as a inapropiate canvas for art. It is neither one thing nor the other and that brings obvious pros and cons – www.flickr.com/escif, www.myspace.com/escif

Evol – *1972 – 1974 picked up first pencil – 1994 picked up first spraycan – 2000 Kuopio academy of crafts and design (Finland) – 2001 degree in product design, Hochschule für Gestaltung Schwäbisch Gmünd (Germany) – lives and works in Berlin (Germany) – www.wilde-gallery.com/artist_evol.html

Finsta – www.finstafari.com

G* – www.human.ist.free.fr

Husk Mit Navn – www.huskmitnavn.com

Influenza – "Jeroen Jongeleen (Influenza) lives and works in Paris and Rotterdam. His practice evolves out of an on-going engagement with public space and much of his work is presented in the form of subtle interventions, which seem to target advertisements, architectural structures and signs that regulate public behavior. Often he creates imprints of these interventions, viruses left to engage with the body of the citizenry and disrupt status quo signification. In other cases, he leaves no trace that could place him on the radar and heaves yet another step between art and material objects, instead seeming to concentrate on the joys of failures, findings and improvement. As artworks, these actions speak of opportunities and demonstrate an ongoing relationship between artist and subject, an examination of urban potentiality and pitfalls. It is not simply doing for doing, but doing to discover what can be done and in documenting that as a work of art, Jongeleen manages to reveal parts of his act without compromising the magic. What we see in this case is not a conceptual movement, but a personal philosophy being lived. Most of the time there is no violent gesture. But always there is the artist's joy as he explores himself in the world." – Harlan Levey (Modart Magazine) – www.flu01.com

Jan KRSN Garet – *1974 Germany. He began his artistic carrer as an techno act when he was 15 years old. He got finally tired by the bpm and then focused on chess and graffiti until the young designer award was given to him by a female highschool jury in 1997. After a severe neck jinx he discovers drawing and today his work is showed and sold around the world. He lives and works in Paris since 1999 – www.nsrknet.free.fr

Ji Lee – www.pleaseenjoy.com

Jonathan Yeo – www.jonathanyeo.com

Jordan Seiler – Jordan Seiler began the PublicAdCampaign project in December of the year 2000 as a way of questioning advertising's assumed right to public space, while championing the public's role in the curation of our shared environment. Since then it has grown from a singular artistic endeavor to a widespread collaborative activist movement. Projects range from single advertising appropriations, to large scale organized civil disobedience actions spanning entire cities. While aesthetics may inform the PublicAdCampaign project, the ultimate goal is to empower myself and others to freely alter our public spaces in an effort to build a healthier relationship with our cities and therefore communities – www.publicadcampaign.com

Just – just/ekosystem.org

JR – JR is a French artist. He creates engaging projects for monumental urban, actions and exhibitions. In 2007, Face2Face illegally presented giant portraits of Israelis and Palestinians on both sides of the Separation wall / Security barrier and in 8 cities. In 2008, he embarked on an international journey for Women Are Heroes, a project in which he highlights the dignity of women. In 2010, his feature film eponyme entered the competition for the Caméra d'Or of the Cannes Film Festival. JR has exhibited in Paris, London (Tate Modern), Amsterdam (Foam), Arles (Rencontres Internationales), Berlin, Los Angeles, and New York – www.jr-art.net

Kid Acne – *1978 in Lilongwe, Malawi. Lives and works in Sheffield (United Kingdom). He began writing graffiti at the age of twelve, inspired by its infinite scale, color and immediacy. Applying the same DIY ethos to the rest of his output, he spent his teenage years creating underground fanzines, comics and releasing limited run 7"s and LP's on his own Invisible Spies imprint. Using spray paint, household gloss, screen print and ink on paper, Kid Acne embraces the ephemeral nature of the great outdoors and connotes fantasy and folklore, turning the mundane into spectacle, evoking a ritual and playful deceit. His work can be seen throughout the world - in galleries from Helsinki to Melbourne and Munich, in wheat-pastes and rap sprays from New York to Azerbaijan - on a prolific course that gains momentum. Whilst Kid Acne's signature illustrations have furnished apparel for the world's leading brands, the man himself remains independent and continues to paint walls in sub-zero temperatures. His current cast of warrior women and mythical creatures inhabit a fantastical world of epic slogans and backhanded compliments. And, he still has acne – www.kidacne.com

Kinsey – lives and works in Los Angeles (USA) – www.kinseyvisual.com

Klaus Dauven – Since 1997 Klaus Dauven has been drawing on dirty surfaces, cleaning parts of them and creating artworks with this technique of contrast between dirt and clean surface. In the beginning he just used a vacuum cleaner on paper and has been using a high-pressure cleaner and a brush since 1999. In 2007 and 2008 he created two big artworks on barrage in Germany and Japan – www.klaus-dauven.de

Krink – Craig Costello a.k.a. "Krink" or "KR", is one of the most visionary and inspirational street artists working today, and is also the creator of Krink, a line of the finest quality handmade inks and markers, beloved by artists and vandals alike – www.krink.com

L'Atlas – L'Atlas is a french artist born in 1978. He started writing Graffiti in the 90's. Fascinated with the line and writing's work, he went to study traditional Arabic calligraphy in Morocco, Egypt and Syria. He took special interest in the Kufi, a geometric calligraphy which he transposes the codes in the Latin alphabet, creating its own typography. He also worked for a while in the cinema industry, learning the techniques of montage, and directed few documentaries. Stronger with his experience and without stopping his interventions on the street, he developed a pictorial universe where each letter is considered as a shape, and every shape as a letter. Little by little, the city itself appeared to him loaded with signs which he collected to the almost abstract trail, with some printing system. He lives and works in Belleville, Paris (France) – www.latlas.net

Leon Reid IV – Leon Reid IV entered the world of public art as a teenage graffiti writer on the streets of Cincinnati, Ohio in1995. His move to Brooklyn, New York in 1998 signaled a transformation from his traditional graffiti work as under the name Verbs to a more contextual and humorous style under the name Darius Jones. His two and three-dimensional work is considered to form one of the bridges between the Graffiti movement of the late 1990's and the dawn of Street Art at the turn of the century. Leon Reid IV continues to work as a public artist with commissions completed in South America, The United States and Europe. His contemporary public work uses much of the humor and wit found in his previous work as a street artist. Leon Reid IV lives and works in Brooklyn – www.leonthe4th.com

Mambo – Mambo is the not-so-secret alias of Franco-Hungarian artist Flavien Demarigny. A self-taught artist, Mambo began learning his craft as part of La Force Alphabétique, a group of muralists in France during the late 80s and 90s. After 11 years with La Force he joined 9e Concept, an artists' collective whose vision is to bring art to a wider public. Today, he lives and works in Paris. In France, Mambo is best known for creating the graphics and logo for Groland, a sardonic weekly newsreel show on French TV, akin to "The Daily Show with Jon Stewart". Mambo describes his work as an illustrated brain, full of visions and emotions. He draws or paints as if he is writing, creating art that you can read. Everyone can build their own story simply by watching it – www.mambo.vu

Mark Drew – *1978 is an Australian graphic artist, and Co-Founder of Sydney's China Heights Gallery (www.chinaheights.com). Recent artworks revolve around his teenage music collection and 90's rap music. The (C-90) cassette tape series was a reaction to the disappearing graphic element involved in personal music collections. Drew is currently based in Tokyo, Japan, and spends the majority of his time eating cheap food and walking around – www.makingends.com

Magda Sayeg – *1973 in Houston (USA) – She founded Knitta Please in 2005 – www.magdasayeg.com

Mark Jenkins – *1970 in Fairfax, Virginia (USA), is an installation artist whose main body of work occurs in city streets. He uses packing tape to create casts of objects including himself. These

Info

bjects become characters that include clear ducks, dogs babies as well as hyper-realistic anthropomorphic works. His works turn the street into an absurd stage that he refers collectively to as the Glaled Paradise, an otherworldy place inspired by Li Hongzi's Zhuan 'alun. He has shown his work in major cities including Los Angeles, New York, Tokyo, Sao Paulo, and London. He also conducts workshop to teach his casting techniques as well as the practice of creating empheral sculpture based installations. He currently lives n Washington DC (USA) – www.markjenkinsx.com

Mischa Most – *1981 in Moscow (Russia) – www. mishamost.gallery.ru

Nick Walker – www.apishangel.com

Nomad – "Biographies are for losers. I live free, happy and without fear, and that's all you need to know"

Numskull – Born in Tokyo, Japan. Living and working in Sydney, Australia. Numskull paints false advertising and ridiculous characters using stencils, signs, comics, cartoons and anything else he can get his hands on – www.funskull.com

Nuria – www.nuriamora.com

Oliver Bishop-Young – *1986 in Wales (United Kingdom). Studied at West Wales School of the Arts(Foundation), Goldsmiths University London (BA Hons Design). Currently working freelance in London on varied projects for not-for profit social enterprises, exhibitions and commercial practices – www.oliverbishopyoung.co.uk

Olivier Kosta-Théfaine – *1972. In each of his interventions, Olivier Kosta-Théfaine plays with the codes and clichés of popular culture. He uses the languages and codes of the city and its suburbs, changing or modifying their original meaning so it can be understood by a broader public. His reflection is essentially based in rehabilitating the, often deconsidered, elements that belong to the city. His fascination for the suburbs has switched to a passion that is essential to his everyday work. The city is his muse, the drive for his artistic inspiration. He tries to decipher a discredited world through simple and ironic little mechanisms which he then transposes into galleries. By introducing the language of popular culture into the white cube, Olivier Kosta-Théfaine uses the suburb's many clichés, plays with the truth and distorts the elements of pop culture. Olivier Kosta-Théfaine makes fun of himself ... While others wear a tie and work on improving their table manners, he's proud of being suburbanite and claims it loud and clear. His work is more ironic than fundamentally serious. He asserts his pride of belonging to the concrete universe of suburbs, on the edge between glam and pop. He lives and works in Paris (France) – www.olivierkostathefaine.com

OsGemeos – www.osgemeos.com.br

Ox – www.ox.com.fr

Paul Insect is one of cult art's most recognizable and prominent artists. He has executed some of the most celebrated and provocative exhibitions in recent memory. Along with eye-popping gallery exhibitions, Insect has established himself as one of street art's seminal figures. Known for his visceral pop style, Insect mixes bright colors with morbid themes, Donald Duck and Pinocchio brandishing guns and bombs, while human skulls sport multi-hued Playboy bunny ears. His self portrait in bronze, "Pixel-man" has a computer-headed body melting, clutching a keyboard, while a second set of arms are tied behind his back. Insect's work has been seen on walls worldwide: from the streets of London to LA, from Stockholm to the separation wall in Palestine. His art often blends politics, death, sex and current culture with a satirical edge and has been compared to the steam-punk strain of science fiction. "Bullion", Paul's first major solo show in 2007 at the Lazarides Gallery in London, saw him dryly place real gold bars on the streets of London. Before it even opened, Damien Hirst spent a reported £500,000 buying the entire show of Pop Art-inspired screen prints, oil paintings and a continuation of the gold bars with a half ton sculpture of 100 bullion bars with some that had bites taken out of them. Paul continues to work in London and on the streets of London – www.paulinsect.com

Posterboy – There's no bio. Poster Boy is only an idea that exists for others.

Princess Hijab – *1988, is a Paris-based street artist whose work centers on "Hijabizing" the placing of black veils on advertisements. She is anonymous, and nobody knows of her identity.

Ripo was born and raised in New York (USA). He began drawing at the age of five and has not stopped making pictures since. After graduating from art school in the United States he quickly left the country for Barcelona, Spain where he has since dedicated himself to painting and creating in the streets. In recent years his work has become primarily text-based, exploring and communicating through typography, calligraphy and other hand-painted elements. He often offers more questions than answers and always with a sense of sarcasm and humor constantly crawling below the surface. His influences are rooted in his upbringing in New York as well as his extensive travels and the large tours he has realized across Europe

and Latin America. He has illegally exhibited his work in over 36 countries across the world – www.ripovisuals.com

ROA, *1976 in Belgium – "The artist's organic animal forms, reminding spectators of the forgotten natural world beneath the city's streets. Through his large-scale installations of very wild wild-life on the industrial canvas of the city, ROA produces a juxtaposition of the overtly natural against the mechanic that is both feral and nostalgic, a reminiscence of what the world used to be before cement and concrete. ROA is known for his large black and white works that depict both the outer and inner appearance of rodents, bulls, roaches et al, who slumber on garage doors and cement blocks, copulate in abandoned alleyways and decay on brick walls. ROA began pulling animals out of the depths of the industrial world in his home country Belgium, where he explored the area around his home and was inspired by the life that lurked in its lonely smokestacks. His resulting work snarls at you from wherever it prowls, awaking a visceral reaction that comes from seeing something familiar yet unknown, an uncanny portrayal of the animals within and around ourselves that our contemporary lifestyles have made null. Since his Belgium beginnings, ROA's work has hit the ground running like the animals he depicts, scattering on four legs all over major cities, showing up on the walls and abandoned factories alike."
– Margaret Boykin –
www.roa-bestiaria.com

Ron English – www.popaganda.com

Said Dokins – Said Emmanuel Dokins Milián – 1983 in México City (Mexico), lives and works in Mexico.

Samuel Francois – *1977 in Pompey (France), lives and works in Berlin (Germany) and Hettange-Grande (France). Samuel François works in a variety of mediums including painting, sculpture, photography and installations. A joyful manipulator of symbols, his goal is above all to preach a transitory art of which spontaneity and decasualization of the images are the bases of the work. In the majority of his work, Samuel questions its decorative position, hugely declined today amongst our society, this one including contemporary creation – www.samuelfrancois.com

Sat One – www.satone.de

Senioritas by Collective CC – Collective CC was created within an artistic residency of Cabracega with ConTactoCultural, a creative platform for the youngsters of ConTactoCultural. Cabracega is a Experience Design studio, which it's essence relies on the daily experiences. From the everyday analysis new ideas rise that question and add a different meaning to spaces, services, rituals and objects, thus creating innovative experiences that transform observers into participants. ConTactoCultural is a project based on development of communitarian living, adding value to the dynamics of young people in specific neighborhoods of Lisbon – www.cabracega.org

Sheone – *1969 in London (United Kingdom) – Sheone's unique brand of Abstract Typography is rooted deep in the new wave graffiti era of early eighties New York, however his trademark strokes and bold expressive approach to image making put him firmly in the present. His paintings are a constant rerendering of now. Hip, data injected splats and oversprays, acurate spills and bloodloss ornamentation reveal a deliberate and complex layered story. Works relay an emotional argot, mapped out in a highly personal and stylised shorthand, derived from years of acute mark making. One of the first generation of English artists to work exclusively in spraypaint, commit works to unruly curator free environments and eventually transfer this aesthetic style and medium to canvas. Sheone began to make works on canvas in tandem with his wall painting as a reaction to the transient nature and short lifespan of such works in the early 90's. In recent years he has managed to successfully transfer the scale and energy of illegal street painting into the well lit confines of the gallery creating international exhibitions and site specific installations. He says: "I was fortunate to start making graffiti as a teenager, fortunate because spraypaint and the application of graffiti, unlike today, had no legitimate artistic legacy and so I was free from any preconcieved critique of my approach to image making." –
www.blackatalier.com

Shepard Fairey is the man behind Obey Giant, the graphics that have changed the way people see art and the urban landscape. What started with an absurd sticker he created in 1989 while studying at the Rhode Island School of Design has since evolved into a worldwide street art campaign, as well as an acclaimed body of fine art – www.obeygiant.com

Sixeart – www.sixeart.net

Skewville – www.skewville.org

Skki© – In the eraly 80's Skki© was one of the first conceptual graffiti artists in europe. He left his code name on the walls of various cities around the world like Paris, Tokyo, New York or the Berlin wall during the cold war till1989. His statement marks all sort of work with a certain Eastern European awareness of contradiction. In his wide ranging deuvre, dichotomies pile up spirituality – capitalism – absurdity – reason – abstraction – narration.

Ultimately the opposites come to resemble one another. Skki© refuses to adopt a signature style –
www.myspace.com/skki

Slinkachu – "My «Little People Project» started in 2006. It involves the remodelling and painting of miniature model train set characters, which I then place and leave on the street. It is both a street art installation project and a photography project. The street-based side of my work plays with the notion of surprise and I aim to encourage city-dwellers to be more aware of their surroundings. The scenes I set up, more evident through the photography, and the titles I give these scenes aim to reflect the loneliness and melancholy of living in a big city, almost being lost and overwhelmed. But underneath this, there is always some humour. I want people to be able to empathise with the tiny people in my works." –
www.slinkachu.com

Spy – "Spy is an artist from Madrid (Spain) whose first urban performances began in the mid-eighties. A little later, established as the leading figure in the graffiti scene, he began to explore other forms of artistic communication in the street. His work consists of taking over urban elements by means of transformation or replica, the commentary on urban reality and the interference in his communicative codes. The bulk of his production stems from the observation of the city and an appreciation of its components not as inert elements, but as a palette of materials overflowing with possibilities. The will of the game, the careful attention to the context of each piece and a constructive, not invasive attitude unmistakably characterize his performances. Spy's pieces want to be a parenthesis in the automated inertia of the urbanite. They are pinches of intention that are hidden in a corner for those who want to let themselves be surprised. Filled with equal parts of irony and positive humor, they appear to make the passer-by smile, incite reflexion, and to favor an enlightened conscience."
– Javier Abarca (Javier Abarca is a critic and university professor specializing in urban art and subcultures) – www.urbanario.es

Tenten/1010 – www.1010101010101010101010.biz

Urban Blooz – www.urbanblooz.org.

Urban Camouflage – Sabina Keric & Yvonne Bayer – Sabina Keric, *1984, lives and works in Berlin (Germany). Yvonne Bayer, *1983, lives and works in Cologne (Germany). Urban Camouflage deals with the question how to camouflage oneself and one's identity in the commercial space. The costumes are inspired by «Ghillie Suits», the camouflage suits of snipers and hunters. The commercial space is a clean and untouched area, usually there aren't any artistic activities. The customer expects nothing out of ordinary in a world of brands and price labels. Our project exeeds the limit and enters the world of commerce without any permission. The camouflaged person blends into the surrounding. He or she can dissapear for one moment and gets the possibility to merge with the supermarket to defend from the noise of commerce – www.urbancamouflage.de

Vhils (Alexandre Farto) – *1987 Seixal, South of Lisbon (Portugal). Alexandre Farto has been writing graffiti and expressing his visual poetry under the name of Vhils since the early 2000s. He got into graffiti in his early teens and became proficient in bombing trains. His skills became atuned to experimenting, researching and interacting with the urban environment, picking up tools such as stencilling and other media. He soon took up his artwork seriously and started expanding boundaries both outdoors and indoors, both solo and with the VSP collective. After trying out graphic design and 2D/3D animation, he moved to London in 2007 and started a working partnership with Pictures on Walls. In 2008 he took part in the Cans Festival, where his "Scratching the Surface" series was exposed to a wide audience. He presently works with Lazarides Gallery in London, Studiocromie in italy and the Vera Cortés Art Agency in Lisbon – www.alexandrefarto.com

The Wa – www.the-wabsite.com

Zasd concentrates in his practice on social relations, architectural situations and hidden phenomena in urban context. The mainly conceptual works use the structures of the outdoor space cleverly and unsolicited. To support his non-commisioned projects you can purchase editions at www.urban-art.info – www.thomasbratzke.com, www.ritschezast.com

Please also check out:

PUBLISHING PROGRAM

http://www.stylefile.de
http://www.publikat.de

INTERNATIONAL TOPSPRAYER
taps & moses
05.2011
isbn: 978-3-939566-35-9
international topsprayer
hardcover with flip image. 30 × 22 cm. 288 pages

MURAL ART #3
murals on huge public surfaces around the world
11.2010
isbn: 978-3-939566-28-1
kiriakos iosifidis
hardcover. 30 × 21 cm. 272 pages

STYLEFILE BLACKBOOK SESSION #4
graffiti on paper, scribbles, outlines and
full-color-stuff
07.2010
isbn: 978-3-939566-30-4
mike hefter, markus christl
paperback. 23 × 16 cm. 160 pages

HERAKUT
the perfect merge
04.2009
isbn 978-3-939566-24-3
jasmin siddiqui, falk lehmann
flexicover. 21 × 26 cm. 200 pages

ACTION PAINTING
bringing art to the trains
05.2009
isbn 978-3-939566-25-0
kristian kutschera
paperback. 21 × 26,5 cm. 216 pages

BANKSY
wall and piece
11.2006
isbn: 978-3-939566-09-0
banksy
paperback. 21 × 26 cm. 240 pages

FLYING FÖRTRESS
part of rebellion #1
11.2008
isbn: 978-3-939566-16-8
c100
paperback. 15 × 18,8 cm. 128 pages

DAVE THE CHIMP
part of rebellion #2
05.2009
isbn: 978-3-939566-17-5
c100
paperback. 15 × 18,8 cm. 128 pages

EROSIE
part of rebellion #3
11.2009
isbn: 978-3-939566-18-2
c100
paperback. 15 × 18,8 cm. 128 pages